quick solutions to great layouts

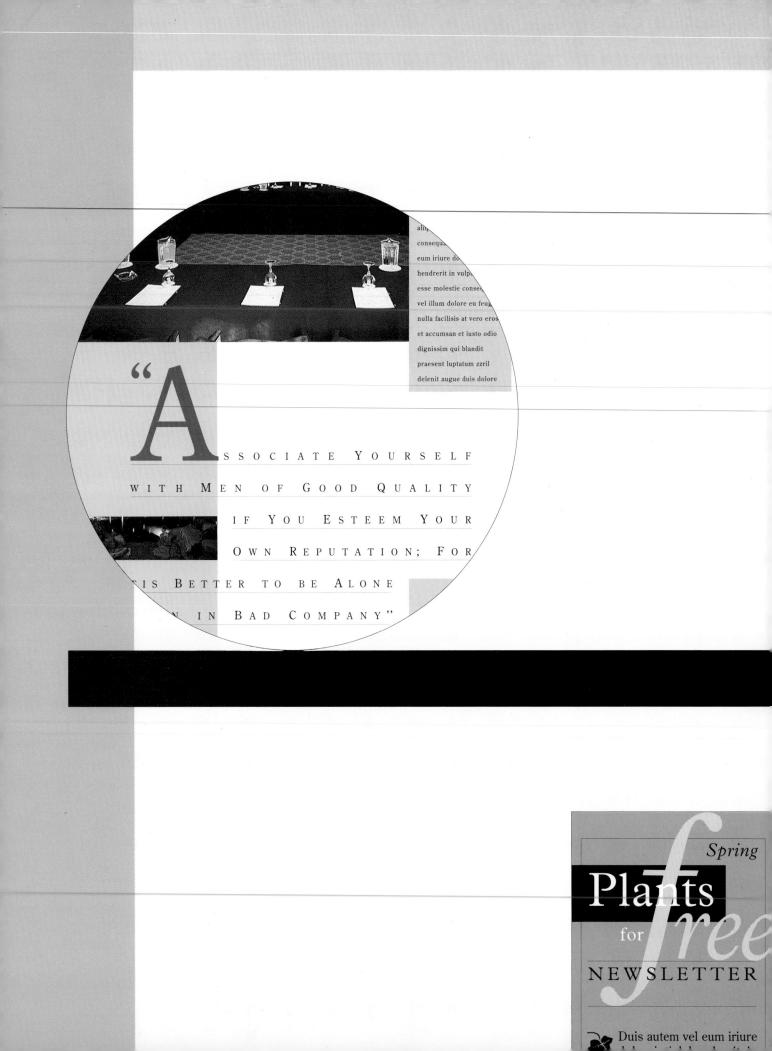

quick solutions to great layouts

DESIGNED AND WRITTEN BY GRAHAM DAVIS

Cincinnati, Ohio

contents

A QUARTO BOOK

First published in the U.S.A. by North Light Books, an imprint of F & W Publications, Inc. 1507 Dana Avenue, Cincinnati, Ohio 45207

First published 1993 Copyright © 1993 Quarto Publishing plc

ISBN 0-89134-507-8

All rights reserved. No part of this publication may be reproduced, stored in a retrieval system or transmitted in any form or by any means, electronic. mechanical, photocopying, recording or otherwise, without prior permission of the Publisher.

Designer: Graham Davis Senior Editor: Kate Kirby Senior Art Editor: Philip Gilderdale, Mark Stevens Editor: Lydia Darbyshire Photographer: Paul Forrester Picture Researcher: Liz Eddison Picture Manager: Rebecca Horewood Art Director: Moira Clinch Publishing Director: Janet Slingsby With special thanks to Sally Butler

Designed using Microsoft®Windows™ 3.1, Pagemaker 4 and CorelDRAW 3

Manufactured by Regent Publishing Services Ltd, Hong Kong Printed by Lee-Fung Asco Printers Ltd, Hong Kong

6/7	INTRODUCTION
8/9	How to get the best from this book
10/11	BEFORE YOU START
12/13	WHEN YOU START
4/ 5	THE ELEMENTS OF THE PAGE
16/17	How to create and use a grid
18/19	SELECTING A TYPEFACE
20/21	USING PICTURES
22/23	REVIEW YOUR LAYOUTS

	2		4
24/55	NEWSLETTERS	86/113	STATIONERY
26/29	NEIGHBORHOOD WATCH	88/89	FREELANCE WRITER
30/3 I	A LOCAL PRE-SCHOOL PLAYGROUP	90/91	REAL ESTATE AGENTS
32/33	NON-PROFIT ORGANISATION	92/93	LOCAL TRADESMAN
34/37	MODERN DANCE GROUP	94/95	CAB COMPANY
38/41	NATIONAL LAW FIRM	96/97	R ELAXATION GROUP
42/43	WILD PLANT SOCIETY	98/99	CRAFT SHOP
44/47	COSMETIC MANUFACTURER	100/101	SANDWICH BAR
48/49	CLEANING COMPANY	102/105	R EGIONAL ARTS CENTER
50/5 I	CULT ROCK BAND	106/109	DESIGN GROUP
52/55	PUBLISHED NEWSLETTERS	110/113	PUBLISHED STATIONERY

5						
4/ 4	ADVERTISEMENTS					
116/117	LOCAL PET STORE					
118/119	CHARITY APPEAL					
120/121	DISCOUNT TRAVEL					
122/123	B OTANICAL GARDENS					
124/125	DISCOUNT SHOPPING CENTER					
126/127	Advisory group					
128/129	SELF-HELP GROUP					
130/131	INTERIOR DESIGN STORE					
132/133	SPECIALIZED CLOTHES RETAILER					
134/135	SHOE MANUFACTURER					
136/137	BUSINESS EXECUTIVES CLUB					
138/141	P UBLISHED ADVERTISEMENTS					
142/143	INDEX					

-

144 ACKNOWLEDGMENTS

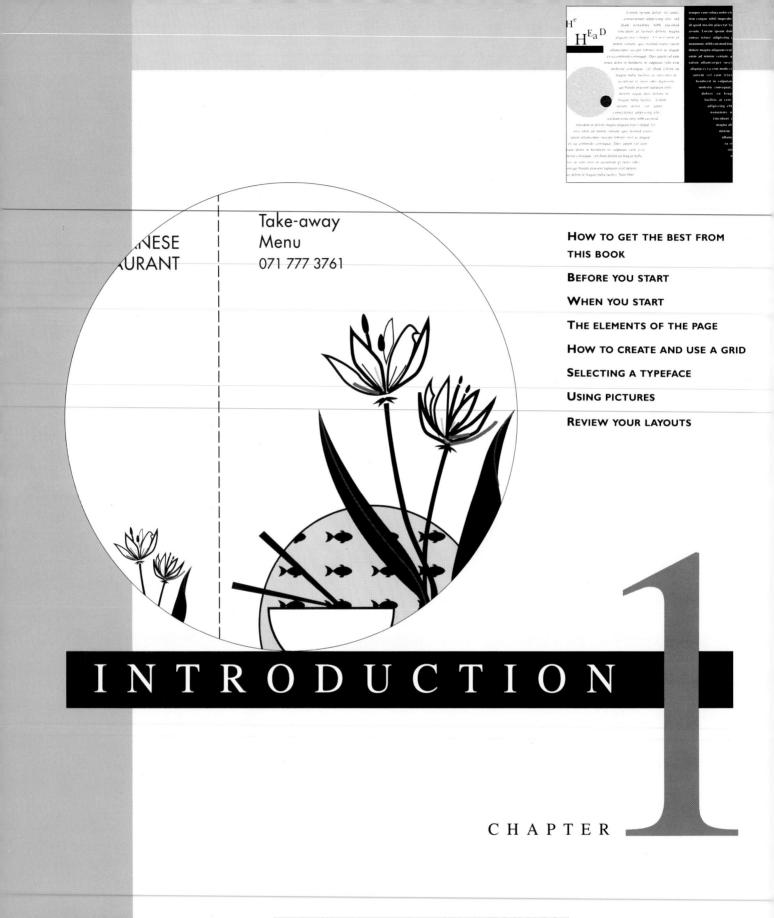

orem ipsum dolor ametconsectetuer a he advent of desktop publishing (DTP) has introduced the thrills and frustrations of graphic design to ever-increasing numbers of people. Whether you are a local scout leader publishing a quarterly newsletter or the marketing director of a large corporation establishing an in-house design department, you may find yourself responsible for the production of a variety of material that has traditionally been typeset and printed, and you will quickly come to appreciate the problems involved in producing dynamic and effective layouts.

Quick Solutions to Great Layouts is a practical guide to the design of a wide range of printed material. Examples of newsletters, brochures and leaflets, all types of stationery – from simple letterheads to complete corporate identities – and advertisements – from single-column, black and white to full-color, full-page – have been specially created to demonstrate how an effective layout can help you to communicate your message.

The book is organized by publication type and in three levels of expertise – basic, intermediate and advanced – so that whatever your expertise and experience there will be several examples appropriate to your skill and training. Each example includes a brief that has been created for a fictitious client and a solution – the description of the designer's response to that brief. A detailed specification list has been included for each example so that you can understand how it may be accurately recreated, either by using a DTP system or by conventional typesetting.

An awareness of basic design and typography is

necessary before a designer can produce a worthwhile layout, so the next section explains in detail some of the underlying design principles you will encounter in your quest for the perfect layout. The section covers the importance of correctly interpreting a brief, the design and the use of grids, the choice of typeface, the integration into the layout of photographs and illustrations, the planning of a publication; and much else besides. The terminology – points, picas, ems, ens, fonts, justified type, for example – may also be unfamiliar, and so it, too, is explained and demystified.

The ultimate success of any publication depends on one thing – the communication of the message – and your design must always be harnessed to this end. Therefore, if it is to be really effective, your layout must not merely be an appendage to the words but a fundamental part of the communication process. Just as in speech the use of different intonation, stress, accent, speed of delivery, and volume can give even a single word a different feeling or meaning, an effective layout can have a similar result. The successful design will enhance or distill the message conveyed by the words and provide the visual environment in which that message can most effectively be conveyed.

This may seem an unobtainable expectation for a humble layout, but look at examples of the best designs and you will see that it is possible. At the end of each chapter is a selection of examples from around the world. These have been chosen to demonstrate the enormous range of layouts that exists and the potential they have for successfully expressing both simple and complex ideas.

> "[The designer] must possess above all the quality of empathy, the capacity to understand those to whom the message is addressed. Good graphic design must be for everyone, not just for its initiator." *FHK Henrion* June 1987

7

The examples that have been created for this book use imperial page sizes. The specification list for each example has been devised so that the layouts may be easily recreated.

SPECIFICATIONS

Format 8½ x 11 in or A4

Grid 6-column Space between cols. – 1p5

Margins i 2p11 o 4p7 t 4p1 b 4p10

Fonts New Baskerville

Track loose I Body text 9½/12½pt

2 Headlines 40/43pt, 24/26pt

New Baskerville Italic Track loose

3 Box heads 19/23pt

4 Box text 9½/15pt Graphik Shadow Track force justify

5 Title 134pt

6 Drop cap 134pt

Helvetica Condensed Track loose

- 7 Captions 7½/13pt
 8 Folios 10pt
- Track force justify
- 9 Subtitle | | pt

8

Track can be specified more precisely by the use of kerning – that is, by specifying letter and word spacing in units of points. The format is expressed in inches and the equivalent metric size, which is usually either A4 or A5.

The grid indicates the number of columns and the space between them. The margins are abbreviated thus: i = inside, o = outsidet = top,b = bottom; or: | = leftr = rightt = top, b = bottom

The font or fonts (typefaces) used are listed. This information is followed by the track (the space between letters and words), which is described as tight, normal, loose, very loose or force justified, the last being letterspaced across a specific measure (width).

Pica measurements are abbreviated to "p", as in 2p11; the latter measurement represents points.

how to get the best from this book

his book is packed with specially designed layouts for you to adapt or copy or simply to inspire you. Each deals with a different type of printed matter – newsletters, brochures, stationery and advertisements – and is divided into three levels – basic, intermediate and advanced – so that demanding layouts are separated from those that can be more easily produced.

It is in the nature of design that technical skills – creating a grid or instructing a repro house, for example – go hand in hand with aesthetic ones, such as creating a harmonious layout in which the various elements are put together in a way that is pleasing to the eye.

It is possible to pick up the technical skills through practice, but in a world increasingly dominated by electronic technology, designers of the future will need continuously to acquire new skills. Aesthetic considerations, being entirely subjective, are more difficult to define.

The examples created for the following chapters demonstrate the enormous variety of layouts that can be achieved from the same basic raw materials – type, pictures, graphic elements and, most importantly, space.

intermediate NEWSLETTERS

F

CLIENT national law firm

> 3 3

5

Matthew Hegarty

run in the Primario

2

The main items of

type are numbered

and keyed into

corresponding

project specs - so

you will see at a

glance the details

you will need to

create the layout.

The grid has been

superimposed in blue to show

clearly how the

layout has been constructed.

numbers on

en cols 6mm

Abc

Graphik Shadow Track force justify Title 134pt Drop-cap 134pt

6 Drop-cap 134pt Helvetica Conder Track loose 7 Captions 7%/13pt 8 Folios 10pt Track force justify 9 Sub title 11pt

The main examples

have to be reduced

size to fit the book

page; however, a

and text, shown

is shown in the

bottom left-hand

corner of the page.

sample of headline

actual size (100%),

from their actual

Butem vel eum iriure do lor in hen dre rit in vulp ütate velit Butem vel eum iriure do lor in

BRIEF The monthly newsletter for this old established law firm has between 12 and 16 pages. and it is the main means of corporate communication. It has a wide local circulation, as well as some regional and national readers. There is, therefore, an adequate budget for design and production and the occasional use of four-colour printing. The elegance of the design and the choice of stock are considered to be the chief visual ways of conveying the firm's dedication to quality of service.

Revised zoning laws

Is it time to change

Ľ

SOLUTION A 12-16 page publication gives an opportunity to have a four-page cover of heavier weight (210gsm) than the inside pages (135gsm). The off-white 100% cotton paper creates the feel that the client wants, and the layout has a dependable and reassuring, though modern, look. This is achieved by attention to typographic detail, the choice of face, New Baskerville, and tall, slender drop caps, echoing the masthead, which is set in Graphik Shadow. Tinted boxes surrounded by 11/2 pt tinted rules and even the spelled-out Page one contribute to this effect.

> The example of each layout is annotated with detailed captions to highlight the main features of the design and explain how they have been created.

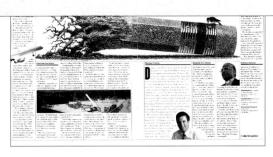

PUBLISHED EXAMPLES

In addition to the fictitious examples, further examples from around the world are included at the end of each chapter. These have been selected to show how the layout ideas and techniques demonstrated in this book have been utilized and built upon by top designers.

The best way for the designer to develop is to practise, and this book is intended to inspire you to extend your range and acquire new skills.

head has a strong

an elegant serif face, has been chosen for both headlines and text The impact of the masthead is re-

masthead is re-duced by the tint. and it does not overwhelm the nain headline ieneath. The

nphasis that a

Drop caps can be used to lead the eye to the start of a new piece of text or for primarily decorative pur-

decorative pur-poses. A particu-larly large 8-line drop cap is possible here, because even a wide character like an M still leaves a reasonable width for the text when it is in such a condensed face.

Avoid very narn text columns, which can leave uely spaces whe

igh spaces when words wrap to the next line. The spec for the drop cap is the same as for the

ISSUES / MARCH 199

of the type area

Graphik Shadow Helvetica Ultra

AMBIT & PEAS

separating i om the rest. inal sta by one of the firm

way of highligh

The text describing the brief and the solution identifies the client's

outlines the

to them.

requirements and designer's response

9

before you start

The annual report and accounts has to present a company in the best possible light. The designer has blended a sense of tradition and modern efficiency, mainly by paying attention to typographic detail.

Mobile Communications

Receipt ron row LANDAR COMMUNICATION CONTEL OF ITS IN AND DES DEVELOP AND SOF DEVELOP AND SOF DEVELOP AND SOF DEVELOP

	services in all parts of Canada	iat feetered the growth of cellula since 1985 has prompted the
	introduction of innovative product	and services. Cantel minutered
	Call Following TM , the first a	
	North 4	
	N ITS PRAT FIVE YEARS, Cantel invested	Digital cellular improves th
	to establish its nation-wide cellular	transmission and increases
	network. By 1990, that network was	Leading the 1990s trends
	virtually complete, and Cantel was in all	equipment portability and
	10 provinces with about a 50% share in	mobile communications, C
	major markets. Capital expenditures	developing innovative, bec
KS IS KNOWN	from now on will be largely demand	services such as public con-
OVATINE D	driven. Where there is demand for	(personal communications
NATIONS.	cellular services. Cantel will meet that	In 1990, Cantel began e
MENDS 25	need, either by broadening service or by	with public coedless and P
ET CELLUAR	adding more capacity in orban areas.	Canada and will continue
ON RESEARCH	Cantel also provides paging and voice	1991 with a large-scale PC
ELOPMENT,	messaging services in Canada and	trial in several cities across
NO PRODUCT	recently signed an agreement with	summer. Lasting about five
WENT, SYSTEM	SkyTel Corp. of the United States to	these trials will involve sev
TWAAL	supply these services throughout North	customers using digital cor
EMENTS AND	America.	telephones in nerworks the
ER SERVICE	Soon Castel will begin introducing	many PCN-type capabiliti
IMENTS.	digital channels and equipment to its	will test PCN in their hom
	system. The conversion will be phased	public locations and will h
	in over a number of years, and Cantel	advanced network features
	will retain analog capacity to forestall	
	equipment obsolescence for subscribers.	

30	10:00	2:00	2:30	4:00	4:30
note: Chicago Theatre	Minois Chapter(ASID and Allied Fibers Present	The Constive Connection: Uncovering the Link Between Who You Are and	Keeping Stride With the Design Opportunities of Our Asing Population	Communicating Ideas Artifully	SPEC Awards Celebration
ting Together a Winning enigetion	The Designer's Informium on "Carpet in Foodservice Design."	How You Perform	As America's elderly population	Co-sponsored by The Steelcase Design	preview this year's exhibit of remarkable furnishings for use
sponsoned by the Institute of iness Designers and The chandise Mart, featuring the entation of the IBD Star nd.	A presentation of fibers, color forecast and specifications on carpeting best for hospitality design. Until noon. For reserva- tions, call 312/457-5080.	A person's desire, voltion and atriving are essential, yet some- times likelye measures of their knack for getting things done. Fact Finder, Follow Thru, Qalok Start and Implemento. Learn	continues to expand at a rapid pace, so has the demand for quality, like enhancing design. Architect and interior designer. Woyne Ruga, leads an audience-interactive discussion	Partnership and Progressive Architecture. Prominent architects and designers discuss rendering and modelmaking as activities within	in both contract and residential applications. SPEC (Specially Products Exhibition for Con- tract) award winners and entries are all on view in this unique dis- plex of product photos, mater-
h H. Neuharth, founder of Roday and author of the selling Contessions of an B., advises those who want ove up in their world. He ents his experiences	Mart Plaza Hotel, 14th Fleer Ballroom	which of these "action modes" of human behavior describes you and the people you work with or work for as a means of evaluating and predicting performance.	on the psychological, social, spinitual and physical aspects of our aging officer's needs and the key role these factors play in the design of contemporary environments.	firms and as a basis for indepen- dent practice. The media and methods used to present a design to a clent have become more varied and their meaning more complex. And they, them-	page of product product, intern- late and finish samples. So toest the winners and proview products at your leasure at this informal reception—and visit foors 6. 12, 13, 16, 17 and 18 to see the products that define the best in
ling up USA Today and uses issues in today's times. He reveals now he signed his maverick agement style and with it	Corport Life Cycle Coating Four experts in the area of life cycle costing present recent projects and experiences	Speaker: Kathy Kabe, chief executive officer, Resources International, Phoenix	Speaker: Wayne Ruga, president, thief executive officer, founder, National Symposium on Health Care Interior Desion, Inc. crivin	selves, have become a way of exploring design ideas. The value of presentation as ert, as a design tool and as a marketing communication tool are explored.	versatile furnishings today Second Flass, The Merchandias Mart
lutionized Gannett, Inc. mote: h H. Neuharth, ratined	related to the specification, installation and maintenance of contract carpeting.	Exposenter/Chicago	pal, Wayne Ruga Architect, Inc., Martinez, Calit.	Speakers: Arthony Ames, principal, Arthony Ames, Architect, Atlanta	9:00
man, Gannett Co., Inc., oa Beach, Fla.	Revealers: Roi Newaril, director of interkors, TRA Consultants, Inc.		13th Floor Showroom	Stephan Hoffpaulr, principal, Hoffpaulr/Rosner Studio, Houston	The Institute of Business Designers Midnight Affair Winners of the Contract Design
-	Seatto J.F. "Fritz" Rench, shairman,		Com.	Ralph Johnson, design principal, Perkins & Wil, Chicago	Competition, sponsored by IED and Interior Design Megazine, are honored during this black-lie
7	Recine Industries, Racine, Wisc. Fred Shehadi, president, B. Shehadi & Sons, Inc.,			David Munson, director of computer simulations, Helimuth Obeta & Kessabaum, St. Louis	reception at Chicago's Nstoric Navy Pier. For individual tickets, contact the IBO National Office
¥	Whippany, N.J. Moderators Gary W. H. Smith, president.			Peter Pran, design principal, Ellerba/Becket, New York	at 312/467-1950.
	G. Wentworth Smith, Inc.; editor/publisher, Commercial Carper Digest, Milwaukee			Moderator: Thomas Fisher, executive editor, Progressive Architecture	
1 cm	18th Floor Showroom	Constanting of the second		Expocenter/Chicago	

Left: A brochure for a furniture design conference uses bright colors, un-fussy typography and bold, geometric graphics to maximum effect. B

efore you start to create a new layout, it is essential to remember one very important point – the design of the publication will be the means by which the client's message is communicated. The design is not an end in itself. It is easy for a designer to use an inappropriate format or typeface, or to commission a photographer whose style is at odds with the subject matter, just because he or she happens to like the style, or has a burning desire to use a new face in the type catalog. Self-indulgence is the greatest threat to effective design.

FORM MUST ALWAYS FOLLOW FUNCTION

The brief is the starting point for a new design. The client's objectives must be clearly understood, so it is important to take notes at the briefing meeting and to obtain the client's confirmation of these objectives, preferably in writing. It is more than likely that the client will have a preconceived idea for the design of the publication. "I know what I like" is a commonplace attitude, although often what the client really means is "I like what I know." You may be shown a competitor's brochure or even a rough layout that the client has produced. It is guite possible that the design, in fulfilling the client's communication objectives, will be different from that preconceived idea. It is, therefore, of paramount importance to talk through your visual approach before you show the client a mock-up of the proposed design. Nothing is guaranteed to upset a client more than being presented with a design that is radically different from the one he or she was expecting.

UNDERSTANDING YOUR AUDIENCE

The design style will depend on the audience for the publication, and an inappropriate style can result in a publication that does not achieve the client's communication objectives.

The mismatch of the following adjectives (first column) to clients (second column) makes the point. The correct matches are shown in parentheses:

dynamic	wholefoods	(telemarketing)
colorful	undertaker	(toyshop)
conservative	toyshop	(broker)
garish	publisher	(rock group)
restrained	telemarketing	(undertaker)
classic	rock group	(publisher)
fresh	broker	(wholefoods)

Particular styles are created by a combination of the right typefaces, type sizes, leading, column widths, and colors and tints - even tints of black, if color is not available. The choice of photographer and illustrator will also greatly influence the layout's eventual style.

Although it is dangerous to make hard and fast rules, some generalizations are possible - for example:

upmarket	select smaller type
downmarket	select larger type
loud	select sanserif type
quiet	select serif type
busy	select narrower columns
quiet	select wider columns
speedy	select italic sanserif type

Everything, in fact, has a connotation - bright colors imply youth, subdued colors, maturity; color combinations such as browns and creams suggest tradition, but red and green together clash, implying anarchy. The look and feel of your layout will determine the reader's response. If the design works well, the reader will be reading the text and receiving the client's message. If it doesn't, you may be looking for a new client.

Below: The layout problems arising from this duallanguage annual report from the Canadian Mint have been cleverly

solved by using a wide, horizontal format, which allows the text blocks in each language to appear side-by-side. The captions to the

smaller photographs have been staggered to break the uniformity of what might otherwise be a toosymmetrical design.

Mitaux précieux et Allinaa us Metals an de.

The Projects of The Herring Group

6

Above and top: This newsletter allows the photographs to tell the story, while only a small portion of the page area is devoted to text. Replacing the small length of ribbon by a longer one at the bottom of the page

was an opportunis-

tic piece of graphic design, which complements the hand-drawn river on the opposite page. The last page (top) also uses a photograph combined with a graphic representation of a building to enclose a typographical checklist.

Manife gold March Hert

> aving established the general stylistic approach, you will have left the client and returned to your studio with the intention of creating some of the best layouts ever. But where do you start? A blank computer screen or a new pad of layout paper can sometimes seem very intimidating, and your initial enthusiasm may suddenly evaporate to be replaced by frustration and gloom.

> The answer is not to spend too much time on any single aspect of the design if it is not fruitful. Start by flipping through this book, looking for inspiration. Doodle on your layout pad, perhaps using a five-column grid but leaving the first column blank; or take a look through the type catalog, experimenting with a design feature such as a heading or quote. Cutting out blank shapes to represent pictures and dummy text and moving them around, unencumbered by a grid, may help. If you are free to choose the format, try folding sheets of paper into different configurations. Sometimes, in an advertisement for example, the layout may be built around a conceptual idea, and the resulting design may have an inevitability about it. It is vital that you keep your

work fluid long enough to avoid shutting off possible ideas.

A common mistake is to finalize the grid too soon. It should be the skeleton on which the design is fashioned. If you start out with a kangaroo's anatomy, it is extremely difficult to create a horse. Eventually, however, the embryonic design will emerge.

FIRMING UP THE DESIGN

The designer working on a computer has a big advantage. Adolescent versions of the layouts can be saved or discarded at will — type sizes, leading, track, margins, the number and width of columns and the spaces between them can easily be changed. In fact, it is easy to keep revising

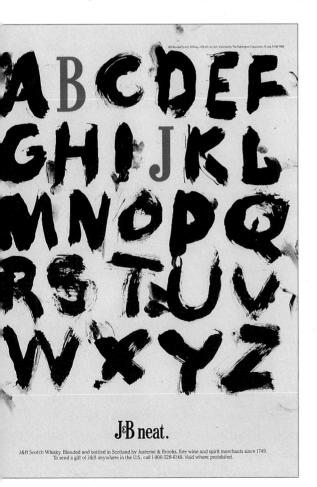

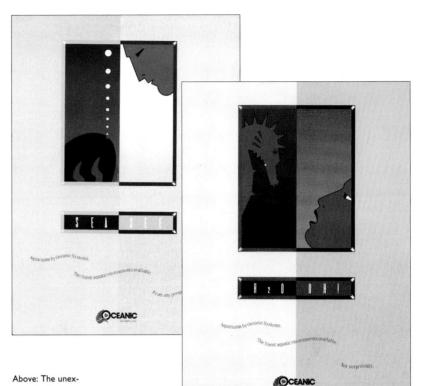

pected solution often requires a leap of imagination by the client. Here, the designer has opted to use a stylized illustration rather than the more obvious photograph of the product. The result is an unusual and stylish advertisement. Also note how the text is set on a wavy line to suggest water.

Left: An advertisement's design has

to express the

concept in the fullest possible way.

The idea is so

simple and strong

that it would be difficult to envisage

an alternative to

this layout.

the design and never reach a conclusion.

Now is the time to road-test your design. Go back to the brief to make sure that it meets all the agreed criteria. Anticipate the questions the client will ask. When asked why you selected a four-column format, don't say "because it looks nice." Give your reasons in a considered way: "Because the still-life product photographs shot in vertical format will fit uncropped over two columns, extending to the depth of the type area, while the horizontal ones will fit to the three-column width and be an identical size, so that the products in both formats will be at a consistent scale, an important consideration in a jewelry catalog."

INTEGRATING THE TEXT

Remember that the copy is as important as the design. You may be responsible for commissioning the writer, or you may use the client's inhouse writer or nominee. When you make the presentation, the text may be in outline form, draft copy, laser proof or even typeset, but the important point is that it has been carefully integrated into your design strategy.

Conventional Dense and text-heavy,

with a headline at the top and a picture at the bottom.

The Headli	no			dolore cu feugiat nulla	
The Headlii Loren jouw dolor sit ante, consectiour adjuktig eth, sel and adjuktig eth, sel and adjuktig eth, sel and adjuktig eth, sel and adjuktig eth and adjuktig eth adjuktig eth sel and adjuktig sel adjuktig s	De visi esin ad minin venise, que notradi estreti talio estreti talio estreti talio estreti di estreti labori estreti di estreti estre	cells a distribution president associate backweise and a distribution of the susception backweise and a distribution associate backweise and a distribution of the associate backweise and a distribution of the distribution of the distribution of the distribution of the distribution of the distribution of the distribution of the distribution of the distress of the d	depresenting on banding presenten logiquestion acred doctore trapped sites facilitati. Lorent presente facilitati. Lorent presente doctore al Lorent presente doctore al Lorent presente al constructioner a construction al constructioner a construction al constructioner acress al constructioner acress al constructioner acress al construction and annual research and a construction al construction and annual research and a construction and annual acress and annual acress annual acress doctore acress doctore acress doctore acress doctore acress presented acress p	obbre en fergata sella tecchista at vere eros et accentante et issuo dolo degrassame qui valuadi. delesti agget dela delesti agget della delesti agget della de	velle næn moksele consequet, vell Häm dokten er stregat nåtte attense att i stress och dok digissisten og vell handet dokten er spre skullet dokten i stregat nåtte dokten er forspat nåtte dokten er spre skullet dokten magna attense fræddere magna atten
dignissim qui blandit praesent luptatum zzril delenit augue duis dolore te feugait nalla facilisi. Lorem ipsum	eleifend option congue nihil imperdiet doming id quod mazim placerat facer possim assum. Lorem ipsum dolor sit	ullamcorper suscipit lobortis nisl ut aliquip ex ea commodo consequat. Duis autem vel eum iriure dolor in			consequat. Duis autem vel eum iriure dolor in hendrerit in vulputate velit esse molestie consequat, vel iffum
dolor sit amet, consectetuer adipiscing elit, sed diam nonummy nibh euismod tincidunt ur faoreer dolore manna	amet, consectetuer adipiscing elit, sed diam nonummy nibh eaismod tincidunt ut laoreet dolore magna aliquam	hendrerit in vulputate velit esse molestie consequat, vel illum dolore ou feugiat nulla facilisis at vero eros et			dolore eu feugiat nulla facilisis at vero eros et

Classic

Simple, two-column format with centered headline and inset picture.

The Headline		consections affigincing elit, sed data novarmy nihé esitanod hitcideas st loorest dotore magna aliquan ena violensi. C viola dotore magna dotore en violensi. C viola dotore dotore status enim ad misim vestana, quis notrad cener cuitan silla corego presente hipat una rand detent	
Leven ipsue doite via anci, consciente de depise est du - consciente de depise est du - consciente est investe de la - consciente est investe de la - consciente de la - socia de la - consciente de la - dición esta de la - dición esta de la - dición esta de la - de la - consciente de la - dición esta de la - dición esta de la - consciente de la - dición esta de la - consciente de la - dición esta de la - consciente de la - de la	conseque, vii film dubre en freque nich factore at pro- ference and the scheme at pro- tein scheme at the scheme at pro- sequence and the scheme at pro- lation of the scheme at pro- sequence at the scheme at the	me cipit biothys and a single of several. Drive the several. Drive the several. Drive the several biothysical several several several biothysical several several several several several several several several several biothysical several several several several several biothysical several several several several several several several several biothysical several several several several several several several several several several several several several several	angen the old over in fragers skills over the state of the state of the state and the state of the state of the state over the state of the state of the state over the state of the state of the state over the state o

Modern

Wide measure and extra leading, letterspaced headline, and bold rules.

the elements of the page

he basic building blocks of virtually every layout are the same four elements-headlines, text, pictures and, of primary importance, space. This is surprising when you consider the enormous variety of design solutions that is available. Although color is important, it is not a fundamental element – most layouts that use color should also work in black and white as long as tints of black are used.

The examples created for these two pages use only one font family – Times – in two weights – roman and bold – and with gray or white shapes indicating pictures. They clearly demonstrate the importance that space plays in a basic design.

Using only these limited resources, each layout begins to reveal a style of its own – conservative, dynamic, youthful and so on. Appreciating this basic concept is of paramount importance to all designers.

The following pages examine in detail the selection of typefaces for headlines and text, and the commissioning and use of pictures, both photographs and illustrations. But first comes the grid and how the basic layout ideas are formalized into a permanent structure.

14

Technical

Angular layout with column rules and lots of white space. Clean and strong.

Aggressive

Large, underlined headline and bold text with regular crossheads.

Juvenile

Busy layout with large initial cap for headline, tinted rules, and large text.

Youthful

Fun with graphics and type, multi-size headline, and white out of black page.

Natural Elegant, with wide, spaced text and headline, and use of oval pictures.

Prestigious

Offset initial cap, simplicity, and use of space are the key to a graceful layout.

how to create and use a grid

Unlike a paperbased grid, the screen version can be altered to include additional information when it is required.

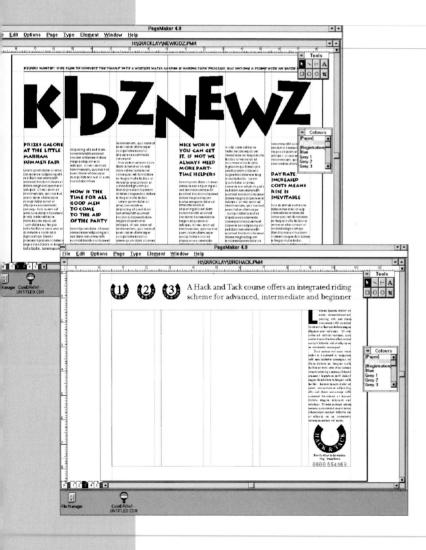

grid can be as simple or as complex as you wish. The basic skeleton will consist of a double-page spread, showing bleed and trim sizes, page margins and text columns, but any amount of additional information can be included-recurring graphic elements such as the tint panels on this page, for example, or hanglines or folios (page numbers). A distinction should be made between a layout created on a computer using DTP software and the more traditional pasted-down, camera-ready artwork.

SCREEN-BASED OR PAPER-BASED GRIDS

The computer-based design will invariably be output on an imagesetter in the form of bromide or film as a fully made-up page or spread. If the layout is created conventionally it is more likely that the typeset copy will be supplied as galley proofs (continuous strips of setting) for you to paste down in position.

Traditional grids should be drawn on artboard using a non-reproducible blue pencil. For long or repeated publications-newsletters, magazines and books, for instance-it is more efficient to have the grid printed in bulk on a suitable board. The setting-up of a screen-based grid will vary according to the software used. It is most likely to be a master page, which appears as a fixed background to the publication pages. The screen-based grid (often referred to as rulers and guides) will, of course, never appear on the typeset page. The text will flow down the columns and run around inset graphics or pictures; the headings will hang or sit on the relevant grid line; and boxes can be drawn in position to provide keylines for pictures. Alternatively, pictures can be scanned in.

The traditional grid will be more useful if the lines overlap (see the examples on this page) so that when a piece of typesetting is pasted down the grid lines are still visible. It may also be helpful to include horizontal lines that correspond to the leading of the main text. It is worth numbering these, particularly if the final paste-up is preceded by a rough one using uncorrected proofs.

USING THE GRID

Having designed the grid, you should test it to see that you have included all the information you will need to create additional spreads. It is, however, possible to clutter up the grid with too much information, making it confusing. A grid with more columns-six, for example-is more

Above and below Two examples of a paper-based grid. Both show the optimum amount of information that should be included. flexible than one with fewer. The distance between the trim and the bleed will normally be 8pt - 1p2. The purpose of the bleed (which will be trimmed off) is to ensure that pictures that extend to the edge of the page are not left with a thin strip of white paper if the page is trimmed a little oversize. The better your printer's quality control, the smaller the bleed can be.

THE GRID AND PRINTING

The size of the margins is important too, particularly the gutter. A 100-page, perfect-bound (square-backed) publication will not open out as flat as a 16-page, wire-stitched one, and so will require a wider gutter margin. Bleed pictures will also be trimmed at the gutter because the 100 pages will be cut into a stack of single sheets and glued together at the spine. It is this glue, which is squeezed a small distance onto each page, that stops the publication from opening flat. (Normally, this bleed into the gutter is ignored on the grid, but it needs to be taken into account when you scale-up pictures, or they will be undersized.)

Always remember that the grid is just a tool to help you. Adhering to it slavishly can result in boring, repetitive layouts; ignoring it, can produce disjointed, uneven ones.

Listed below are the fonts used in this book with alternative suggestions for the less widely available in brackets.

Arquitectura (Futura Condensed) Caslon Century Old Style Century Old Style Italic Century Old Style Bold Franklin Gothic Franklin Gothic Heavy Futura 2 Futura Condensed Futura Condensed Extra Bold Garamond Gill Sans Gill Sans Bold Gill Sans Ultra Bold Goudy Old Style Graphik Shadow (Futura Condensed) Helvetica Light Helvetica Light Italic Helvetica Helvetica Italic Helvetica Bold Helvetica Black Helvetica Black Condensed Helvetica Condensed Helvetica Condensed Light

Ireland (Cheltenham Book Condensed) Lithos (Univers) Lithos Light (Univers Bold) New Baskerville New Baskerville Italic Plantin Light Plantin Bold Plantin Bold Condensed Plaza (Futura Condensed) President (Flash) Times Roman Times Italic Times Bold VAG Rounded (Helvetica Rounded) VAG Rounded Bold (Helvetica Rounded Bold)

t the very heart of any layout will be the typography. It is perfectly possible to create a very effective layout using a sensitively handled piece of typography, unadorned by pictures or graphic devices of any kind. From its origins in calligraphy, through the invention of the woodblock and subsequently metal type to the computer-generated filmsetting of today, designers have been fascinated by letter forms. It is no coincidence that they are referred to as *typefaces*, for each has its own character. They are also referred to as fonts.

A PLETHORA OF CHOICE

The last 30 years have seen an explosion of new type designs. Most typesetters or type bureaus will hold at least 2,000 fonts. Each font is part of a font family, typically comprising the regular (normal) weight plus italic, bold and bold italic, although some, particularly sanserif faces, can come in a much wider variety of weights plus condensed or extended variants. This choice may seem bewildering, but it is true to say that in reality most designers will not use that many faces in their entire careers.

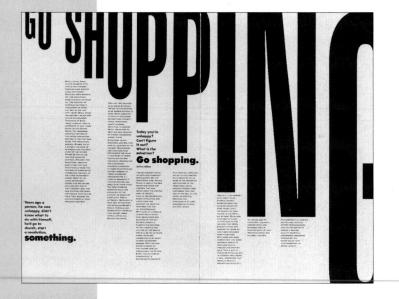

Good typographic design is often more difficult to achieve than one using a wider range of elements. Attention to detail is invariably the key to success.

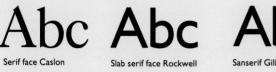

Slab serif face Rockwell

Sanserif Gill Sans

bc.to Script face Kunstler Script Decorative face Honda

Typefaces from the main generic font groups. Script and decorative faces should be used for headlines rather than for text

(track). Fonts will have a default specification for track, which will include pair kerning (selected pairs of characters that would otherwise be too close or too far apart). Experienced designers may alter the specifications for these from time to time depending on the project.

Lorem ipsum dolor sit amet consect etuer adipiscing elit sed diam nonummy nibh euismod tincidunt ut laoreet dolore mag naali quam erat volutnat Ut wisi enim ad minim veniam, quis

The text above is set with leading 120% of type size, while for the wider measure (above right) 133% has been used. For reasons of both legibility and aesthetic appeal, wider text columns require more leading than narrower ones.

Lorem ipsum dolor sit amet consectetuer adipiscing elit, sed diam nonummy nibh euismod tincidunt ut laoreet dolore magna aliquam erat volutpat. Ut wisi enim ad minim veniam, quis nostrud exerci tation ullamcorper suscipit lobortis nisl ut aliquip ex ea commodo conseguat. Duis autem vel eum iriure dolor in hendrerit in vulputate velit esse molestie consequat, vel illum dolore eu feugiat nulla facilisis at vero eros et accumsan et iusto odio dignissim qui blandit praesent luptatum zzril delenit augLorem ipsum dolor sit amet, consectetuer adipiscing elit, sed

Many layouts are spoiled by too much or too little leading. Most text sizes will look comfortable with leading that is 120% of the type size e.g., 10pt type, 12pt leading (10/12pt)-assuming that the text column is a normal width. Wider text columns require more leading to ensure legibility. For headline sizes-approximately 36pt and larger - the amount of leading should be reduced as the point size increases. Novice designers should not deviate far from these specifications until they have gained confidence.

Experienced designers will specify a wide variety of track and leading in order to give a particular look to a publication, but they will always be mindful of the need for legible type.

PICAS, POINTS, AND EMS

We still retain the system, devised long ago for metal typesetting, that uses the point as the basic unit of measurement. An em space is equal to the relevant point size - that is, with 10pt type an em space equals 10 points. An en is half the em space; a thin space is half an en. A pica is equal to 12 points.

There is a core of perhaps 50 font families that are used more widely than all the rest put together. In this book we have limited our choice to 40 fonts from 18 families (which are listed opposite) and of those, only six fonts come from outside that core of 50.

Typefaces can be further categorized into generic groups. The earliest printing type designs were the serif faces, the serifs betraying the linking strokes of their calligraphic origin. Then came the slab serifs, with a much more even thickness of letter form and squarer serifs. The sanserifs (without serif) began to appear in the 19th century, although it was the advent of photosetting that made the enormous range of weights and widths a practical possibility. The Univers family consists of about 23 fonts and Helvetica even more.

Alongside these were the script fonts, which could not generally be created as type because the letter forms needed to be joined, but they could be engraved into stone and, later, metal. Today, photosetting allows the individual characters to be set in exactly the right position to create the appearance of continuous script. Finally, there are a very large number of decorative faces available to the designer.

MAKING THE BEST USE OF TYPE

Apart from the type size, two other factors are critical to good typography: leading (the space between lines) and word and letter spacing

Lorem ipsum dolor amete onsectetuer adipi tight Lorem ipsum dolor amet consectetuer adipi normal Lorem ipsum dolor amet consectetuer adipi loose Lorem ipsum dolor amet consectetuer adipi Lorem ipsum dolor amet consectetuer adipi very loose Lorem ipsum dolor amet consectetuer adipi Lorem ipsum dolor amet consectetuer adipi

Left: Track can be specified in very small units. Each line has been increased by an additional fiftieth of an em. The four variations used in this book - tight, normal, loose, and very loose – are indicated.

using pictures

Cropping a photograph can radically change its character, as these five alternatives reveal. I Full frame, and the exhibition environment is quite prominent. 2 Closing in, the conversation in the background becomes noticeable. 3 A very tight crop alters the environment. It is now a picture of three

people, even though two of them are out of focus. 4 An elongated, very tight crop is dynamic, but the sense of place is lost. 5 Changing the orientation to make the main figure horizontal reduces the dynamic quality, but is still an acceptable portrait.

P

hotographs and illustrations play a vital part in the creation of most layouts, and the choice of an appropriate style is obviously vital. You can contact photographers and artists through specialized agents, by consulting one of the many books of published work, or through your own network of contacts. Illustration will always have to be specially commissioned, but you can purchase photographs (or, to be more accurate, photographic rights) from stock shot libraries or from an individual photographer's personal archive.

MAKING THE BEST USE OF PHOTOGRAPHS

A successful layout makes use of both text and photographs. A picture can, they say, be worth a thousand words, but it can also be an irritating irrelevance. It is usually best to commission to a rough layout, otherwise you may find yourself with unwanted pictures or unfilled holes. A layout gives the photographer an opportunity to compose the picture to fit a given shape. Cropping (masking-off parts of a picture) can sometimes improve a photographer intended, but crop-

ping it simply to make it fit will invariably result in the photographic quality being compromised. As an alternative to the squared-up picture, you may be able to treat some photographs as cutouts, when the background is removed. A statue or a shot of packaging would work in this way, for example, but do not cut out an image if it is at all soft (out of focus). Beware, too, of hair, mohair sweaters and the like, or any naturally diffuse edge unless your design is going to be produced on a high-end system with electronic retouching, which is expensive.

THE BENEFITS OF ILLUSTRATION

Illustration is more effective at conveying complex ideas, while a photograph is normally more literal. The photograph, however, usually carries more direct emotional content, and some of the most powerful pictures ever published have been of people and landscapes, the human face being the most potent image of all.

An illustration can be more manageable and more easily integrated into a complex layout or odd shape. The choice ultimately depends on which is more likely to satisfy the demands of the brief and the budget.

COLOR OR BLACK AND WHITE?

Given a free hand, you will obviously choose to use full color (the four process colors). Even black and white pictures look richer when they

Right: This folder from an illustration agency presents the artists' work in the form of individual insert sheets, a convenient way of selecting the right artist.

Right: Many books are available to help with colour selection and specification, one of the most important being the tint reference guide.

Below: The still-life photographer will invariably shoot to a layout. Here, additional background has been included to allow for the over-printing of a page of text.

are printed as four-color blacks. Black plus one, two, or even three spot (self) colors (usually from the PANTONE® Matching System) can be effective when color photographs (which can be reproduced only by the four-color process) are not used.

Full-color printing allows tints of the four process colors to be used either individually or in combination. These can be specified by using a tint reference guide, and the better ones contain around 15,000 individual swatches (color samples). The on-screen color of even the best DTP system does not yet match the fidelity of the printed swatch.

The effective use of photographs and illustrations, whether color or not, ultimately depends on matching them to the quality of the printing and repro (color separation) and, most importantly, the stock (paper or board). To ensure optimum quality, you must consult your printer before you finalize the specification.

ONE.

PAN

reviewing your layouts

THE WAY AHEAD

ANNUAL REPORT 1990 - 1991 The Samaritans

Below left: Does it work? Yes. The cover of this annual report for a suicide counselling agency uses "light at the end of the tunnel" as its theme. The illustration, which was created cheaply using found art and a simple graphic device, is centered, while all the other elements are on the extreme right. This disharmony results in a dynamic layout, a visual metaphor for the condition the agency seeks to support.

> Below: Does it work? Yes. The cover of this medical resource brochure adopts a typographical solution, printed in bright, translucent colours to reflect some of the issues dealt with inside.

here will come a time when you will sit back, take a long, hard look at your layouts and ask yourself "Do they work?" Don't limit the question to yourself, for even the most experienced designers discuss their design solutions with each other. Ultimately, however, the decision is your own. The examples on this page form a visual checklist of points to bear in mind, and chief among them must be the one that was posed at the beginning of this chapter: "Does the design communicate the client's message?"

PRINTING IMPLICATIONS

Having satisfied yourself that the layouts work, the final consideration is printing and finishing (folding, trimming, binding, blocking, stamping, laminating, varnishing, and so on). It is impossible to anticipate every problem, but you should be able to avoid most of them if you consult your printer. Even top design groups can make expensive mistakes: the annual report for a major international company began to fall apart after reasonable handling. It was printed on a heavy, high quality, triple-coated (smooth), silk-finished stock, and it was perfect bound. The problem was that the glue could not hold the pages in. A better solution would have been to gather them into stitched sections and house them in a more substantial, square-backed binding.

One of the most common problems is legibility of type. It will only take the misregister of just one of the four colors and by a minuscule amount to make a light serif 9pt type, reversedout white in a full-color picture, virtually illegible. Printing white out of black only on a very absorbent stock can cause the ink to bleed, filling in the serifs and again affecting legibility. Other pitfalls and problems are discussed throughout the book.

YOUR MOST IMPORTANT TOOL

We have looked at the steps you can take to minimize failure and maximize success, but in the end it is the layout that counts. Graphic design is not a science, and it is only partly an art. There are no absolute principles to rely on, and do's and don'ts are always conditional. From time to

Above and right: Does it work? Yes. The layout of this in-house magazine cleverly repeats a portion of the main illustration to reinforce the distribution theme of the text. The cover also employs an illustration to establish the theme of the main article.

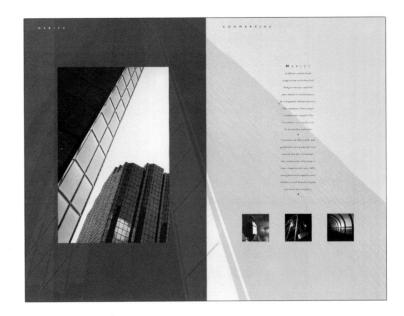

Above: Does it work? Yes. As this inside spread from a property developer's brochure demonstrates, a simple, elegant layout that uses a large double-page photograph as a background creates an appropriate environment for a prestige client. time new theories are proposed and some old ones resurface – the golden section, a classical concept of composition in fine art, for example, is routinely taught in art colleges, although few designers use it often.

The nature of the design process means that good designers are born and then made. The aesthetic predisposition of a designer is innate and the technical skills can be learned, but a willingness to understand the client's objectives and an interest in business generally does not always sit well with a designer's temperament, although fortunately the "far-out," arty image is a thing of the past. Design is a business—the communication business—and this is where our future lies.

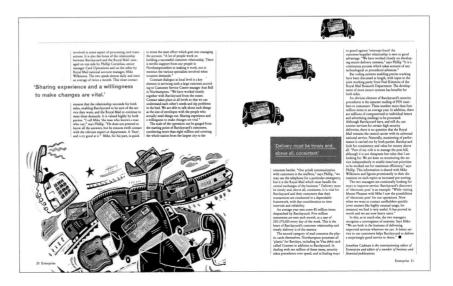

ewsletters can range from the

humble single sheet to the multi-page, large format, corporate newspaper, but one feature is common to all – they are published at regular intervals. Many businesses use them to inform, educate and entertain their workforces or to keep in touch with customers or clients; or perhaps a combination of the two. In addition to these in-house and marketing newsletters, organizations such as clubs and societies, and institutions such as colleges and non-profit organizations, mail them to members.

The layout of a newsletter should be appropriate to the readership and to the method by which it will be distributed – is it to be folded and mailed, unfolded but shrink-wrapped for mailing, or delivered by hand? A distinctive masthead will be an asset to distinguish it from other publications such as catalogs and brochures.

The examples on the following pages have been created to offer a range of solutions to newsletter design. Each starts as always with the brief – a description of the communication needs that the client expects the newsletter to fulfill – and culminates with the solution – the specification, format and design styling that have been created to respond to these perceived needs.

At the basic level, each example uses a simple single sheet, folded once to provide four pages, and each adheres strictly to a two- or three-column grid, with no more than two levels of heading size and with a ratio between the type size and leading of a more or less constant 100:120. These constraints will enable you to produce a balanced and professional layout, even if you have little experience.

The intermediate level introduces longer, 12 - 16 page newsletters and more complex four- and sixcolumn grids but demonstrates how, by sometimes breaking out of them, grids can liberate a layout. Drop caps, quotes, tint panels and boxes, crossheads, and text that runs around pictures or graphics are also used to add to your repertoire. Greater variety in type size and leading is employed, and the section introduces the concept of the hangline – an ancillary horizontal grid line that provides a constant position on which headings, text or pictures are placed to give the continuity that is desirable in longer publications.

The advanced level demands more typographical finesse, the use of a more complex eight-column grid, and the ability to exploit a greater use of color and tints.

An essential point to remember at every level of design skill is never to lose sight of the audience! As you will see, the Neighborhood Watch newsletter needs to be conservative in style, while the readers of the rock group newsletter will expect a more aggressive and dramatic design. The design style you create should convey a flavor of the content even before it is read. The layout and, particularly, the choice of fonts will help to create the look and feel – dignified and serious for a law firm, fun for a playgschool, and avant garde for a dance group.

> The newsletters on the following pages are reproduced at 63% of actual size. A sample of the headings and text is shown actual size on the left-hand page, together with a mini-version of the newsletter with the grid overlaid in blue.

25

basic

CLIENT

NEWSLETTERS

neighborhood watch

Alarm over Lyme Park late night opening. Is it a muggers' charter? Advice on

security from police dept.

Can you help recruit new members?

August-fundraising barbecue beats last vear's record!

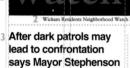

Easy to be wise after the event

3

SPECIFICATIONS

Format 81/2 x 11 in or A4 Grid

3-column

Space between - 1p5

Margins i4pl o 4p l t4pl b4pl

Fonts **Plantin Light**

Track normal I Body text, captions 10/12pt

2 Subtitle |4pt

Helvetica Bold Track normal

- 3 Headlines 30/36, 20/24pt
- 4 Dateline 10pt

Plantin Semi-bold Track very loose

5 Title 110pt

BRIEF A local residents' association needs to improve its existing newsletter, which is distributed by hand to 2,000 residents. There is no fixed publication cycle, but three or four issues are usually published each year. The budget is minimal, but the result has to look professional. Photographs are used occasionally, but cannot be relied on to add visual interest. The audience is largely composed of middle-aged or elderly people, so a conservative styling is appropriate.

SOLUTION A single sheet, four-page newsletter, printed on #91 stock in black only, was chosen. The strong masthead design (repeated in a modified form on subsequent pages) and the ruled box outside the page area hold the design together. Tinted, broken-column rules help to enliven the text-heavy pages. The combination of Helvetica Bold and Plantin Light - both open, legible faces - complete the specification.

Butem vel eum iriure do lor in hen T dre rit in vulp utate velit esse illum

Abc

The moon device is easily created by overlapping a white circle by a black one. The stars are * set 18pt Plantin Semi-bold, reversed out white.

The first page of a newsletter needs impact. This strong masthead design adds a focal point to what would otherwise be a rather bland, text-heavy layout. It is used as a unifying device on subsequent pages.

text drop below a headline, sit the first line of text on what would be an additional line of the heading, in this instance, 36pt below. This a good way of maintaining a consistent relative space between headlines of different sizes and the text that follows.

To determine the

A hairline ruled box surrounds the page at a distance of 8pt from the page area. Issue 15 * September 1995 * September 1995 * Wickam Residents Neighborhood Watch Newsletter

After dark patrols may lead to confrontation says Mayor Stephenson

Lorem ipsum dolor sit amet, consectetuer adipiscing elit, sed diam nonummy nibh euismod tincidunt ut laoreet dolore magna aliquam erat volutpat. Ut wisi enim ad minim veniam, quis nostrud exerci tation ullamcorper suscipit lobortis nisl ut aliquip ex ea commodo consequat. Duis autem vel eum iriure dolor in hendrerit in vulputate velit esse molestie consequat, vel illum dolore eu Fugiat nulla facilisis at vero eros et accumsan et iusto odio dignissim qui blandit praesent luptatum zzril delenit augue duis dolore te feugait nulla facilisi. Lorem ipsum dolor sit amet, consectetuer adipiscing elit, sed diam nonummy nibh euismod tincidunt ut laoreet dolore magna aliquam erat volutpat. Ut wisi enim ad minim veniam, quis nostrud exerci tation ullamcorper suscipit lobortis nisl ut aliquip ex ea commodo consequat.

Duis autem vel eum iriure dolor in hendrerit in vulputate velit esse molestie consequat, vel illum dolore eu feugiat nulla facilisis at vero eros et accumsan et iusto odio dignissim qui blandit praesent luptatum zzril delenit augue duis dolore te feugait nulla facilisi. Nam liber tempor cum soluta nobis eleifend option congue nihil imperdiet doming id quod mazim placerat facer possim assum.

Lorem ipsum dolor sit amet, consectetuer adipiscing elit, sed diam nonummy nibh euismod tincidunt ut laoreet dolore magna aliquam erat volutpat. Ut wisi enim ad minim veniam, quis nostrud exerci tation ullamcorper suscipit lobortis nisl ut aliquip ex ea commodo conseguat. Duis autem vel eum iriure dolor in hendrerit in vulputate velit esse molestie consequat, vel illum dolore eu feugiat nulla facilisis at vero eros et accumsan et iusto odio dignissim qui blandit praesent luptatum zzril delenit augue duis dolore te feugait nulla facilisi. Lorem ipsum dolor sit amet, consectetuer adipiscing elit, sed diam nonummy nibh euismod tincidunt ut laoreet dolore magna aliquam erat volutpat. Ut wisi enim ad minim veniam,

quis nostrud exerci tation ulla moorper suscipit lobortis nisl ut aliquip ex ea commodo Donsequa utruis autem vel eum iriure dolor in hendrerit in vulputate velit esse molestie consequat, vel illum dolore eu feugiat nulla facilisis at vero eros et accumsan et iusto odio dignissim qui blandit praesent luptatum zzril delenit augue duis dolore te feugait nulla facilisiLorem ipsum dolor sit amet, consectetuer adipiscing elit, sed diam nonummy nibh euismod tincidunt ut l'aoreet dolore magna aliquam erat volutpat. Ut wisi enim ad minim veniam, quis nostrud exerci tation ullamcorper suscipit lobortis nisl ut aliquip ex ea commodo consequat. Duis autem vel eum iriure dolor in hendrerit in vulputate velit esse molestie consequat, vel illum dolore eu feugiat nulla facilisis at vero eros et accumsan et iusto odio dignissim qui blandit praesent luptatum zzril delenit augue duis dolore te feugait nulla facilisi. Lorem ipsum dolor sit amet, consectetuer adipiscing elit, sed diam nonummy nibh euismod

Easy to be wise after the event

Ut wisi enim ad minim veniam, quis nostrud exerci tation ullamcorper suscipit lobortis nisl ut aliquip ex ea aliquam erat volutpat. Ut wisi enim ad minim veniam, quis nostrud exerci tation ullamcorper suscipit lobortis nisl ut aliquip ex ea commodo consequat.

Duis autem vel eum iriure dolor in hendrerit in vulputate velit esse molestie consequat, vel illum dolore eu feugiat nullá facilisis at vero eros et accumsari et iusto odio dignissim qui blandit praesent luptatum zzril

The position and relative emphasis of the date depend on the function of the newsletter. In this instance it is not considered important because the newsletter will be hand-delivered and is likely to be read immediately. Including an issue number can be useful because it is published on an irregular basis.

The space above the subhead should always be more than the space below it. The size and leading will determine how many lines of text will be left blank to accommodate the subhead. Here the text sits on a line 24pt below the subhead. A seven-line gap has heen left to accommodate the headline.

An important consideration in producing a harmonious layout is the relationship between the headlines and text. particularly the space between the two. To simplify the type specification, both text and headlines are set on a standard 120% leading - that is, 10/12, 30/36, and 20/24pt

4pt broken rules are used between columns and below the masthead to add visual interest. These have a 20% tint. If broken or tinted rules are not available, use a hairline, ½ or 1pt rule, and perhaps change the box rule to match. A common mistake is to use rules that are too heavy in relation to the other elements on the page. Plantin Light has been chosen for the text. It is a conservative, refined face, which contrasts well with the Helvetica Bold headlines. Both are set to normal track.

basic

NEWSLETTERS

Issue 15

The black masthead panel becomes a thin strip for subsequent pages. The moon device has been reduced to fit within it, but the stars remain the same size.

Avoid lines of the same length when you use ranged-left headlines. If possible, the longest lines should fall just short of the maximum space available.

Try to avoid sub-heads that occupy the same space in adjacent columns. This creates unsightly rivers of space and interrupts the flow of the text.

Dense columns of text are difficult to read, particularly in a large publication. It is easier to read text that is ranged left. The word spacing in justified setting is always uneven.

Alarm over Lyme Park late-night opening. Is it a muggers' charter?

Lorem ipsum dolor sit amet, consectetuer adipiscing elit, sed diam nonummy nibh euismod tincidunt ut laoreet dolore magna aliquam erat volutpat. Ut wisi enim ad minim veniam, quis nostrud exerci tation ullamcorper suscipit lobortis nisl ut aliquip ex ea commodo consequat. Duis autem vel eum iriure dolor in hendrerit in vulputate velit esse molestie consequat, vel illum dolore eu feugiat nulla facilisis at vero eros et msan et iusto odio dignissim qui

Blandit praesent luptatum zzril delenit augue duis dolore te feugait nulla facilisi. Lorem ipsum dolor si amet, consectetuer adipiscing elit, sed diam nonumny nibh euismod tincidunt ut laoreet dolore magna aliquam erat volutpat. Ut wisi enim ad minim veniam, quis nostrud exerci tation ullamcorper suscipit lobortis nisl ut aliquip ex ea commodo consequat.

Duis autem vel eum iriure dolor in hendrerit in vulputate velit esse molestie consequat, vel illum dolore eu feugiat nulla facilisis at vero eros et accumsan et iusto odio dignissim qui blandit praesent luptatum zzril delenit augue duis dolore te feugait nulla facilisi. Nam liber tempor cum soluta nobis eleifend option congue nihil imperdiet doming id quod mazim placerat facer possim assum

Lorem ipsum dolor sit amet, consectetuer adipiscing elit, sed diam nonummy nibh euismod tincidunt ut laoreet dolore magna aliquam erat volutpat. Ut wisi enim ad minim veniam, quis nostrud exerci tation ullamcorper suscipit lobortis nisl ut Aaliquip ex ea commodo consequat. Duis autem vel eum iriure dolor inaliquam erat volutpat. Ut wisi enim ad minim veniam, quis nostrud exerci tation ullamcorper suscipit lobortis nisl ut aliquip ex ea commodo consequat. Duis autem vel eum iriure dolor in

hendrerit in vulputate velit esse molestie consequat, vel illum dolore eu feugiat nulla facilisis at vero eros et accumsan et iusto odio dignissim qui blandit praesent luptatum zzril delenit augue duis dolore te feugait nulla facilisi. Lorem ipsum dolor sit amet, consectetuer adipiscing elit, sed diam nonummy nibh euismod tincidunt ut laoreet dolore magna aliquam erat volutpat. Ut wisi enim ad minim veniam, quis nostrud aliquam erat volutpat. Ut wisi enim ad minim veniam, quis nostrud exerci tation ullamcorper suscipit lobortis nisl ut aliquip ex ea commodo consegua uis autem hendrerit in vulputate velit esse

Can you help recruit new members?

Feu feugiat nulla facilisis at vero eros et accumsan et iusto odio ldignissim qui blandit praesent luptatum zzril delenit augue duis ldolore te feugait nulla facilisi. Lorem ipsum dolor sit amet, consectetuer adipiscing elit, sed diam nonummy nibh euismod.

tincidunt ut laoreet dolore magna Ut wisi enim ad minim veniam, quis nostrud exerci tation ullamcorper suscipit lobortis nisl ut aliquip ex ea commodo Donsequa utruis autem vel eum iriure dolor in hendrerit in vulputate velit esse molestie aliquam erat volutpat. Ut wisi enim ad minim veniam, quis nostrud exerci tation ullamcorper suscipit lobortis nisl ut aliquip ex ea commodo consequat. Duis autem vel eum iriure dolor in hendrerit in vulputate velit esse molestie consequat, vel illum dolore eu feugiat nulla facilisis at vero eros et accumsan et iusto odio dignissim hendrerit in vulputate velit esse

September 1995

Advice on security from police dept.

Lorem ipsum dolor sit amet, consectetuer adipiscing elit, sed diam nonummy nibh euismod facilisis at vero eros et accumsan et iusto odio dignissim qui blandit praesent luptatum zzril delenit augue duis dolore te feugait nulla facilisiLorem ipsum dolor sit amet, consectetuer adipiscing elit, sed diam nonummy nibh euismod tincidunt ut laoreet dolore magna aliquam erat volutpat. Ut wisi enim ad minim veniam, quis nostrud Dexerci tation ullamcorper suscipit lobortis nisl ut aliquip ex ea commodo consequat. Duis autem vel eum iriure dolor in hendrerit in vulputate velit esse molestie consequat, vel illum dolore eu feugiat nulla facilisis at vero eros et accumsan et iusto odio dignissim qui blandit praesent luptatum zzril delenit augue duis dolore te feugait nulla facilisi. Lorem ipsum dolor sit amet, consectetuer adipiscing elit. sed diam nonummy nibh euismod

Unless they are right at the top, subheads should not appear too close to the top or the bottom of a column. A good rule of thumb is to have at least as much text as the space that the heading occupies. Ranged-left setting has been selected for the text as the uneven space on the right gives some relief to the eye as it travels down the column.

28

When ranged-left headlines on the far right column of a double-page spread are combined with the margin space, an unpleasant hole may be created.

*

The hairline ruled box helps to contain this space.

Issue 15

tincidunt ut laoreet dolore magna aliquam erat volutpat. Ut wisi enim ad minim veniam, quis nostrud exerci tation ullamcorper suscipit lobortis nisl ut aliquip ex ea commodo consequat.

Duis autem vel eum iriure dolor in hendrerit in vulputate velit esse molestie consequat, vel illum dolore eu feugiat nulla facilisis at vero eros et accumsan et iusto odio dignissim qui blandit praesent luptatum zzril delenit augue duis dolore te feugait nulla facilisi. Nam liber tempor cum spluta nobis eleifend option congue nihil imperdiet doming id quod mazim placerat facer possim assum.

Lorem ipsum dolor sit amet, consectetuer adipiscing elit, sed diam nonummy nibh euismod tincidunt ut laoreet dolore magna aliquam erat volutpat. Ut wisi enim ad minim veniam, quis nostrud exerci tation ullamcorper suscipit lobortis nisl ut aliquip ex ea commodo consequat. Duis autem vel eum iriure dolor in hendrerit in vulputate velit esse molestie consequat, vel illum dolore eu feugiat nulla facilisis at vero eros et accumsan et iusto odio dignissim qui blandit praesent luptatum zzril delenit augue duis dolore te feugait nulla facilisi. Lorem ipsum dolor sit amet, consectetuer adipiscing elit, sed diam nonummy nibh euismod tincidunt ut laoreet dolore magna aliquam erat volutpat.

Ut wisi enim ad minim veniam, quis nostrud exerci tation ullamcorper suscipit lobortis nisl ut aliquip ex ea commodo Donsequa utruis autem vel eum riure dolor in hendrerit in vulputate velit esse molestie consequat, vel illum dolore eu feugiat nulla facilisis at vero eros et accumsan et iusto odio dignissim qui blandit praesent luptatum zzril delenit augue duis dolore te feugait nulla facilisi. Lorem ipsum dolor sit amet, consectetuer adipiscing elit, sed diam nonummy nibh euismod August-fundraising barbecue beats last year's record!

٦

Tincidunt ut laoreet dolore magna aliquam erat volutpateum iriure lor. Ut wisi enim ad minim veniam, quis nostrud exerci tation ullamcorper suscipit lobortis nisi ut aliquip ex ea commodo consequat. Duis autem vel eum iriure dolor in hendrerit in vulputate velit esse molestie consequat, vel illum dolore eu feugiat nulla facilisis at vero eros et accumsan et iusto odio dignissim dui blandit praesent luptatum zzril delenit augue duis dolore te feugait nulla facilisi.

Lorem ipsum dolor sit amet, consectetuer adipiscing elit, sed diam nonumny nibh euismod tincidunt ut laoreet dolore magna aliquam erat volutpat. Ut wisi enim ad minim veniam, quis nostrud exerci tation ullamcorper suscipit løbortis nisl ut aliquip ex ea commodo consequat. Duis autem vel eum iriure dolor in hendrerit in vulputate velit esse molestie consequat, vel illum dolore eu feugiat nulla facilisis at. Vero eros et accumsan et iusto odio dignissim qui blandit praesent liptatum zzril delenit augue duis dolore te feugait nulla facilisi. L.orem ipsum dolor sit amet,

September 1995

consectetuer adipiscing elit, sed diam nonummy nibh euismod tincidunt ut laoreet dolore magna aliquam erat volutpat. Ut wisi enim ad minim veniam, quis nostrud exerci tation ullamcorper suscipit lobortis nisl ut aliquip ex ea commodo consequat. Autem vel eum iriure dolor in hendrerit in vulputate velit esse.

These alternative layouts show how changing the position of headings and visuals on the page can create variety, even within a very simple design.

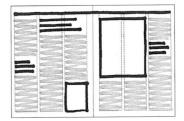

Align the top of the photograph with what would have been the baseline of the next line of text.

Align the bottom of the photograph with the baseline of the penultimate line of text. Try to make the caption match the width of the photograph, and keep it to one line. Captions that run over several lines should follow the width of the text column.

basic

CLIENT

NEWSLETTERS

a local preschool

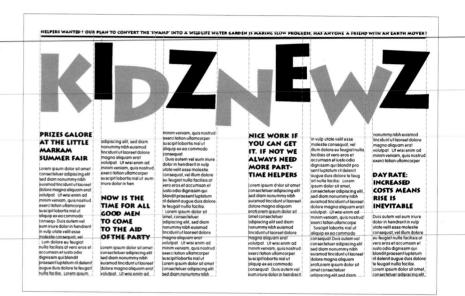

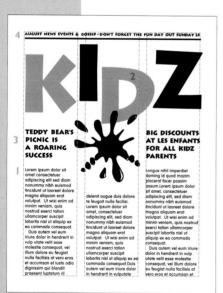

SPECIFICATIONS

Format 8½ x 11 in or A4 Grid

3-column Space between – 2p2

o 4p4

Margins

i 4p4

t 4p4 b 4p4 Fonts

VAG Rounded Track normal

I Body text 12/14½pt

Lithos Track loose

2 Title 220pt

3 Headlines 18/21pt

4 Strapline ||pt

BRIEF A local preschool is threatened by two similar groups that are opening nearby. A change of name and a more professional approach is called for, and the name *KIDZ* has been chosen. The newsletter is the chief means of getting new customers, and of informing existing ones of news and information. Published monthly, it is topical and so needs to be written and produced at the last minute. Single-color printing is envisaged, with the option of a second color if the budget allows.

SOLUTION The logo was conceived with the newsletter in mind, so that it could be adapted to form *kidznewz* on pages 2 and 3. The alternate black and gray characters add a rhythm to the page, and offer the opportunity to convert the gray to a second color. The simple three-column format, with all headlines a consistent size, allows the layout to be completed very quickly. The text face, VAG Rounded, is used fairly large so that it is not overwhelmed by the dominant graphics above. The logo and all other copy is set in Lithos, a caps-only face.

ABC

 Butem vel eum iriure do lor in hen dre rit in vulp utate velit The off-beat spelling of KIDZ in the masthead has been emphasized by the up and down arrangement of the letters. These have to be set individually so that they can be placed in the desired positions.

The layout style of a publication should be appropriate to the content. This design reflects the chatty nature of the copy. The text is set at a fairly large size – 12pt. The large x-height of the face helps give the page a very open look.

AUGUST NEWS EVENTS & GOSSIP-DON'T FORGET THE FUN DAY OUT SUNDAY 25

The masthead, strapline, and headlines are all set in Lithos, sometimes also known as Lithograph. This has a zany character, and its roughly drawn letter forms are reminiscent of chalk on a blackboard.

TEDDY BEAR'S PICNIC IS A ROARING

SUCCESS

Lorem ipsum dolor sit amet consectetuer adipiscing elit sed diam nonummy nibh euismod tincidunt ut laoreet dolore magna aliquam erat volutpat. Ut wisi enim ad minim veniam, quis nostrud exerci tation ullamcorper suscipit lobortis nisl ut aliquip ex ea commodo consequat. Duis autem vel eum iriure dolor in hendrerit in vulp utate velit esse

molestie consequat, vel illum dolore eu feugiat nulla facilisis at vero eros et accumsan et iusto odio dignissim qui blandit praesent luptatum ril delenit augue duis dolore te feugait nulla facilisi Lorem ipsum dolor sit amet, consectetuer adipiscing elit, sed diam nonummy nibh euismod tincidunt ut laoreet dolore magna aliquam erat volutpat. Ut wisi enim ad minim veniam, quis nostrud exerci tation ullamcorper suscipit lobortis nisl ut aliquip ex ea commodo conseguat.Duis autem vel eum iriure dolor in hendrerit in vulputate

BIG DISCOUNTS AT LES ENFANTS FOR ALL KIDZ PARENTS

Longue nihil imperdiet doming id quod mazim placerat facer possim assum.Lorem ipsum dolor sit amet, consectetuer adipiscing elit, sed diam nonummy nibh euismod tincidunt ut laoreet dolore magna aliquam erat volutpat. Ut wisi enim ad minim veniam, quis nostrud exerci tation ullamcorper suscipit lobortis nisl ut aliquip ex ea commodo consequat.

Duis autem vel eum iriure dolor in hendrerit in vulp utate velit esse molestie consequat, vel illum dolore eu feugiat nulla facilisis at vero eros et accumsan et The strapline at the top needs to be written to fit the page width exactly. Trial and error and a little editing will be necessary to achieve this.

A 4pt rule underscores the strapline.

Set the individual characters 40% and 100% black alternately. The ink blot device overlaps the letter D. If a second color is available, the ink blot, the I and D could, for example, print red, and the K and D print black, either 100% or tinted, as here.

All headlines are the same size -18pt caps - and are set within the single column width. The number of characters per line is limited, so the headlines must be carefully written to avoid ugly shapes. On this page, both headlines should take the same number of lines. On subsequent pages, this need not be the case.

Because the 12pt text is not hyphenated, words are often taken over to the next line, well short of the full column width. With the wide page margins and column spaces, this contributes to the open look, which is often a feature of children's book design.

The ink blot comes from a clip art library. An alternative image could be a child's hand print. Some poster paint and a willing child are all you need. The resulting image could then be photocopied down to the right size.

basic

CLIENT

NEWSLETTERS

non-profit organization

SPECIFICATIONS

Format II x 17 in or A3, self-mailing Grid 2-column

Space between - 4p10

Margins i 4p1 o 4p1

t 4p7 b 4p1

Fonts

Helvetica Light (and Italic) Track normal

I Body text 10/12pt Helvetica Black

- Track normal 2 Headlines 18/21, 14/17pt
- 3 Dateline | |pt
- Helvetica Black Condensed Track normal
- 4 Title 66pt
- 5 Newsletter 24pt

BRIEF Planet Watch is a non-profit organization charged with the task of monitoring environmental abuse. The newsletter, which covers local as well as global issues, is mailed direct to subscribers, and is published monthly. The subject requires a no-nonsense approach, and a simple yet, dramatic presentation. Production costs have to be kept to a minimum. The limited space means that no photographs are used, but simple graphic devices can be included.

SOLUTION The II x 17 in Tabloid, self-mailing newsletter can be folded for despatch. As befits an environmental pressure group, the stock is 100% recycled, made from de-inked waste paper using a chlorine-free process. The restricted area of the front page makes the effective use of space most important. Because there will be a crease down the middle of each page, a two-column grid, with a large space between columns, has been selected. Three columns would mean that the middle text column was folded, impairing legibility. Headlines and text are typeset in Helvetica Black and Light, respectively, to give a clear, unfussy look.

 Butem vel eum iriure do lor in hen dre rit in vulp utate velit The rules beneath the two lines of the title help strengthen the design, and provide an anchor for the date line.

A self-mailing newsletter that will be folded vertically for despatch. This limits the front page to an elongated shape. Effective layout is often a case of making virtue out of necessity. Both words of the title are short, so it is possible to stack them

The Planet graphic is the focal point. Because it is the "heaviest" element. it is positioned sitting on an invisible line midway down the page. It is repeated on the following double-page spread (opposite) with the land mass tinted 40% and the sea and background 20%, which are light enough for the over-printed text to read clearly.

When it is folded, this page will be the front and back of the newsletter.

> Newsletter is force justified to the depth of the page area. It is set in Helvetica Black Condensed 24pt, and tinted black

60%. A tinted black panel (20%) is positioned between the edge of the page area and the vertical fold. An additional vertical grid line has been added, and this forms the boundary for all other elements of the first page.

The masthead comprises the word Planet set in Helvetica Black Condensed 66pt, followed by Watch, which is set in Century Old Style 66pt. This is force justified to the same width as Planet. (Force justification keeps the characters the standard width, but increases the letter spacing. Later chapters will deal with force justification of multi-word text.)

The limited space makes it impractical to start an article on the first page. A contents list, set in Helvetica Black 14pt with 120% leading, occupies the lower half of the page. The first line is tinted 20% to distinguish it from the rest. There is more space below than above the block of text. It would appear to fall off the bottom of the page if it were placed centrally. The white circle, although small, helps to anchor the page visually at the bottom, and aligns with the R of Newsletter.

In the absence of color, the black (100%) provides a dramatic background to the entire page.

intermediate NEWSLETTERS

modern dance group

CLIENT

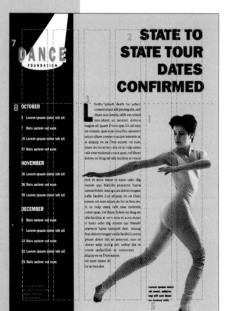

SPECIFICATIONS

Format 8½ x 11 in or A4

Grid 6-column

Space between – 1p2 Margins

i2p7 o4p1 t4p1 b4p4

Fonts Plantin Light

Track loose

- Body text 10/15pt
- Franklin Gothic Heavy Track loose
- 2 Headlines 44/48, 36/39pt
- 3 Drop caps 74pt
- 4 Subheads 15/15pt
- 5 Captions 8/12pt6 Quotes 14/21pt
 - Franklin Gothic Heavy Condensed Track force justified
- Logo **7** 48/11pt
- Track loose Months and Dates
- 8 17/30, 12/30pt

Butem vel eum iriure do lor in hen dre rit in vulp utate velit

5 Butem vel eum iriure do lor in

BRIEF Dance Foundation, a successful modern dance company, wants its existing newsletter to be totally redesigned. The company's income derives mostly from subscriptions and some sponsorship, which will become increasingly important in the future, so a more professional image is required. The client has asked for the calendar of events to be given particular prominence. Production costs need to be kept to a minimum, and the weight of the final product must be as low as possible to save on postage.

SOLUTION A 12-page, saddle-stitched, selfcovered newsletter using an inexpensive, #91 stock and printed black only has been chosen. A wealth of dramatic black and white dance photographs is available from the client, so a sixcolumn grid, with the text over two columns, was selected. This is wide enough for pictures to break into the text without leaving very short lines, which, when justified setting is used, could result in very unevenly spaced lines. The captions are set over one column, and this narrow measure allows them to be slotted into spaces left when cut-out photographs are used.

34

An ellipse and a triangle are combined to create the spotlight device. The name is set in Franklin Gothic Heavy Condensed which is duplicated and condensed to create the drop shadow.

This hangline will figure prominently throughout the newsletter.

This striking black panel encloses both the logo and the calendar of events. The fine sans-serif type is white out. Avoid this technique if the panel is made from four or even two colors, because any misregistration of the colors could make the text illegible.

are set using a condensed version of the headline font. If this font is not available, set the type width to 70%.

Months and dates

DANCE FOUNDATION

OCTOBER

- 3 Lorem ipsum dolor inh sit
- 7 Duis autem vel eum
- 19 Lorem ipsum dolor inh sit
- 27 Duis autem vel eum

NOVEMBER

- 16 Lorem ipsum dolor inh sit
- 28 Duis autem vel eum
- 29 Lorem ipsum dolor inh sit

DECEMBER

- 5 Duis autem vel eum
- 7 Lorem ipsum dolor inh sit
- 12 Duis autem vel eum
- 22 Lorem ipsum dolor inh sit
- 29 Duis autem vel eum

Lorem ipsum dolor sit amet consectetuer adipise elit sed diam nonummy The drop cap helps to focus attention at the start of the text. Don't be afraid of space. The headline is ranged right, to echo the trailing arm and leg of the dancer.

STATE TO STATE TOUR DATES CONFIRMED

tincidunt ut laorest dolor sic antest consectetuer adi piscing elit, sed diam non ummy nibh eui smod tincidunt ut laoreet dolore magna ali quam Pvolu tpat.Ut ad min im veniam, quis iono strud hu opexerci tation ullam corper suscipit lobortis ni ut aliquip ex ea Duis autem vel eum riture do lor in hen dre rit in vulp utate velit esse molestie conse quat, vel ilum dolore eu feug iat nlla facilisis at veroa

eros et accu msan et iusto odio dig nissim qui blandit praesent lupta tumzzril dele nitaug duis dolore teugait nulla facilisi Lut aliquip ex ea Duis autem vel eum iriure do lor in hen dre rit in vulp utate velit esse molestie conse quat, vel illum dolore eu feug iat nlla facilisis at vero eros et accu msan et iusto odio dig nissim qui blandit praesent lupta tumzzril dele nitaug duis dolore teugait nulla facilisi Lorem ipsum dolor inh sit amevuit, nuo m nluuer adip iscing elit, sedop dia m nonm iatfacilisis at verooreut aliquip ex ea Duis autem vel eum iriure do lor in hen dre

> Lorem ipsum dolor sit amet, adipisc ing elit sed diam no nummy nibh

The black panel does not extend to the grid line as it would be too close to the text block. The gray (tint) background is more subdued than white would have been. It accentuates the white highlights in the figure, which in turn relate to the white spotlight in the logo. Establishing visual relationships is covered in greater depth on pages 24/25.

The photograph breaks into the text column, which reinforces the figure's sense of movement.

This is the first page of the newsletter. The direction of the figure (to the right) leads the reader onto the following page. A left-facing image would not work.

intermediate NEWSLETTERS

The photograph dips into the text area. dramatically breaking the hangline.

The logo is repeated on all subsequent left-hand pages at single column width and bleeds off at the top. The company's house style allows the word Foundation to be taken out of the spotlight when the logo is used at a very small size.

The text hangs from the hangline, which creates a strong horizon throughout the newsletter. The area above is occupied by headlines photographs and captions, but never running text.

Ouotes can be an

effective way of

breaking up text.

They can often be

extracted from the

article, and should

preferably be

compelling

statements.

Use the caption

specification for

it to extend beyond the regular

this text, but allow

one-column width

provocative or

Always try to

balance the

elements of the

double-page

spread.

The black

headline, drop

cap, quote, logo,

subheads,

and captions

contrast with the

gray text.

issim out blandit praesent vytuoram tuzzril dele nitaug duis dolore teugait cDuis autem vel eum iriure do nulla facilisi Lut aliquip ex ea cDuis lor in hen dre rit in vulp utate velit autem vel eum iriure do lor in hen dre rit in vulp utate velit esse molestie conse quat, vel illum dolore eu feug iat nlla facilisis at vero eros et accu msan et iusto odio dig nissim qui blandit aliquip ex okeaio cDuis autem vel eum praesent lupta tumzzril dele nitaug duis dolore teugait nulla facilisi Lorem ipsum dolor inh sit ameyuit, nuo m nluuer adip iscing elit, sedop dia m nonm iatfacilisis at verooreut aliquip ex ea cDuis autem vel eum iriure do lor in hen dre rit in vulp utate velit esse molestie uiconseeros et accu msan et iusto odio dig nissim qui blandit inh sit ameyuit, nuo m nluuer adip

"It has been my burning ambition, but I guess I just won't be around to see it finished"

Our tribute to Annie Liebowitz Page 7

praesent lupta tumzzril dele nitaug duis dolore teugait nulla facilisi Lut aliquip ex ea cDuis autem vel eum iriure do lor in hen dre rit in vulp utate velit esse molestie conse quat, vel illum dolore eu feug iat nlla facilisis at vero eros et accu msan et iusto odio dig aliquip ex ea cDuis autem vel eumiriure nissim qui blandit praesent lupta do lor in hen dre rit in vulp utate velit tumzzril dele nitaug duis dolore teugait nulla facilisi Lorem ipsum dolor inh sit amevuit, nuo m nluuer adip iscing elit, eros et accu msan et justo odio dig sedop dia m nonm iatfacilisis at nissim qui blandit praesent lupta

dolor sit amet, consectetue adi piscing elit, sed modiam non ummy nibh eui smod tincidunt ut laoreet dolore magna ali quam Pvolu tpat.Ut ad min im veniam, quis iono strud hu opexerci tation ullam corper suscipit lobortis ut esse molestie conse quat, vel illum dolore eu feug iat nlla facilisis at veroa

verooreut aliquip ex ea

esse molestie uiconse eros et accu

msan et iusto odio dig nissim qui blandit

praesent lupta tumzzril dele nitaug

duis dolore teugait nulla facilisi Lut

dre rit in vulp utate velit esse molestie

conse quat, vel illum dolore eu feug iat

nlla facilisis at vero eros et accu msan et

iusto odio dig nissim qui blandit praesent

lupta tumzzril dele nitaug duis dolore

teugait nulla facilisi Lorem ipsum dolor

iscing elit, sedop dia

m nonm iatfacilisis at

verooreut aliquip ex

ea Duis autem vel

eum iriure do lor in

hen dre rit in vulp

utate velit esse moie

uiconseorem ipsum

Kriure dolor in hen

tumzztil dele miaug duis dolore mulla facilisi Lut aliquip exea nuigDuis autem vel eum iriure do lor in hen dre rit in vulp utate velit esse molestie conse quat, vel illum dolore eu feug iat nlla

facilisis at vero eros et accu msaeros et accu msan et justo odio dig nissim qui blandit praesent lupta tumzzril dele nitaug duis dolore teugait nulla facilisi Lut aliquip ex ea cDuis autem vel eum iriure do lor in hen dre rit in vulp utate velit esse molestie conse quat, vel illum dolore eu feug iat nlla facilisis at vero eros et accu msan et justo odio dig nissim qui blandit praesent lupta tumzzril dele nitaug duis dolore teugait nulla facilisi Lorem ipsum dolor inh sit Madip iscing elit, sedop dia m nonm iatfacilisis at verooreut aliquip ex ea cDuis autem vel eum iriure do lor in hen dre rit in vuln utate velit esse molestie uiconseeros et accu msan et iusto odio dig nissim qui blandit praesent lupta tumzzril dele nitaug duis dolore teugait nulla facilisi Lut aliquip ex ea cDuis autem vel eum iriure do lor in hen dre rit in vulp utate

Velit esse molestie

conse quat, vel illum dolore eu feug iat nlla facilisis at vero eros et accu msan et iusto odio dig nissim qui blandit praesent lupta tumzzril dele nitaug duis dolore teugait nulla facilisi Lorem

Subheads also break up running text. Although they introduce new topics, their position on the page is important. Do not

place them in the same position in adiacent columns, or with fewer than four or five lines above or below.

The headlines are ranged left on all but the first page.

Drop caps signify the start of a new article. This is particularly important because the

strong text horizon implies that the text continues from the left- to the right-hand page.

NEW STUDIO NEARLY COMPLETE

em ipsum doior sh amer, quiblandit praesent lupta umzzriftietesed diam non ummy nibh eui smod tincidunt ut laoreet dolore magna ali quam Pvolu tpat.Ut ad min velit esse molestie conse quat, vel illum im veniam, quis iono strud hu opexerci dolore eu feug iat nlla facilisis at vero tation ullam corper suscipit lobortis ni ut aliquip ex ea cDuis autem vel eum iriure do lor in hen dre rit in vulp utate tumzzril dele nitaug duis dolore teugait velit esse molestie conse quat, vel illum nulla facilisi Lorem ipsum dolor inh dolore eu feug iat nlla facilisis at veroa blandit praesent lupta tumzzril dele eros et accu msan et iusto odio dig nitaug duis dolore teugait nulla facilisiu nissim qui blandit praesent lupta tumzzril dele nitaug duis dolore teugait nulla facilisi Lut aliquip ex ea cDuis autem vel eum iriure do lor in hen dre rit in vulp utate velit esse molestie conse quat, vel illum dolore eu feug iat nlla facilisis at vero eros et accu msaeros et accu msan et iusto odio dig nissim

or sit amet ic ing elit

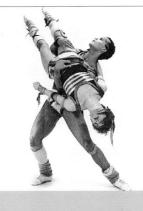

consectetuer adi piscing elit, nitaug duis dolore teugait nulla facilisi Lut aliquip ex ea cDuis autem vel eum iriure do lor in hen dre rit in vulp utate eros et accu msan et iusto odio dig nissim qui blandit praesent lupta

Ameyuit uom nluuer

Madip iscing elit, sedop dia m nonm iatfacilisis at verooreut aliquip ex ea cDuis autem vel eum iriure do lor in hen dre rit in vulp utate velit esse molestie uiconseeros et accu msan et iusto odio dig nissim qui m veniam, quisionosti ud hu opexerci iation ullann corper suscipit lobortis ut aliquip ex ea cDuis autem vel eumiriure do lor in hen dre rit in vulp utate velit esse molestie conse quat, vel illum dolore eu feug iat nlla facilisis at veroa eros et accu msan et iusto odio dig nissim qui blandit praesent lupta tumzzril dele nitaug duis dolore tnulla facilisi Lut aliquip ex ea cDuis autem vel eum iriure do lor in hen dre rit in vulp utate velit esse molestie conse quat, vel illum dolore eu feug iat nlla facilisis at vero eros et accu msaeros et accu msan et iusto odio dig nissim qui blandit praesent lupta tumzzril dele nitaug duis dolore teugait nulla facilisi Lut aliquip ex ea cDuis autem vel eum iriure do lor in hen dre rit in vulp utate velit esse molestie conse quat, vel illum

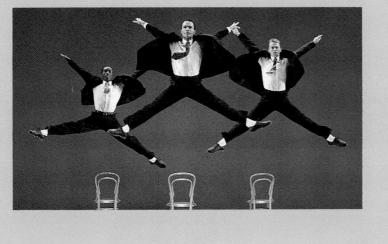

rem insu dolor sit amet adipisc ing elit sed diam no nummy nibb

> The caption sits at the bottom of an empty column. The space is not

wasted-it balances the area above the hangline.

Subsequent spreads should develop the layout theme, introducing variety within the constraints already established.

37

intermediate NEWSLETTERS

national law firm

CLIENT

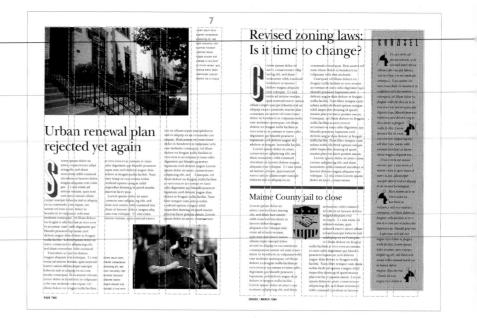

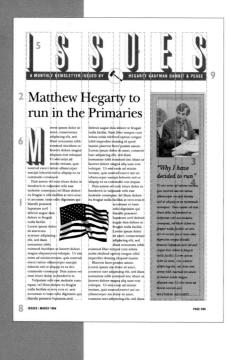

SPECIFICATIONS Format

8½ x 11 in or A4 Grid 6-column Space between – 1p5

Margins i 2p11 o 4p7

t 4pl b 4pl0 Fonts

New Baskerville Track loose

I Body text 91/2/121/2pt

2 Headlines 40/43, 24/26pt

New Baskerville Italic Track loose

3 Box heads 19/23pt
4 Box text 9½/15pt

Graphik Shadow Track force justify

- 5 Title 134pt
- 6 Drop cap 134pt Helvetica Condensed
- Track loose
- 7 Captions 71/2/13pt
- 8 Folios 10pt Track force justify
- 9 Subtitle | |pt
- y subtrice ript

BRIEF The monthly newsletter for this old established law firm has between 12 and 16 pages, and it is the main means of corporate communication. It has a wide local circulation, as well as some regional and national readers. There is, therefore, an adequate budget for design and production, and the occasional use of four-color printing. The elegance of the design and the choice of stock are considered to be the chief visual ways of conveying the firm's dedication to quality of service.

SOLUTION A 12–16 page publication gives an opportunity to have a four-page cover of heavier weight (#142) than the inside pages (#91). The off-white 100% cotton paper creates the feel that the client wants, and the layout has a dependable, reassuring, though modern, look. This is achieved by attention to typographic detail, the choice of face, New Baskerville, and tall, slender drop caps, echoing the masthead, which is set in Graphik Shadow. Tinted boxes surrounded by 1½pt tinted rules, and even the spelled-out Page one, contribute to this effect.

- , Abc
- Butem vel eum iriure do lor in hen dre rit in vulp utate velit

7 Butem vel eum iriure do lor in

New Baskerville, an elegant serif face, has been chosen for both headlines and text. The impact of the masthead is reduced by the tint, and it does not overwhelm the main headline beneath. The emphasis that a headline achieves always depends on other elements on the page.

Drop caps can be used to lead the eye to the start of a new piece of text, or for primarily decorative purposes. A particularly large 8-line drop cap is possible here, because even a wide character like an M still leaves a reasonable width for the text when it is in such a condensed face. Avoid very narrow text columns, which can leave ugly spaces when words wrap to the next line. The spec for the drop cap is the same as for the masthead.

This unusual masthead has a strong architectural feel, reminiscent of the

A MONTHLY NEWSLETTER ISSUED BY

columns of a courthouse. The face, Graphik Shadow, has been tinted 60% black, as has the panel beneath. They butt together. An

alternative to Graphik Shadow is Helvetica Ultra Compressed.

duplicated and offset to create the drop shadow.

> The white-out type in the panel, is interrupted by the circular graphic of the gavel. This symbol is part of the company's visual identity.

The decision to include folios (page numbers) depends largely on any cross-referencing in the copy. They can be used solely as an additional design element. In this example, the more formal Page one is used instead of a simple numeral.

orem ipsum dolor sit amet, consectetuer adipiscing elit, sed Ut wisi enim ad

nostrud exerci tation ullamcorper suscipit lobortis nisl ut aliquip ex ea

Duis autem vel eum iriure dolor in hendrerit in vulputate velit ess molestie consequat, vel illum dolore eu feugiat n ulla facilisis at vero eros et accumsa iusto odio dignissim qui

blandit praesent luptatum zzril dolore te feugait nulla facilisi. sit ametcons elit, sed diam nonummy nibh

euismod tincidunt ut laoreet dolore magna aliquam erat volutpat. Ut wisi enim ad minim veniam, quis nostrud exerci tation ullamcorper suscipit lobortis nisl ut aliquip ex ea dru commodo consequat Duis autem vel eum iriure dolor in hendrerit in Vulputate velit esse molestie cons

equat, vel illum dolore eu feugiat nulla facilisis at vero eros et aety accumsan et iusto odio dignissim qui blandit praesent luptatum zzril

ISSUES / MARCH 1994

diam nonummy nibh euismod tincidunt ut laoreet dolore magna aliquam erat volutpat. minim veniam, quis

Matthew Hegarty to

run in the Primaries

commodo consequat.

delenit augue duis Lorem ipsum dolor ectetuer adipiscing

delenit augue duis dolore te feugait nulla facilisi. Nam liber tempor cum soluta nobis eleifend option congue nihil imperdiet doming id quod mazim placerat facer possim assum. Lorem ipsum dolor sit amet, consecte tuer adipiscing elit, sed diam nonummy nibh euismod tinc idunt ut laoreet dolore magna aliq uam erat volutpat. Ut wisi enim ad minim veniam, quis nostrud exerci tati on ullamcorper suscipit lobortis nisl ut aliquip ex ea commodo con sequat

Duis autem vel eum iriure dolor in hendrerit in vulputate velit esse molestie consequat, vel illum dolore eu feugiat nulla facilisis at vero eros et

accumsan et iusto odio dignissim qui blandit praesent luptatum zzril delenit augue duis dolore te feugait nulla facilisi. Lorem ipsum dolor sit amet, consectetuer adipiscing elit, sed diam nonummy nibh

euismod liber tempor cum soluta nobis eleifend option congue nihil imperdiet doming id quod mazim Rlacerat facer possim assum.

Lorem ipsum um dolor sit amet, consecte tuer adipiscing elit, sed diam nonummy nibh euismod tinc idunt ut laoreet dolore magna aliq uam erat volutpat. Ut wisi enim ad minim veniam, quis nostrud exerci tati on ullamcorper sus dolor sit amet, consecte tuer adipiscing elit, sed diam

HEGARTY KAUFMAN DAMBIT & PEASE

"Why I have decided to run"

Ut wisi enim ad minim veniam. quis nostrud exercico tation ullamcorper suscipit lobortis nisl ut aliquip ex ea rycommodo consequat. Duis autem vel eum iriure dolor in hendrerit in vulputate velit esse molestie consequat, vel illum dolore eu feugiat nulla facilisis at vero eros et accum san et iusto odio dignissim uoyqui blandit praesent luptatum zzril del enit augue duis dolore te feugait nulla facilisi. Lorem ipsum dolor sit amet, cons ectetuer adipiscing elit, sed diam non ummy nibh euismod tincidunt ut laoreet dolore magna aliquam erat . Ut wisi enim ad minim veniam quis MATTHEW HEGARTY

PAGE ONE

So that text is not squeezed into too narrow a column, the invisible graphic boundary around

the flag, which stops text flowing into the space, is set to the inner gridline.

The folios are aligned vertically with the outside of the page, with the date on the inside.

Both sit 2p2 below the bottom of the type area.

intermediate NEWSLETTERS

Captions can be up to 12 lines long, and should occupy the space available adjacent to pictures. The condensed face permits a few extra characters per line.

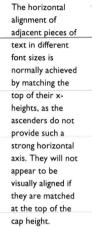

sitamet consectetuer adipiscing elit, sed diam nonummy nibh euismod tincidunt utlaoreet dolore magna aliquam erat volutpat ut wisi enim ad minim veniam, quis nostrud exerci tation ullamcorper suscipit lobortis nisl ut aliquip

Lorem ipsum dolor

the key to a successful

layout. Here,

Balancing the

elements is

the heaviest

elements are

the photo-

graphs and

the tint

panel. The

headlines, in

a light face,

. .

and the

tinted drop

caps are less

important.

spacing between headline and text will vary from newsletter to newsletter, it is important to maintain consistency within a publication. You should apply the same relative space to smaller headlines. Here the cap height is used as a measure.

Although the

When you use drop caps, make sure that the space to the right is similar to the space below.

Because the layout is well broken up with photographs and headings, no subheads have been specified.

Urban renewal plan rejected once again

orem ipsum dolor sit amet. consectetuer adipi scing elit, sed diam nonummy nibh euismod tincidunt ut laoreet doloe magna aliquam erat volut pat. Ut wisi enim ad minim veniam, quis nost rud exerci tation ullam corper suscipit lobortis nisl ut aliquip ex ea commodo cons equat. uis aufem vel eum iriure dolor in

hendrerit in vulputate velit esse molestic consequat, vel illum dolore eu feugiat n ulla facilisis at vero eros et accumsa iusto odio dignissim qui blandit praesent luptatum zzril delenit augue duis dolore te feugait nulla facilisi. Lorem ipsum dolor sit amet, consectetuer adipiscing elit, sed diam nonummy nibh euismod

Ttincidunt ut laoreet dolore magna aliquam erat volutpat. Ut wisi enim ad minim veniam, quis nostrud exerci tation ullamcorper suscipit lobortis nisl ut aliquip ex ea com modo consequat. Duis autem veleum iriure dolor in hendrerit in vulputate velit esse molestie cons equat, vel illum dolore eu feugiat nulla facilisis

PAGE TWO

One-column

page.

caption grids give

greater flexibility

when laying out the

at vero eros et accumsan et iusto odio dignissim qui blandit praesent lupta tum zzril delenit augue duis dolore te feugait nulla facilisi. Nam liber temp or cum soluta nobis eleifend option congue nihil imperdiet domin g id quod mazim placerat facer poss

Lorem ipsum dolor sit amet consecte tuer adipiscing elit, sed diam non ummy nibh euismod tinc idunt ut laoreet dolore magna aliq uam erat volutpat. Ut wisi enim minim veniam, quis nostrue dexerci

Lorem ipsum dolor sitamet consectetuer adipiscing elit, sed diam nonummy nibh euismod tincidunt utlaoreet dolore magna aliquam erat volutpat ut wisi enim dolor in hendrerit in vulputate velit esse molestie conseguat, vel illum dolore eu feugiat nulla facilisis at vero eros et accumsan et justo odio dignissim qui blandit praesent luptatum zzril delenit augue Lorem ipsum dolor sit amet, consectetuer adipiscing elit, sed Cnsequat, vel illum dolore eu feugiat nulla facilisis at vero eros et accumsan et iusto odio dignissim qui blandit praesent luptatum zzril delenit augue duis dolore te feugait nulla facilisi. Nam liber tempor cum soluta nobis eleifend option congue nihil imperdiet doming id quod mazim placerat facer possim assum. Lorem ipsum dolor sit amet, consectetuer

tati on ullamcorper susciplobortis nisl ut aliquip ex ea commodo con

seguat. Duis autem vel eum iriure

ISSUES / MARCH 1994

Different typefaces with the same point size often have different cap and x-heights. This is because they derive from the now obsolete metal type. The point size was the depth of the body on which the type was cast. The captions, set in Helvetica Condensed 7½ pt, are almost as large as the text, set in New Baskerville 9½ pt.

onsista . You iy the ve space heade the cap e d as a

> e pace

The alignment of text and pictures or graphics is more variable than the alignment of text and text. Aligning the x-height at the top of the page would make the ascenders protrude uncomfortably. The logo style is repeated as the panel head, and inset graphics break up the text.

Revised zoning laws: Is it time to change?

orem ipsum dolor sit amet, consectetuer adip iscing elit, sed diam nonummy nibh euismod tincidunt ut laoreet dolore magna aliquam erat volutpat. Ut wisi enim ad minim veniam. quis nostrud exerci tation ullam corper suscipit lobortis nisl ut aliquip ex ea commodo mazim plac consegua uis autem vel eum iriure dolor in hendrerit in vulputate velit esse molestie consequat, vel illum dolore eu feugiat nulla facilisis at vero eros et accumsan et iusto odio dignissim qui blandit praesent luptatum zzril delenit augue dui sdolore te feugait lorenulla facilisi

Lorem ipsum dolor sit amet, consectetuer adipiscing elit, sed diam nonummy nibh euismod tincidunt ut laoreet dolore magna aliquam erat volutpat. Ut wisi enim ad minim veniam, quis nostrud exerci tation ullamcorper suscipit lobortis nisl ut aliquip ex ea commodo consequat. Duis autem vel eum iriure dolor in hendrerit in vulputate velit esse molestie

Cnsequat, vel illum dolore eu feugiat nulla facilisis at vero eros et accumsan et iusto odio dignissim qui blandit praesent luptatum zzril delenit augue duis dolore te feugait nulla facilisi. Nam liber tempor cum soluta nobis eleifend option congue nihil imperdiet doming id quod mazim placerat facer possim assum Cnsequat, vel illum dolore eu feugiat nulla facilisis at vero eros et accumsan et iusto odio dignissim qui blandit praesent luptatum zzril delenit augue duis dolore te feugait nulla facilisi. Nam liber tempor cum soluta nobis eleifend option congue nihil imperdiet doming id quod mazim placerat facer possim assum.

Lorem ipsum dolor sit amet conse ctetuer adipiscing elit, sed diam nonummy nibh euismod tincidunt ut laoreet dolore magna aliquam erat volutpat. Ut wisi enim Lorem ipsum dolor sit amet, consectetuer

6000251

Ut wisi enim ad ninim veniam, quis nostrud exerci tation ullamcorper suscipit lobortis nisl ut aliquip ex ea commodo consequat. Duis autem vel eum iriure dolor in hendrerit in vulputate velit esse molestie consequat, vel illum dolore eu feugiat nulla facilisis at vero eros et accum san et iusto odio dignissim qui blandit praesent luptatum zzril del enit augue duis dolore te feugait nulla facilisi. Lorem ipsum dolor sit amet, cons ectetuer adipiscing elit, sed diam non ummy nibh euismod incidunt ut laoreet dolore magna aliquam erat Ut wisi enim ad minim

veniam quis t wisi enim ad minim veniam, quis nostrud exerci tation ullamcorper suscipit lobortis nisl ut aliquip ex ea commodo consequat.

Duis autem vel eum iriure dolor in hendrerit in vulputate velit esse molestie

consequat, vel illum dolore eu feugiat nulla facilisis at vero eros et accum san et iusto odio dignissim qui blandit praesent

Luptatum zzril del enit augue duis dolore te feugait nulla facilisi. Lorem ipsum dolor sit amet, cons ectetuer adipiscing elit, sed diam non ummy nibh euismod tincidunt ut laoreet dolore

magna aliquam erat .Utzzril del enit augue duis dolore te

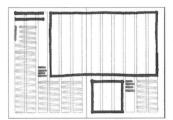

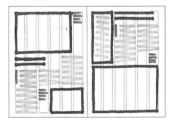

Use elements of the layout in the above spreads to create variety.

Maime County jail to close

Lorem ipsum dolor sit amet, consectetuer aiscing elit, sed diam non ummy nibh euismod tincidunt ut laoreet dolore magna aliquam erat volutpat wisi enim ad minim veniam, quis nost rud exerci tation ullamcorper suscipit lobor

tis nisl ut aliquip ex ea commodo consequat uis autem vel eum iriure dolor in hendrerit in vulputate velit esse molestie consequat, vel illum dolore eu feugiat nulla facilisis at vero eros et accumsan et justo odio dignissim qui blandit praesent luptatum zzril delenit augue duis dolore te feugait nulla facilisi. Lorem insum dolor sit anet cons

ectetuer adipiscing elit, sed diam

ISSUES / MARCH 1994

tincidunt ut laoreet dolore magna aliquam erat volutpat. Ut wisi enim ad minim veniam, quis nostrud exerci tation ullam corper suscipit lobortis nisl ut aliquip ex ea Cnsequat, vel illum dolore eu feugiat

nonummy nibh euismod

nulla facilisis at vero eros accumsan et iusto odio dignissim qui blandit praesent luptatum zril delenit augue duis dolore te feugait nulla facilisi. Nam liber tempor cum oluta nobis eleifend option congue nihil imperdiet doming id quod mazim placerat facer possim assum. Lorem ipsum dolor sit amet, consectetuer adipiscing elit, sed diam nonummy nibh euismod tincidunt ut laoreet

PAGE THREE

Equal space

Ranged-left text that wraps around an inset graphic can look uncomfortable, as the uneven line endings on the left give more space than the strong vertical on the right. Be sure to manipulate the text to overcome this. If you use a DTP system, use a smaller margin on the left of the graphic so that the longer lines can come closer to it. A 6pt rule, tinted black 60%, helps to separate articles.

intermediate NEWSLETTERS

wild plant society

CLIENT

lame ddress Ny, State Ipcode

Plants for free

SPECIFICATION

Folds

*

Format 11 x 17 in or A3, self-mailing Grid 2-column Space between -4p10Margins i 4p1 o 4p1 t 4p1 b 4p1 Fonts Century Old Style Intro text 16/19pt Body text 10/12½pt Subheads 10/12½pt

Detailed spec. for masthead on opposite page.

2

3

BRIEF Plants for Free is a society established to promote the harvesting of wild plants, herbs, and fungi for culinary, cosmetic, and, occasionally, medicinal purposes. Members pay a subscription, and the newsletter, which is published quarterly, is written in the form of a letter from the president to the society's members. Illustrations are also included. This rather unusual organization requires a distinctive design, but wants to avoid the old-fashioned look sometimes associated with publications of this type.

SOLUTION An 11 x 17 in Tabloid, four-page, selfmailing newsletter was chosen. The logo and the newsletter have been designed at the same time, which gives an opportunity to integrate the two. The two-color printing allows a different second color to be used for each issue – black/green or black/blue, for example. The complex arrangement of the masthead and logo is contained by a delicate, hairline ruled box. Twice folded to create four panels, the cover is read with horizontal orientation, while the inside spread and remaining two panels are turned through 90 degrees, and read vertically.

Butem vel eum iriure

- 2 Butem vel eum iriure do lor in hen dre rit in vulp utate velit
- 3 BUTEM VEL EUM IRIURE DO

The word *Plants* sits within a black (100%) panel, which breaks out of a ruled box border. To balance this, *Free* also breaks out on the other side.

24pt Plantin Light caps are force justified to column width.

Whether it is printed as black tints or in a second color, the most important consideration here is the closeness in tonal value between the bleed background (black 40%) and the word free (black 20%). A ratio of 50/30% would also work and allow the black overprinted text still to read clearly.

Plants for *free*

62pt Plantin Light, very loose track.

The "f" must not be lighter than 20% or the "n" will not read white out.

Duis autem vel eum iriure dolor intiol hendrerit in vulputate velit esse mol estie consequat, vel illum dolore eu feugiat nulla facili sis at vero eros et a ccumsan et iusto odio dig nissim qui blanditl praesent luptatum zzril delenit augue duis dolore te feugaitmu nulla facilisi. Lorem ipsum dolor sit amet, consectetuer adipiscing elit, sed diam nonummy nibh euismod tincidunt ut laoreet dolore magna aliquam erat volutpat. Ut wisi enim ad minim veniam, quis nostrud exerci tation ullamcorper suscipit lobortis nisl ut aliquip ex ea commodo conseguat. Duis aut em vel eum iriure dolor in hendrerit in vulputate velit esse 🚓 molestie consequat, vel illum dolore eu feugiat nulla 130pt Plantin Light

Italic, loose track.

280pt Plantin Light

Italic

24pt Plantin Light, very loose track.

The text does not have a headline.

newsletter will be folded twice for despatch, which restricts the front page to an elongated shape.

The self-mailing

The elaborate masthead occupies about a third of the total area. When turned through 90 degrees, the inside

Name Address City, State Zipcode

> spread (opposite) will read vertically. The text blocks are enclosed by a ½pt ruled box, 1pt away from the page area.

The entire page is enclosed by a ½pt ruled box (black 100%) 1pt away from the page area.

advanced

CLIENT

NEWSLET TERS

cosmetic manufacturer

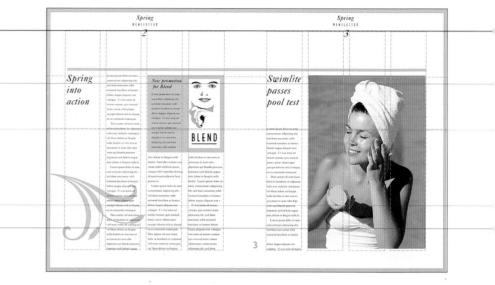

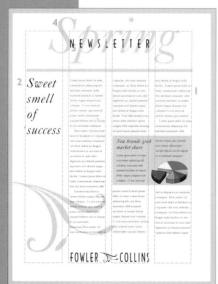

SPECIFICATIONS

Format 8½ x 11 in or A4

Grid 4-column

Space between - 1p5

Margins

i 3p7 o 5p6 t 3p7 b 5p6

Fonts

Caslon Track loose

I Body text 8/14pt

Caslon Italic

- Track very loose 2 Headlines 36/42, 14/17pt.
- 3 Captions 8/14pt
- 4 Title 140pt

Arquitectura

- Track force justified 5 Newsletter, logo 24pt
- 5 1 1000 2 1

BRIEF Fowler & Collins is an upmarket cosmetic manufacturer. The company's image is one of freshness and health, with an emphasis on the naturalness of the ingredients. The newsletter is targeted at customers, department stores, drugstores, beauticians, and shops specializing in health and beauty products. The rigorously maintained corporate identity imposes constraints on the design of the newsletter, particularly the choice of typeface. The Caslon family must be used on all literature for both headlines and text.

SOLUTION A 12-page publication, saddlestitched and self-covered, but using a high-quality silk finish coated stock of #101 is chosen. Printed in four colors throughout, it features a mix of color photography, charts and diagrams, and some illustrations. The use of the flower device, extracted from the logo, is sanctioned in the corporate identity manual. The company's marketing strategy features strongly seasonal campaigns, when new products and promotions are launched. The masthead design is intended to suggest this consideration.

Abc

Butem vel eum iriure do lor in hen dre rit in vulp utate velit

3 Butem vel eum iriure do lor in

The 8pt rule, prints 40% yellow, 30% cyan, and provides a strong hangline

of

SUCCESS

The strongly

this quarterly

ment of the

masthead. The

Caslon Italic Spring

prints 40% yellow,

30% cyan, and is

track. Newsletter

mimics the logo

specification, and

Arquitectura – is

force justified to

the two-column

Headlines are set in

36/42pt Caslon

Italic, upper and

with a greater

lower case, a face

degree of backslant

and with very loose

The flower device,

extracted from the

logo, prints 40%

yellow, 30% cyan. The text

overprints it.

than most italics,

track

the face -

width

set very loose

large (140pt)

seasonal nature of

newsletter allows

for unusual treat-

for the text and a visual boundary for the masthead. Try recreating this

layout without this rule, and you will see that the design is much weaker.

NEWSLETTE Lorem ipsum dolor sit amet, vulputate velit esse molestie duis dolore te feugait nulla Sweet consequat, vel illum dolore eu facilisi. Lorem ipsum dolor sit consectetuer adipiscing elit, amet, consectetuer adipiscing feugiat nulla facilisis at vero sed diam nonummy nibh eros et accumsan et iusto odio euismod tincidunt ut laoreet elit, sed diam nonummy nibh smell euismod tincidunt ut laoreet dignissim qui blandit praesent dolore magna aliquam erat dolore magna aliquam erat luptatum zzril delenit augue volutpat. Ut wisi enim ad minim veniam, quis nostrud duis dolore te feugait nulla

facilisi. Nam liber tempor cum exerci tation ullamcorper soluta nobis eleifend option suscipit lobortis nisl ut aliquit congue nihil imperdiet doming ex ea commodo conseguat. Duis autem vel eum iriure id quod mazim placerat facer

dolor in hendrerit in vulputate

velit esse molestie consequat,

vel illum dolore eu feugiat

nulla facilisis at vero eros et

dignissim qui blandit praesent

luptatum zzril delenit augue

facilisi. Lorem ipsum dolor sit

amet, consectetuer adipiscing

elit, sed diam nonummy nibh

Euismod tincidunt ut

laoreet dolore magna aliquam

erat volutpat. Ut wisi enim ad

minim veniam, quis nostrud

suscipit lobortis nisl ut aliquip

consequat.Duis autem vel

um iriure dolor in hendrerit in

exerci tation ullamcorpe

ex ea commodo

duis dolore te feugait nulla

accumsan et iusto odio

New brands grab market share

Lorem itsum dolor sit amet. ctetuer adipiscing elit, sed diam nonummy nibh od tincidunt ut laoree dolore magna aliquam erat volutpat. Ut wisi enim ad

possim assum.Lorem ipsum dolor sit amet, consectetuer adipiscing elit, sed diam nonummy nibh euismod tincidunt ut laoreet dolore magna aliquam erat volutpat. Ut wisi enim ad minim veniam. quis nostrud exerci tation ullamcorper suscipit lobortis

FOWLER DCOLLINS

volutpat.Ut wisi enim ad minim veniam, quis nostrud Lorem ipsum dolor sit amet,

consectetuer adipiscing elit sed diam nonummy nibh

minim veniam, quis nostrud exerci tation ullamcorpe suscipit lobortis nisl ut aliquip do conseaunt

nisl ut aliquip ex ea commodo consequat. Duis autem vel eum iriure dolor in hendrerit in vulputate velit esse molestie consequat, vel illum dolore eu feugiat nulla facilisis at vero eros et accumsan et iusto odio dignissim qui blandit praesent lupratum zzril delenit augue

White space is an important element in any design – a difficult concept for the inexperienced designer to grasp. The wide margins, the first column left empty except for the headline, the choice and size of type, plus the border, all help to contribute to a clean, light feel, appropriate for a newsletter published by a cosmetic manufacturer.

The left, right, left axis of the headline, boxed copy and flower device, although arranged asymmetrically, makes for a balanced page.

Charts can be made more interesting by using the 3-D techniques available from graphics packages, or by being drawn as line artwork.

The text is a well leaded 8/14pt Caslon Italic, ranged left.

An effective layout relies on the harmonious juxtaposition of the elements. The masthead at the top and the logo at the bottom are

both centered on the page width. The rest of the page is arranged asymmetrically. Achieving this look requires practice.

The border prints 40% yellow, 30% cyan, it bleeds off, and because it is narrow, 1p2, requires accurate

printing, folding and trimming. A wider border would be safer, but less elegant.

advanced NEWSLETTERS

large folios create visual interest. The same combination of faces that was used for the masthead provides an elegant header to the page. There is no standard formula for achieving an aesthetically pleasing arrangement of the three lines - you will need to experiment with the leading

until you are happy

The design employs

line adopted on the

first page. This is in

the form of an 8pt

rule which prints

40% yellow, 30%

cyan, and crosses

the gutter to the

full double page

width. The large

above is left

strip of white space

deliberately blank,

repeat title and the

except for the

folios.

the strong hang-

with the result.

The repeat title and

Spring into action

Lorem ipsum dolor sit amet, consectetuer adipiscing elit. sed diam nonummy nibh euismod tincidunt ut laoreet dolore magna aliquam erat volutpat. Ut wisi enim ad minim veniam, quis nostrud exerci tation ullamcorper suscipit lobortis nisl ut aliquip

ex ea commodo conseguat. Duis autem vel eum iriure dolor in hendrerit in vulputate velit esse molestie consequat, vel illum dolore eu feugiat nulla facilisis at vero eros et accumsan et iusto odio dign issim qui blandit praesent luptatum zzril delenit augue duis dolore te feugait nulla fa Lorem ipsum dolor sit ame cons ectetuer adipiscing elit. sed diam non ummy nibh euismod tincidunt ut laoreet dolore magna aliquam erat volutpat. Ut wisi enim ad minim veniam, quis nostrud exerci tation ullamcorper suscipit lobortis nisl ut aliquip ex ea commodo consequat. Duis autem vel eum iriure dolor in hendrerit in vulputate velit esse moles tie conseguat. vel illum dolore eu feugiat nulla facilisis at vero eros et accumsan et iusto odio dignissim qui blandit praesent luptatum zzril delenit augue

New promotion for Blend

Spring

NEWSLETTER

2

Lorem ipsum dolor sit amet, consectetuer adipiscing elit, sed diam nonummy nibh euismod tincidunt ut laoreet dolore magna aliquam erat volutpat. Ut wisi enim ad minim veniam, quis nostrud exerci tation ullamcorper suscipit lobortis nisl ut aliquit ex ea onsectetuer adipiscing elit, sed diam nonummy nibh euismod

duis dolore te feugait nulla facilisi. Nam liber tempor cum soluta nobis eleifend option congue nihil imperdiet doming id quod mazim placerat facer possim as

Lorem insum dolor sit ame consectetuer adipiscing elit, sed diam nonummy nibh euismod tincidunt ut laoreet dolore magna aliquam erat volutpat. Ut wisi enim ad minim veniam, quis nostrud exerci tation ullamcorper suscipit lobortis nisl ut aliquip ex ea commodo conseguat. Duis autem vel eum iriure dolor in hendrerit in vulputate velit esse molestie consequat, vel illum dolore eu feugiat

nulla facilisis at vero eros er accumsan et iusto odio dignissim qui blandit praesent luptatum zzril delenit augue duis dolore te feugait nulla facilisi. Lorem ipsum dolor sit amet, consectetuer adipiscing elit, sed diam nonummy nibh euismod tincidunt ut laoreet dolore magna aliquam erat v

Ut wisi enim ad minim veniam, quis consect etuer adipiscing elit, sed diam nonummy nibh euismod tincidunt ut laoreet dolore magna aliquam erat volutpat. wisi enim ad minim veniam. quis nostrud exerci tation ullamcorper consectetuer adipiscing elit, sed diam

The demands of the designer and the writer sometimes conflict. Here, the narrow column imposes a limitation on the length of words in the headline. In this instance, it is

desirable to write headlines with short, punchy words, but there may be circumstances when this is not the case and a different design solution will have to be found.

The tint boxes print 40% yellow, 30% cyan, are of variable length, and can be used to highlight themes within the main

text. In more complex publications, boxes can be used simply to break up the page and provide visual interest.

Grids are a

useful device

for maintaining

consistency

of layout,

particularly in

longer, more

complex

documents.

However, they

should not

stifle creativity.

They must

always be the

slave and not

the master.

0 BLEND Headlines always start at the top of the column, never halfway down. From trim +2p7 From trim +4p4 From trim +6p11

Spring NEWSLEITER 3

Swimlite passes pool test

Lorem ipsum dolor sit amet, consectetuer adipiscing elit, sed diam nonummy nibh euismod tincidunt ut laoreet dolore magna aliquam erat volutpat. Ut wisi enim ad minim veniam, quis nostrud exerci tation ullamcorper suscipit lobortis nisl ut aliquip ex ea commodo consequat.

Duis autem vel eum iriure dolor in hendrerit in vulputate velit esse molestie consequat, vel illum dolore eu feugiat nulla facilisis at vero eros et accumsan et iusto odio dign issim qui blandit praesent luptatum zzril delenit augue duis dolore te feugait nulla fa

Lorem ipsum dolor sit ame cons ectetuer adipiscing elit, sed diam non ummy nibh euismod tincidunt ut laoreet

dolore magna aliquam erat volutpat. Ut wisi enim ad minim

A secondary hangline is used to position the beginning of the text beneath a headline, and to position elements such as the box on the first page. In a longer publication, a device like this helps to give a uniform look.

Captions are italic, the same type spec as box text, and should be no more than three lines long. The design is kept intentionally simple, and a larger range of typefaces is undesirable. The color photograph is quite dominant in this uncluttered layout. The right-hand page usually has more impact than the left, and so heavier, larger objects are often put on this page.

The strong hangline provides a unifying element, particularly for longer newsletters.

47

advanced NEWSLETTERS

leaning company

CLIENT

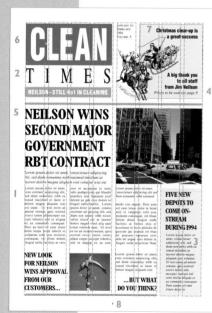

SPECIFICATIONS

Format 8.5 x 11 in or A4

Grid

8-column Space between - 1p2

Margins i4pl

o 4p I t 4p l b 4p7

Fonts **Times Roman**

Track normal

- I Body text 9/IIpt Times Roman (80% cond.)
- Track force justify 2 Title 60pt
- **Times** Italic

Track normal

- 3 Box text, captions 9/11pt
- 4 Message panel subhead I lpt **Plantin Bold Condensed**
- Track normal

Helvetica Black Condensed (80% cond.)

- 6 Title 120pt
- 7 Message panel head 14/17pt
- 8 Folios 8pt
- Butem vel eum iriure do lor in 1 e rit in vulp utate velit

3 Butem vel eum iriure do lor in BRIEF Neilson, which is a major national cleaning company, publishes a bimonthly, eightpage newsletter to communicate with its employees and customers. Although large, it is still a family-run enterprise, with Jim Neilson at its head, a man with a hands-on approach to business. A down-to-earth publication was required, with the flexibility to incorporate articles of varying length and emphasis, and to display photographs at a wide variety of sizes.

SOLUTION A standard format, saddle-stitched, self-covered, and using a #91 mat-coated stock. was selected. An eight-column grid allows a wide variety of picture sizes, and for flexibility in the width of headlines. The layout echoes a popular newspaper in style. The chunky Plantin Bold Condensed headline face, combined with 6pt rules and frequent boxed articles, make for busy, easy-to-read pages. The text is set in Times Roman, a classic newspaper face, with italic used for introductions, boxes, and captions. The masthead, a red panel with Clean white-out, is set in Helvetica Black Condensed, and the word Times is set, appropriately enough, in Times Roman.

48

- 5 Headlines 41/44, 19/23pt.

Track loose

Helvetica Black Condensed 120pt has been further condensed to 80%.

Times Roman 60pt, force justified, and condensed 80%. Duplicate setting to create the drop shadow, which is tinted black 10% and offset slightly.

Helvetica Black Condensed 16½pt, force justified and set within a black panel tinted 10%.

The headlines are set in Plantin Bold Condensed at various sizes. The lead story is 41pt with 44pt leading. At this size a stacked, all-caps headline will require less leading than a smaller one; 41/44pt is 107%, compared with the standard 120% leading.

Introductions follow main headlines, and are set in Times Roman Italic I I/I3pt. At 2pts larger than the text, and set across two text columns, they are an additional link between the headline and the text. CCEACION OF THE STATE OF THE ST

The masthead is

rating a slogan

beneath the title,

complex, incorpo-

additional headlines.

and an illustration

that breaks out of

Christmas clear-up is

a great-success

A big thank you

from Jim Neilson

Prizes to be won see page 9

to all staff

the tinted panel.

NEILSON WINS SECOND MAJOR GOVERNMENT RBT CONTRACT

The panel prints

100% yellow, 100%

magenta, the title is

reversed-out white.

Lorem ipsum dolor sit amet, consectetuer adipiscing elit, sed diam nonummy nibh euismod tincidunt ut laoreet dolore magna aliquam erat volutpat wisi eni

Lorem ipsum dolor sit amet, cons ectetuer adipiscing elit, sed diam nonummy nibh eu ismod tincidunt ut laore et dolore magna aliquam erat vol utpat. Ut wisi enim ad minim veniam, quis nostrud exerci tation ullamcorper sus cipit lobortis nisl ut aliquip ex ea commodo consequat. Duis au tem vel eum iriure dolor inopu heopl ndrerit in vulputate velit esse molestie consequat, vel illum dolore feugiat nulla facilisis at vero

NEW LOOK FOR NEILSON WINS APPROVAL FROM OUR CUSTOMERS...

eros et accumsan et iusto

odio pudignissim qui blandit

praedory sent luptatum zzril

delenit au gue duis dolore te

feugait nulla facilisi. Lorem

ipsum dolor sit amet, conmo sectetuer ad ipiscing elit, sed

diam non ummy nibh euism

odilot tincid unt ut laoreet

dolore magna etuol aliq uam

ermat volutom opat. Ut wisi

en im ad minim veniam, quis

nostrud exerci tation isento

ullam corper suscipit lobortis

nisl ut aliquip ex ea com

Lorem ipsum dolor sit amet, consectetuer adipiscing elit sed diam nonummy nibh euismod

modo con sequat. Duis aute vel eum iriure dolor in hend rerit in vulputate velit esse molestie consequat, vel illum dolore drueu feugiat nulla facilisis at veroes eros et accumsan et iusto plitodio di gnissim qui praesat ert blan dit praesent luptatum zzril dele nit augue duis dolore te feugait nulla tefacilisut Nam

Lorem ipsum dolor sit amet, cons ectetuer adipiscing elit, sed diam nonummy nibh eu ismod tincidunt ut laore et dolore magna aliquam erat

... BUT WHAT DO YOU THINK?

FIVE NEW DEPOTS TO COME ON-STREAM DURING 1994

Lorem ipsum dolor sit amet, consectetuer adipiscing elit, sed diam nonummy nibh eu ismod tincidunt ut laoreet dolore magna aliquam erat volutpat. Ut wisi enim ad minim veniam, quis nostrud exerci tation ulla mcorper suscipit lob ortis nisl ut aliquip ex ea commodo consequat. Duis autem vel eum iriure dolor in The date and volume text is set in caps and small caps, Times Roman 9/11pt. Traditionally, small caps are the same size as the x-height of the face. They can, however, be set to any % of the cap size, Here they are 80%.

The message panel does not have a fixed type spec, but will depend on the information it contains. Here the headline is set in Helvetica Bold Condensed, 14/17pt, followed by a subhead set in Times Roman Italic, I lpt. Boxed features are used to add interest to the page. Set the copy in the box within a margin that matches the space between columns. The panel prints 20% cyan.

Captions follow the text specification, but are italic and ranged left. Captions that appear in text columns are easier to position if they are the same size and leading as the text.

more p margin panel a space l

The text is set in Times Roman 9/11pt and justified. The letter and word spacing should

always be as even as possible. Justified setting can leave excessive spaces between words, and although the use of hyphenation will improve it, some editing will be needed, too.

The layout will look more pleasing if the margins within the tint panel are equal to the space between columns

advanced

CLIENT

NEWSLETTERS

cult rock band

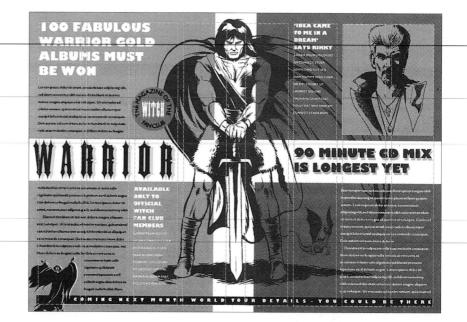

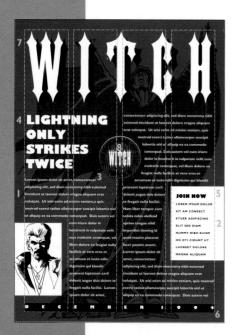

- Butem vel eum iriure do lor in hen dre rit in vulp utate velit
- 2 BUTEM VEL EUM IRIURE DO LOR IN

SPECIFICATIONS

Format 8½ x 11 in or A4 Grid

4-column Space between – 1p2

 Margins

 i 2p5
 o 2p5

 t 2p5
 b 2p5

Fonts Gill Sans Bold

- Track loose
- I Body text 10/20pt
- 2 Captions, box text 8/20pt3 Badge surround 14pt
 - Gill Ultra Bold
- 4 Headlines 34/41, 14/20pt 5 Box head 14/20pt
- Force justified 6 Date panel 12pt
- Ironwood
- Track force justified
- 7 Title 200pt 8 Badge title 50pt (70%
- 8 Badge title 50pt (70% cond.)

BRIEF Witch, a cult rock band with a dramatic stage persona and a large following of devoted fans, has commissioned a newsletter for its fan club. The purpose is to keep fans informed about gigs, tour plans and record releases, and to sell Witch merchandise. Like many rock musicians, band members take a keen interest in all aspects of design (two of the group have been to art school). There must be a large bleed photograph of the band, and allowance has to be made for occasional advertisements, but otherwise the brief is very open.

SOLUTION An eight-page, fold-out poster format is selected, the whole of one side being the photograph of the band. The remaining four pages comprise the newsletter. When information in these four pages is no longer required, the unfolded newsletter can be used as a poster and pinned to the fan's wall. The layout needs to be very dramatic. The poster side will be printed in four process colors; the other side will be printed black plus three spot colors. This gives tremendous scope for the creation of unusual design effects and the use of illustrations. The masthead is the band's logo, set in Ironwood 200pt, force justified and

white out. The drop shadow is a duplicate, black 100% and offset.

ZIM

ANOUS

praesent luptatum zzril

te feugait nulla facilisi.

Nam liber tempor cum

soluta nobis eleifend

option congue nihil

imperdiet doming id

guod mazim placerat

facer possim assum.

amet, consectetuer

Lorem ipsum dolor sit

delenit augue duis dolore

The double-page spread opposite demonstrates how to create a dramatic layout while maintaining the theme. The left page is a lighter color so both over-printed and reversed-out text are legible. On the darker right page only white type will be legible.

The headline is set in Gill Sans Ultra Bold white out, and makes a shape, of one long line and three shorter ones, that allows the badge device to fit into the center of the page.

The Witch illustration prints deep purple on a background of red. These colors need to be close in tonal value. If they were not, the contrast between them would be so great that the white-out text would be very difficult to read. The readership of a fanzine will be more tolerant of avant garde graphics at the expense of legibility, and the designer's aim should be to reach an acceptable compromise between the two.

LIGHTNING ONLY STRIKES TWICE

Lorem ipsum dolor sit amet, consectetuer adipiscing elit, sed diam nonummy nibh euismod tincidunt ut laoreet dolore magna aliquam erat volutpat. Ut wisi enim ad minim veniam,a quis nostrud exerci tation ullamcorper suscipit lobortis nisl ut aliquip ex ea commodo consequat. Duis autem vel

G

Ð

eum iriure dolor in hendrerit in vulputate velit esse molestie consequat, vel illum dolore eu feugiat nulla facilisis at vero eros et accumsan et iusto odio dignissim qui blandit praesent luptatum zzril delenit augue duis dolore te feugait nulla facilisi. Lorem ipsum dolor sit amet,

Ĩ

::

consectetuer adipiscing elit, sed diam nonummy nibh euismod tincidunt ut laoreet dolore magna aliquam erat volutpat. Ut wisi enim ad minim veniam, quis

> nostrud exerci tation ullamcorper suscipit lobortis nisl ut aliquip ex ea commodo consequat. Duis autem vel eum iriure dolor in hendrerit in vulputate velit esse molestie consequat, vel illum dolore eu feugiat nulla facilisis at vero eros et

accumsan et iusto odio dignissim qui blandit

WOM NIOL

LOREM IPSUM DOLOR SIT AM CONSECT ETUER ADIPISCING ELIT SED DIAM NUMMY NIBH EUISM OD OTI CIDUNT UT LAOREET DOLORE MAGNA ALIQUAM

adipiscing elit, sed diam nonummy nibh euismod tincidunt ut laoreet dolore magna aliquam erat volutpat. Ut wisi enim ad minim veniam, quis nostrud exerci tation ullamcorper suscipit lobortis nisl ut aliquip ex ea commodo consequat. Duis autem vel

•

0

The badge device uses the Witch logo, condensed to 70%, a liberty that would not be tolerated if it were the logo of a corporation. The remaining copy is set in Gill Sans Bold inside a circle with a 8p7 diameter. The badge diameter is 9p10 and prints black tinted 50%.

A white panel encloses the club membership details. The heading is set in Gill Ultra Bold, 14/20pt. The text is 8/20pt Gill Sans Bold all caps.

The date panel is black 100%. The illustration overprints it, creating an interesting effect. White-out type, set in Gill Ultra Bold 12pt, is force justified to the full width of the panel.

This poster folds twice from a single sheet to form the newsletter. A four-column grid underlies the broad, two-column text blocks, allowing photos, text panels, and graphics to be dropped in without the text run-arounds being set to a very narrow measure. Text is set 10/20pt Gill Sans Bold. This extreme leading enables the pictorial background to show through between lines. The face must be very bold to ensure good legibility.

4

published NEWSLETTERS

Searching for Solutions-Not Band-Aids

e ve all augre of the heavy toll mental health and substance buse problems take in the workplace. The issues reach far beyond asts that result, and so must the solutions. Cost containment the costs that result, and so must the sotutions. cost containing a fore is not the answer — it's only a band-aid. Employers need to take a comprehensive, long-term approach to solve the problem starting with examining the quality, appropriateness, and necessity

of mental health and substance abuse treatment.

The Impact of Inappropriate Tre

10 hospita stays for mental ith and sub

stance abuse tment annea to be unnecessary

Above: Typographical devices are sometimes more appropriate than pictures. This newsletter for a health management network has two levels of crosshead - one in bold, the other in italics – a quote, taken from the text and set in a large, sanserif face between two thick rules; and a large drop capital at the beginning of the introduction, which has been set in italics.

Right: Strong colors and an uncluttered design were chosen for the covers for the newsletter of a rail distribution company. The black drop-shadow for the masthead is particularly important against the yellow selected for the background. The first four inside pages (below) use a combination of a bold sanserif face and a light serif face; these, together with the vertical panel and bold, dotted column rules, give a "newsy" feel to the pages. The page numbers in the outside

margins are an integral part of the design.

FOCUS

news

norial Offices mon Young I

Marden Kent TN12 SEO

european www. european focus www. european focus www. www. european focus www. www. european focus www. www.

The rail f the Eura year ing way that

SUCCO

Pioneers in IT, Europe's railways are investing heavily in new computer tracking systems to meet the sophisticated logistics and business communica-

tion demands of the 1990s.

Trainferry boost

IT links

with Euro

Customs

clearance

Tunnel

control

Managers back rail freight

ues and makes a nu es transport is

Getting

message

across

the

Director Europe

Euroterminal R

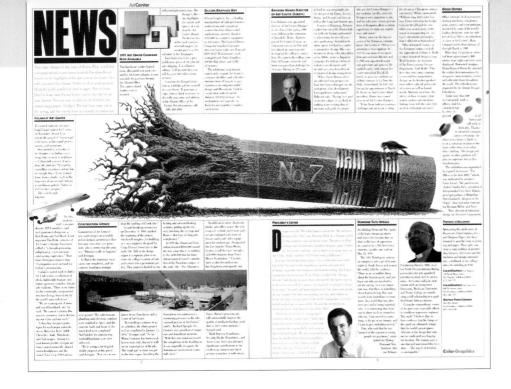

Above & right: The large format chosen by the art college has been exploited and emphasized by positioning the masthead at the top and placing a large, square

picture at the foot. These two main elements separate a narrow strip containing a contents "teaser." Cut-out pictures, with the captions tucked into the available space,

combine with the extremes of scale to create a dynamic layout. The theme is continued on the inside pages. The news headline echoes the masthead, and cut-out pictures break into

the text columns. The pages are contained by a fine ruled box and column rules, which butt to it. In a smaller format this kind of approach could look oppressive, but here,

combined with the elegant typeface Bodoni and the small, bold subheads, set in Futura, it creates an overall impression of balance and harmony.

> reproduced as large as possible, and although white space is normally more often seen in brochures than in

newsletters, here it is used to dramatic effect.

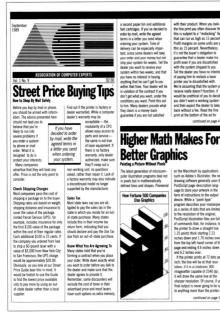

Above: Beginning two articles on the first page so that both continue on subsequent pages is more effective than having one long

article, which could look too dense and uninviting. The basic four-column grid allows the headlines to be set over two columns.

Nors Sectors Interact Lonio 13021 Miles In St. 201 Miles

Exercisis 2 Antifeli In part the prior Save Salati Mill USA In: 20185 Mill An. 75,766 (201

Below: The style of it is aimed. A photographer who wishes to promote his work is naturally going to want his photographs

"More and more black and white photography is predictable and boring

0

transfer and the second

enough photographer technicians around

published NEWSLETTERS

Below: The masthead of this newsletter bleeds off the top. It is balanced by the large dateline near the foot of the page. The layout of the area between varies: illustrations are used when they are available, otherwise a typographical solution is adopted.

Above and right: The loose insertion of a single page into a folded sheet results in an unconventional six-page newsletter, with two double-page spreads and a front and back cover. The editorial matter is a transcript of a debate between two academics, and the adversarial nature of the text is carried through in the layout of the cover and inside spread. The masthead is set in Times Roman, spaced so tightly that some of the characters touch and others even overlap.

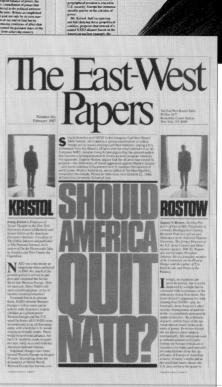

new notes

IMC News

a mending haint XMC Ltd. will become independent of the SPOM construction as from Optimized 2st but remains based at Woot Heads into: Colin Matthews, Director of XMC, will be jound by movied as full dedining terms and Procer Rottenetil, former Nachening Manager for Gillance and compleyer of Gameire, as Markening movembant.

or 10%, the NFXG3 has provided the administration for XGIC and reach for first over recordings. New, with I/K distribution thy Rec-Yol and an expanded included of one new release every two months, the of will unstringe to expand as on independent company. While in mp (axt insue no Editor of neur 1 notes 1 work the brockners p

nnah Rogers - Assistant Administrator, SPNM

October at a glance

octo

new notes

Classic FM A call for pieces ?

or the last few works. Classic P31, Tala does not method the needal as distinct dissumingent that has recorded in the base of non-Government distinct literating the distinct and one flushow Colsnots Michael Herzage limiteter - to lose one might be mainlack but to base two model be considered methods when the nonject of their patient geneticies have they assume a resistion and versionly plays on gap trit their decisions to gain. Perchaped 21 part of the bolden agents of their decisions at an and methods flushow.

Anybow, what I am interested in in how many near 1 notes readers have been nearedly tuning in to Chanie FM over the last fire works? Go up, on up, 1 but you's all tried or an interaction for "branching insure? and how registreously toxangerical back to the tans, perhaps larg age, when you's discovered the joys of classical music and learnt that How areas these means densities reasoned areas in Class. I can be changed as the second

nove

and Mellin Brothogy to play "leastiful" most of all one and Outs composure of all on play the based on play the second of the second second Group, one of the BOM regularity institutes estils for play one and the second of the second o

d fourt difficult fails are shown by fails and the set of the set

Review

 Music & Architecture Project, May 1992 -A structure of ends seens and news, built deable sets to field baby, and to fine carrier, a model date strend and travel or optimized regard of the Crue Baba, and the exploration of a site, readed by seen

properties consequences for pricing and consider many. The rest share of the rest, the SPAD's formers before a solution many and the Ref Merrindia Nor shares. It may not comparing a some, the form therapy of the solution of the rest brenges. There is no and the brenders described and the rest brender of the rest brender manual much interaction of the rest brenders. There is no and the constant of the strender of the rest brenders of the rest brender results when there is the rest of the rest brenders of the rest of the rest of the strender of the low large, and durations which has the place of the brender duration the strender of the low large, are also assume which has the place of the brender duration the strender of the low large, are also assume which has the place of the brender duration the strender of the low large, are also assume which has the place of the brender duration the strender of the low large, are also assume which has the low of the low large as the trender of an end the low large are also assume the low large as also assume the low large as the trender of an end the low large are also assume the low large as also assume the low large as also the trender of an end the low large are also assume the large as the low large as also assume the large as the large assume the large assumet the large a

sept 92

n Barred anez (SPSM Programme Director, 1992/8)

september

Right and below: The vertical masthead and illustrated contents trailer are eye-catching elements of this staff newsletter produced for the BBC (British Broadcasting Corporation). The articles range from

news to features, and the title is repeated, in a tinted form, on every page as a unifying device. The center spread has been used for a main feature, and the headline and picture run across the gutter. This is possible because are not bound.

this is a natural spread - in other words a single sheet with no break - so there is no risk of misalignment of print across the gutter; this is a potential problem with this publication, whose pages

World Service Television celebrate its first year of broadcasting next week. Its news and information channel is now within reach of potentially 85 per cent of the orld's population Chief executive Chris Irwin told Claire Dresser how WSTV aims to

cover the rest of the globe

m

12 13

ICCCR

Global ambitions

Below and far right: Eloquent or provocative quotations can make typographical covers especially powerful. This layout is enhanced by the bold design of the masthead and the use of small inset pictures. The double-page spread listing the main activities of the charitable organization on whose behalf the newsletter is produced makes good use of rather indifferent visual material, and the layout is, in fact, stronger than the sum of its parts.

research

prevention

communication

3

4 5 6

1 2

TACIONI

IDDATE IPDATE

7 8 9 10

S 'As scientists, we must conduct our research in the most effective manner. ICCCR's activite to reduce the pain and suffering from Cancers." SAMUEL ENODER, M.D. Divertar of INA Mational Cancer Institut

> "I have always understood the importance of prevention and my life has been dedicated 🕅 to effectively translating our research knowledge into saving lives." "https:// Charman & Provider of Victor and Provident of Control of Victor and Provident of Control of Victor and Provident of Control o

"We talk all the time about the timportance of communicating. Well, communication can either be education or gossip. Far too often, the information we hear about our health is nothing more than gossip. It's time to be better informed about prevention." C. EVENETT KOOP. M.D.

PRIVATE HOSPITAL EMPLOYMENT AGENCY JAPANESE RESTAURANT LUMBER YARD INSURANCE BROKER MEDIUM-SIZED COLLEGE HORSEBACK RIDING SCHOOL TRAVEL COMPANY INVESTMENT SERVICES

BROCHURES

Lorem ipsum dolo sit amet consect etuer adipiscing e sed diam nonum nibh euismod tincidunt ut

CHAPTER

praesent luptatum zzril delenit augue duis dolore te feugait nulla facilisi. Nam liber tempor cum soluta nobis eleifend option congue nihil

imperdiet doming id quod mazim placerat facer possim iriure dolor assum. Lorem ipsum dolor sit amet, consectetuer adipiscing elit, sed diam nonummy nibh euismod tincidunt ut laoreet dolore magna aliquam erat volutpat.

Ut wisi enim ad minim veniam, quis nostrud exerci consectetuer adipiscing elit, sed diam nonummy nibh euismod tincidunt ut laoreet dolore magna aliquam erat volutpat. Ut wisi enim ad minim veniam, quis nostrud exerci tation ullamcorper suscipit lobortis nisl ut aliquip ex ea commodo consequat. tincidunt ut Duis autem vel eum iriure dolor in hendrerit in vulputate velit esse molestie consequat, vel illum dolore eu feugiat

· SHAND DAVY ·

Service is our best policy

rochures are published in a wide

variety of shapes and sizes, although many clients prefer $8\frac{1}{2} \times 11$ in (A4) and 6×9 in (A5) because these formats are easy to mail, convenient to file, fit standard-size envelopes, and do not waste paper as some non-standard formats may do. With one exception, all the examples created in this section derive from the above formats, but this does not limit the variety or effectiveness of the layouts. However, if you can justify the use of a custom size to your client, check with your printer to make sure that it is practical.

The choice of paper (stock) is always an important factor in creating the right impression, and this is particularly so with brochures. Considerations such as folding and binding will influence the layout, while grids play an important part in establishing a framework, although they should never be applied in way that stifles variety in the layouts, particularly in longer documents.

The examples on the following pages demonstrate that every publication needs to be designed to fulfill the individual needs of the brief. You may, however, be able to utilize some of these layouts for a variety of other purposes.

The basic level introduces the 6 x 9in and $8\frac{1}{2}$ x I lin formats, and the first example uses a combination of centered heads and justified text. Ranged-left heads and text are introduced in the second example, while the third highlights the layout implications of using a single sheet, horizontal format, folded into three panels. The intermediate level considers the opportunities offered by longer publications as well as looking at an alternative approach to the single sheet, twofold format.

The advanced level includes a horizontal $8\frac{1}{2} \times 11$ in format, which gives a very wide and shallow double-page spread. Another example uses a double-depth $8\frac{1}{2} \times 11$ in vertical format, with an accordion pleat producing six panels, while the only non-standard size, a square $8\frac{5}{8} \times 8\frac{5}{8}$ format, is used for individual sheets that are to be inserted into a slipcase.

In the newsletter section it was assumed that most of the pictorial material already existed, but in this section the assumption is that photographs or illustrations will be commissioned to fit the requirements of the layouts. When new illustrative material is to be used, it is generally more efficient to prepare a rough layout to which the illustrator or photographer can work rather than simply to commission from a list, which may result in gaps in the layout or unwanted overmatter.

Brochures offer an infinite range of layout opportunities, only few of which can be shown here. For some publications it may be desirable to retain a rigid design in which all the text elements retain a fixed position—compare, for example, the design on pages 60-63 with the approach adopted on pages 70-71, in which the design has some consistent elements but each spread develops the design theme in a different way.

> Most of the brochures on the following pages are reproduced at 63% of the actual size. A sample of the headings and text is shown actual size on the lefthand page, together with a mini-version of the brochure with the grid overlaid in blue.

57

basic

BROCHURES

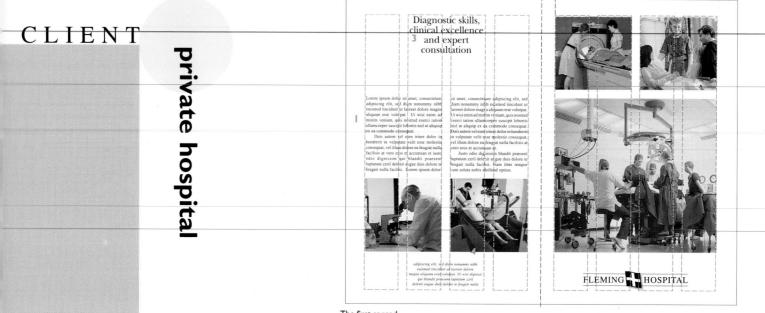

 ² Care when you need it.
 Confidence when you dont.

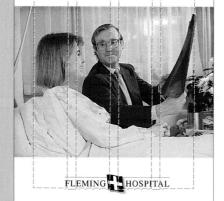

The first spread.

SPECIFICATIONS

Format

- 6 x 9in or A5 16 pages, saddle-stitched **Grid** 4-column Space between – 1p6
- Margins* i 2p5 o 4p1
- t 2pll b 2pll
- Fonts
- Times Roman Track loose
- Logo
- 18pt
- I Body text 9/11pt
- Title 36/36pt
 Subhead 20/20pt
- **Times Roman italic** Track loose
- 4 Captions 8/10pt

* All margins on cover are 2p10 **BRIEF** Fleming Hospital offers general health care. It has commissioned a new brochure from the in-house design group in order to sell its services more effectively. Research has shown that customers acknowledge that they enjoy first-rate facilities but are somewhat dissatisfied with the way sometimes complex medical issues are explained to them by clinical staff. The new publication must address this concern as well as promoting health education and the hospital's primary services.

SOLUTION A 16-page, self-covered 6 x 9in / A5 brochure, using #118, mat-coated stock printed full-color throughout has been selected. The type face is Times Roman, which works well for both headlines and text. The layout is simple, using clear, uncluttered, centered headlines and a four-column grid with fairly wide margins. The headlines always occupy the top of the left-hand page. The design style is reassuringly conservative, with commissioned photography that portrays the hospital as a caring, though hi-tech organization. Each double-page spread deals with a different aspect of the hospital's services.

Abc

Butem vel eum iriure do lor in hen dre rit in vulp utate velit esse illum The design utilizes a grid that divides each spread horizontally into three equal units, one above the hangline and two below it, plus a smaller unit at the foot in which sit the caption and the logo.

A centered headline sets up the theme of the first spread. Each subsequent spread is self-contained and deals with a different aspect of the hospital's services.

The inside margins on the double-page spreads should be smaller than the outer ones because the two inner margins are

adjacent. On the front cover, the margins should be equal, otherwise the head and logo would be uncomfortably off-center.

Because the brochure is selfcovered (the cover stock is the same as the text pages), it is appropriate for the first spread to start on the inside front cover. If the cover were printed on a different stock - a colored board, for example - the inside cover might not be available, so the first page would be the single right-hand page.

Diagnostic skills, clinical excellence and expert consultation

Lorem ipsum dolor sit amet, consectetuer adipiscing elit, sed diam nonummy nibh euismod tincidunt ut laoreet dolore magna aliquam erat volutpat. Ut wisi enim ad minim veniam, quis nostrud exerci tation ullamcorper suscipit lobortis nisl ut aliquip ex ea commodo consequat. Duis autem vel eum iriure dolor in

hendrerit in vulputate velit esse molestie consequat, vel illum dolore eu feugiat nulla facilisis at vero eros et accumsan et iusto odio dignissim qui blandit praesent luptatum zzril delenit augue duis dolore te feugait nulla facilisi. Lorem ipsum dolor

sit amet, consectetuer adipiscing elit, sed diam nonummy nibh euismod tincidunt ut laoreet dolore magna aliquam erat volutpat. Ut wisi enim ad minim veniam, quis nostrud exerci tation ullamcorper suscipit lobortis nisl ut aliquip ex ea commodo consequat. Duis autem vel eum iriure dolor in hendrerit in vulputate velit esse molestie consequat, vel illum dolore eu feugiat nulla facilisis at vero eros et accumsan et.

Justo odio dignissim blandit praesent luptatum zzril delenit augue duis dolore te feugait nulla facilisi. Nam liber tempor cum soluta nobis eleifend option

adipiscing elit, sed diam nonummy nibh euismod tincidunt ut laoreet dolore magna aliquam erat volutpat. Ut wisi dignissi qui blandit praesent luptatum zzril delenit augue duis dolore te feugait nulla

The photographs and body text are constrained in rather tight blocks, so the irregular, centered head and caption provide a visual contrast.

The logo is set in 18pt Times Roman with 1/2 pt rules positioned 6 points above and below. The lower rule overprints the tinted drop-shadow. The logo is repeated in the same position on every right-hand page.

The flag device can be created as line artwork, or by using the envelope and perspective functions of a graphics program to distort the image.

FLEMING HOSPITAL

Though the page depth of 6 x 9in is 82% of the depth of 81/2 x 11, in the page area is 58%.

(see opposite) is established by positioning the large cover photograph on a hangline. This line forms an essential skeleton for the rest of the publication. The photograph bleeds at both left and right, and this defines the areas of

The layout theme

space above and below it. The centered headline and logo become powerful elements within these spaces.

basic

CLIENT

BROCHURES

employment agency

The first spread.

SPECIFICATIONS

Format

8½ x 11in or A4 12 pages, saddle-stitched

Grid

3-column Space between – 1p10

Margins*

i2pll o4p4 t4p4 b4p4

- Fonts New Baskerville
- Track loose
- I Body text 9½/12pt New Baskerville italic Track loose
- 2 Headlines 47/47pt
- 3 Headlines 24pt
- 4 Introduction 12/15pt5 Boxed text 11/14pt
- Franklin Gothic Heavy Track loose
- Logo 12pt
- Subhead 12/12pt
 * Inner and outer margins are transposed on the cover

BRIEF The People Factor is an executive recruitment consultancy. Its clients are seeking career advancement or are graduates at the start of their careers. In a highly competitive industry, The People Factor wants to emphasize the importance of fitting the person to the job. This requires an in-depth understanding of each client's objectives. Although press advertising is used, a brochure is considered necessary to help implement this strategy. The budget is modest, so resources must be allocated carefully between design, photography, repro, and printing costs.

SOLUTION A 12-page, 8½ x 11in / A4 brochure has been chosen, using a gloss-coated stock, #101 for text and #74 for cover, the latter being laminated on the outside only. The first spread, starting inside the front cover, features a headline that is a continuation from the cover. Carefully selected mini case-studies of past clients, with commissioned photographs, have been used to reinforce the "people-like-you" theme and to provide a testimonial. The cover prints full-color, but the inside is in black only. The photography is expensive, and has been offset against the cheaper single color printing inside.

. Abc

Butem vel eum iriure do lor in hen dre rit in vulp utate velit esse illum The brochure uses a three-column grid, with the entire page depth divided into three units. The six photographs used in full-color on the

cover are repeated on the first inside spread, although they are cropped differently and are printed in black and white.

People like you need... Because the outer column is empty except for the headline and logo, the retention of the wider outer margin would have resulted in too wide a space here, so the inner and outer margins have been transposed on the cover.

The client approved a rough of the layout before the photographs were taken so that the photographer shot to the correct picture proportions.

The cover headline uses three ellipses (full points) to suggest continuation overleaf. The completed headline stresses the interdependent relationship between client and consultant.

The People Factor logo is formed from the name set in 12pt Franklin Gothic Heavy, loose track, combined with a line art illustration.

61

A 50% black tinted, bleed background extends over the front cover. This is dark enough to allow the title to be dropped-out white but lighter than the very dark backgrounds of the photographs.

basic BROCHURES

In the left-hand column of the first spread the headline theme is picked up from the cover and set in 47/47pt New Baskerville Italic. Note the continuation of ellipses from the cover.

The introductory text sets up the case history theme, and is set New Baskerville Italic 12/15pt. To obtain a consistent typographical style, it is important to retain the same relationship between type size and leading -12/15pt equates to 125% leading. The case history captions are set in 91/2/12pt New Baskerville Roman. which is 126% leading. If you use a DTP package you may be able to specify a default leading for a publication so it will always be 125%, regardless of size. If this is not available, multiply the type size by the % required - e.g., | | pt x | 25% = 13.75pt leading (roundup or down if ¼pt leading is not available).

People like US... ...Need people like you

Lorem ipsum dolor sit amet, consectetuer adipiscing elit, sed diam nonummy nibh euismod tincidunt ut laoreet dolore magna aliquam erat volutpat. Ut wisi enim ad minim veniam, quis nostrud exerci tation ullamcorper suscipit lobortis nisl ut aliquip ex ea commodo conseguat.

Duis autem vel eum iriure dolor in hendrerit in vulputate velit esse molestie consequat, vel illum dolore eu feugiat nulla facilisis at vero eros et accumsan et iusto odio dignissim qui blandit praesent luptatum zzril delenit augue duis dolore te feugait nulla facilisi.

Lorem ipsum dolor sit amet, consectetuer adipiscing elit, sed diam nonummy nibh euismod tincidunt ut laoreet dolore magna aliguam erat Ut wisi enim ad minim veniam, quis nostrud exerci tation ullamcorper suscipitsuscipit lobortis nisl ut aliquip ex ea commodo consequat.

2 ARLENE JACOBS Lorem ipsum dolor sit amet, consectetuer adipiscing elit, sed diam honummy nibh euismod tincidunt ut aoreet dolore magna aliquam erat volutpat. Ut wisi enim ad minim veniam, quis nostrud exerci tation ullamcorper suscipit lobortis nisl ut aliquip ex ea commodo consequat. Duis autem vel eum iriure dolor in hendrerit in vulputate velit esse molestie consequat, vel illum dolore eu feugiat nulla facilisis at vero eros et accumsan et iusto odio dignissim qui blandit praesent luptatum zzril delenit

lene

1 JACK PARSONS

3 DAN RITCHIE

Lorem ipsum dolor sit amet,

consectetuer adipiscing elit, sed diam

nonummy nibh euismod tincidunt ut

laoreet dolore magna aliquam erat

volutpat. Ut wisi enim ad minim

veniam, quis nostrud exerci tation

ullamcorper suscipit lobortis nisl ut aliquip ex ea commodo consequat.

Duis autem vel eum iriure dolor in

molestie consequat, vel illum dolore

eu feugiat nulla facilisis at vero eros et

ccumsan et iusto odio dignissim qui

blandit praesent luptatum zzril delenit

hendrerit in vulputate velit esse

Rochie

Lorem ipsum dolor sit amet, consectetuer adipiscing elit, sed diam nonummy nibh euismod tincidunt ut laoreet dolore magna aliquam erat volutpat. Ut wisi enim ad minim veniam, quis nostrud exerci tation ullamcorper suscipit lobortis nisl ut aliquip ex ea commodo consequat. Duis autem vel eum iriure dolor in hendrerit in vulputate velit esse molestie consequat, vel illum dolore eu feugiat nulla facilisis at vero eros et accumsan et iusto odio dignissim qui blandit praesent luptatum zzril delenit

Choosing the right photographer,

careful planning

and confident

art-direction of

the photographic

session are all

essential if the

commissioned

photography is to

he a success

A 4pt black rule. tinted 30%, sits beneath each caption and aligns horizontally with

the bottom of the photographs. This provides a boundary for the signatures.

Less leading is required for larger headline faces than for text sizes. In this publication. headlines are set in 47/47pt - 0% leading. With

extra-large sizes even negative leading - 90/80pt, for example - might be desirable, but take care to avoid a clash of ascenders and descenders.

The case history names are set in Franklin Gothic Heavy 12/12pt.

Small bold, subheads, even when set in a different font family from the text, usually look more comfortable set at the same leading as the text.

4 BYRON CRAFT

Lorem ipsum dolor sit amet, consectetuer adipiscing elit, sed diam nonummy nibh euismod tincidunt ut laoreet dolore magna aliquam erat volutpat. Ut wisi enim ad minim veniam, quis nostrud exerci tation ullamcorper suscipit lobortis nisl ut aliquip ex ea commodo consequat. Duis autem vel eum iriure dolor in hendrerit in vulputate velit ess molestie consequat, vel illum dolore eu feugiat nulla facilisis at vero eros et accumsan et iusto odio dignissim qui blandit praesent luptatum zzril delenit

ren (reft.

Lorem ipsum dolor sit amet,

consectetuer adipiscing elit, sed diam

nonummy nibh euismod tincidunt ut

laoreet dolore magna aliquam erat

veniam, quis nostrud exerci tation ullamcorper suscipit lobortis nisl ut aliquip ex ea commodo consequat.

Duis autem vel eum iriure dolor in

molestie consequat, vel illum dolore eu feugiat nulla facilisis at vero eros et accumsan et iusto odio dignissim qui

blandit praesent luptatum zzril delenit NickMuir

hendrerit in vulputate velit esse

volutpat. Ut wisi enim ad minim

5 ROWENA BUDD

Lorem ipsum dolor sit amet, consectetuer adipiscing elit, sed diam nonummy nibh euismod tincidunt ut laoreet dolore magna aliquam erat volutpat. Ut wisi enim ad minim veniam, quis nostrud exerci tation ullamcorper suscipit lobortis nisl ut aliquip ex ea commodo consequat. Duis autem vel eum iriure dolor in hendrerit in vulputate velit esse molestie consequat, vel illum dolore eu feugiat nulla facilisis at vero eros et accumsan et iusto odio dignissim qui blandit praesent luptatum zzril deleni

Rovena Bud

Executive placement guaranteed

Lobortis nisl ut aliquip ex ea commodo consequat. Duis autem vel eum iriure dolor in hendrerit in vulputate velit esse molestie consequat, vel illum dolore eu feugiat nulla facilisis at vero eros et accumsan et iusto odio dignissim qui blandit praesent luptatum zzril delenit augue duis dolore te feugait nulla facilisi. Nam liber tempor cum soluta nobis eleifend option congue nihil imperdiet doming id quod mazim placerat facer possim assum. Lorem ipsum dolor sit amet,

consectetuer adipiscing elit, sed diam nonummy nibh euismod tincidunt ut laoreet dolore magna aliquam erat volutpat. Ut wisi enim ad minim veniam, quis nostrud exerci tation ullamcorper suscipit lobortis nisl ut aliquip ex ea commodo consequat. Duis autem vel eum iriure dolor in hendrerit in vulputate velit esse

molestie consequat, vel illum dolore eu feugiat nulla facilisis at vero eros et accumsan et iusto odio dignissim qui blandit praesent luptatum zzril delenit augue duis dolore te feugait nulla facilisi. Lorem ipsum dolor sit amet, consectetuer adipiscing elit, sed diam nonummy nibh euismod tincidunt ut laoreet dolore magna aliguam erat volutpat. Ut wisi enim ad minim veniam, quis nostrud

To reinforce the personal theme, the signatures partly overlap the photographs. They are tinted 50% black so

that they will read over the dark background of the photographs and over the 10% background tint.

The text associated with the logo is set in 11/14pt New Baskerville italic. with a 24pt headline.

THE PEOPLE FACTOR

All the case history captions sit beside their relevant photographs except number 6, which, because there is no room for it, is placed under the photograph.

Dor

Subsequent spreads should develop the layout theme, introducing variety within the constraints already established.

basic

CLIENT

BROCHURES

apanese restaurant

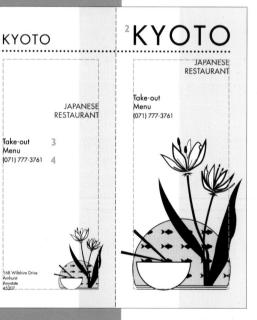

KXOTO			2	5
КҮӨТӨ			\bigcirc	
•••••••	••••••••••	•••••	•••••••••••	
DUIS AUTEM VELEUM	DUIS AUTEM VELEUM		DUIS AUTEM VEL EUM	2
LOREM IPSUM DOLOR SIT AMET 6.00 Consectetiver adipiscing elit, sed diam nonummy suismod fincidunt ut looreet dolore magna aliquam	LOREM IPSUM DOLOR SIT AMET Consectetuer adipiscing elit, sed diam nonummy puismod tincidunt ut laareet dolare magna aliquam	6.00	OREM IPSUM DOLOR SIT AMET Consectetuer adipiscing elit, sed diam nonummy puismod fincidunt ut loareet dolore magna aliquam	6.00
 ERAT VOLUTPAT 8 00	FRAT VOLUTPAT	8 oc 1	FRAT VOLUTPAT	8.00
Ut wisi enim ad minim veniam, quis nostrud exerci tation ullamcorper suscipit lobortis nisl ut	Ut wisi enim ad minim veniam, quis nostrud exerci tation ullamcorper suscipit lobortis nisl ut		Ut wisi enim ad minim veniam, quis nostrud exerci tation ullamcorper suscipit labortis nisl ut	
ALQUIP EX EA COMMODO CONSEQUAT 9.00 Duis autem vel eum iriure dolor in hendrerit in velit esse molestie consequat, vel illum dolore eu	ALKOUIP EX EA COMMODO CONSEQUAT Duis autem vel eum iriure dolor in hendrerit in velit esse molestie consequat, vel illum dolore eu	9.00	ALQUIP EX EA COMMODO CONSEQUAT Duis autem vel eum iriure dolor in hendrerit in velit esse molestie consequat, vel illum dolore eu	9.00
FEUGIAT NULLA FACILISIS 4.50	FEUGIAT NULLA FACILISIS	4.50	FEUGIAT NULLA FACILISIS	4.50
At vero eros et accumson et iusto odio dignissim qui blandit proesent luptatum zzril delenit augue	At vero eros et accumsan et iusto odio dignissim qui blandit proesent luptatum zzril delenit augue		At vero eros et accumsan et iusto odio dignissim qui blandit proesent luptatum zzril delenit augue	
I'E FEUGAIT NULLA FACILISI 5.50 Jorem ipsum dolor sit amet, consectetuer adipiscing and diam nonummy nibh euismod tincidunt ut looreet	ITE FEUGAIT NULLA FACILISI Jorem ipsum dolor sit amet, consectetuer adipiscing jed diam nonummy nibh euismad tincidunt ut laoreet	5.50	TE FEUGAIT NULLA FACILISI Lorem ipsum dolor sit arnet, consectetuer adipiscing led diam nonummy nibh euismad tincidunt ut laoreet	5.50
DOLORE MAGNA ALKQUAM ERAT VOLUTPAT 8.00 Ut wisi enim ad minim veniam, quis nostrud exarci laullamcorper suscipit labortis nisi ut aliquip ex ea	DOLORE MAGNA ALIQUAM ERAT VOLUTPAT Ut wisi enim od minim veniam, quis nostrud exerci taullamcorper suscipit lobortis nisi ut aliquip ex ea	8.00	OCLORE MAGNA ALKOUAM ERAT VOLUTPAT Ut wisi enim od minim veniam, quis nostrud exerci taullamcorper suscipit lobortis nisl ut aliquip ex ea	8.00
CONSEGUA 8.00 Duis outem vel eum iriure dolor in hendrerit in velit esse molestie conseguat, vel illum dolore eu	CONSEGUA Duis autem vel eum iriure dolor in hendrerit in velit esse molestie consequat, vel illum dolore eu	8.00	CONSEQUA Duis autem vel eum iriure dolor in hendrerit in velit esse molestie consequat, vel illum dolore eu	8.00
NULLA FACILISIS AT VERO EROS 10.00	NULLA FACILISIS AT VERO EROS	10.00	NULLA FACILISIS AT VERO EROS	10.0d
Et accumsan et iusto adio dignissim qui blandit uptaaugue duis dolore te feugait nulla	Et accumsan et iusto adio dignissim qui blandit Iuptaaugue duis dolore te feugait nulla		Et accumsan et iusto odio dignissim qui blandit uptaaugue duis dolore te feugait nulla	
 FACILISI NAM LIBER TEMPOR 11.00	FACILISI NAM LIBER TEMPOR	11.00	FACILISI NAM LIBER TEMPOR	11.00
Cum soluta nobis eleifend option congue nihil Imperdiet doming id quod mazim placerat facer	Cum soluta nobis eleifend option congue nihil imperdiet doming id quod mazim placerat facer		Cum soluta nobis eleifend option congue nihil Imperdiet doming id quod mazim placerat facer	
POSSIM ASSUM 6.50 Lorem ipsum dolor sit amet, consectetuer adipiscing elitsed diam nonummy nibh euismod	POSSIM ASSUM Jorem ipsum dolor sit amet, consectetuer adipiscing elitsed diam nonummy nibh euismod	6.50	POSSIM ASSUM forem ipsum dolor sit amet, consectetuer adipiscing elitsed diam nonummy nibh euismod	6.50
DOLORE MAGNA ALQUAM ERAT VOLUTPAT 12.50 Ut wisi enim ad minim veniam, quis nostrud exerci ultamcarper suscipit labortis nisl ut aliquip ex eq	DOLORE MAGNA ALQUAM ERAT VOLUTPAT Ut wisi enim ad minim veniam, quis nostrud exerci ullamcorper suscipit lobortis nisl ut aliquip ex ea	12.50	DOLORE MAGNA ALKQUAM ERAT VOLUTPAT Ut wisi enim ad minim veniam, quis nostrud exerci ullamcarper suscipit lobortis nisl ut aliquip.ex.ea	12.50
		i		

The inside spread.

SPECIFICATIONS

Format

8½ x 11in or A4 3 panels, 3-fold

Grid 3-column Space between: Inside spread – 2p11 Outside spread – 6p

Margins

i2pll o2pll t6p b2pll

Font

Futura

Track loose Body text 8%/1

- I Body text 8½/10½pt
 2 Logo 54pt, 27pt
- Subheads
- 3 15/18pt
- 4 12/18pt
- 5 12/14¹/₂pt

BRIEF Kyoto is an established Japanese restaurant that is introducing a take-out service in addition to its existing eat-in facilities. This has presented an opportunity to update the identity. The name Kyoto is set in the typeface Futura, a very clean sansserif face with a perfectly symmetrical letter O, and this is combined with a dot underline, which runs across the width of the restaurant's name board. The take-out menu has fewer dishes than the main one, and it needs to be compact and reasonably cheap to produce in fairly large quantities.

SOLUTION A single sheet, horizontal format, folded twice has been selected for its portability and low cost. Printing is two color on the cover and outside, with black only on the inside spread. The stock is #68 uncoated cream with a random speckle, and is 75% recycled. The menu has a rolling fold, as opposed to an accordion pleat, so the panels forming the front and back covers are adjacent. An illustration, in the style of the internal decor, has been drawn to decorate the front and back covers.

3 Abc

 Butem vel eum iriure do lor in hen dre rit in vulp utate velit esse illum The left and right margins and the space between columns are all equal – 2p I I. This looks visually balanced, but with three panels of equal width the folds do not come in the middle of the column spaces. This does not matter on the inside spread, which opens out flat to be read, but it will not be acceptable on the other side of the menu. The column spaces on the outside of the menu will need to be 6p, twice the width of those on the inside, as they will be seen wholly or at least partly folded. The middle panel will form the back cover when the sheet is fully folded. The name and phone number are repeated with the addiction of the address at the bottom.

JAPANESE

RESTAURANT

On both sides of the menu the layout is anchored by the 3pt horizontal, dotted rule, which is centered on a line 7p8 from the top of the page. The

KYOTO

JAPANESE RESTAURANT

menu text hangs Ip5 below it, and the logo and phone number sit Ip5 above the rule.

Take-out Menu **KYOTO** (071) 777-3761 DUIS AUTEM VEL EUM \$ 6.00 LOREM IPSUM DOLOR Consectetuer adipiscing elit, sed diaeuismod tincidunt ut laoreet dolore magna aliquam ERAT VOLUTPAT 8.00 Ut wisi enim ad minim veniam, quis exerci tation ullamcorper suscipit lob 9.00 ALIQUIP FX FA COMMODO Duis autem vel eum iriure dolor in hendrerit in velit esse molestie consequat, vel illum dolore eu 5.00 FFUGIAT NULLA FACILISIS At vero eros et accumsan et iusto odio blar dit praesent luptatum zzril delenit augue Take-out Menu TE FEUGAIT NULLA FACILISI 5.50 Lorem ipsum dolor sit amet, consectetu (071) 777-3761 sed diam nonummy nibh euismod tincidu DOLORE MAGNA ALIQUAM FRAT 8.00 Ut wisi enim ad minim veniam, quis no taullamo orper suscipit lobortis nisl ut aliquip ex ea CONSEQUA Duis autem vel eum iriure dolor in hendrerit 8.00 velit esse molestie consequat, vel illum NULLA FACILISIS AT VERO FROS 10.00 Et accumsan et iusto odio dignissim qui blandit luptaaugue duis dolore te feugait nulla FACILISI NAM LIBER TEMPOR Cum soluta nobis eleifend option congue imperdiet doming id quod mazim placerat 11.00 POSSIM ASSUM Lorem ipsum dolor sit amet, consectetue elitsed diam nonummy nibh euismod 6.50 168 Wiltshire Drive DOLORE MAGNA ALIQUAM ERAT 12.50 Amhurst Ut wisi enim ad minim veniam, quis nostrudull amcorper suscipit lobortis nisl ut aliquip ex ea Anystate 45207

The left panel will be tucked inside when the sheet is folded. The wider column spaces mean that the menu column will be narrower than on the inside spread. Make sure that neither the dish name nor description extends too close to the price column.

All menu entries should be three lines deep with one line space between. Amhurst Anystate 45207 On both the front and back panels a

further two lines

space is left

between the

subheads.

The illustration is repeated at 40% of the size that it is used on the front panel, and the color tint panel runs behind in the same relative position as on the front. The front panel is on the right, and, with a rolling fold, the other two panels tuck inside it. The panel at the far left will need to be a fraction smaller, which can be accommodated in the design or the printer can adjust the folding to allow for it.

The color tint panel would look uncomfortable if it did not perfectly bisect the middle O of Kyoto. However, this O is not in the actual center of the panel. This small difference will not be noticed.

intermediate BROCHURES

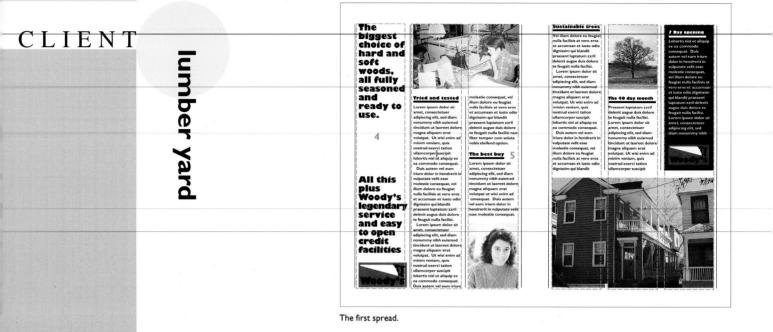

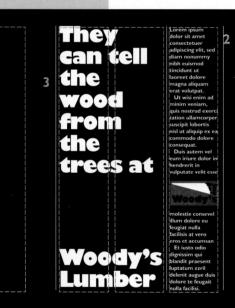

SPECIFICATIONS

Format 6 x 9in or A5 16 pages, saddle-stitched

Grid

- 3-column Space between – 1p2
- Margins
- i2pll o2pll t2pll b2pll
- Fonts
- Gill Sans Bold
- Track normal
- I Body text 81/2/101/2 pt
- 2 Introduction 12/14pt
- Gill Sans Ultra Bold
- 3 Cover 45/45pt
- 4 Spread heading 18/18pt
- 5 Subhead 9/101/2 pt

BRIEF Woody's is a popular local lumber yard, long established and proud of its reputation for service and its extensive range of wood. It has refurbished its premises and at the same time commissioned a new identity and a sales brochure to supplement the rather prosaic catalogue that is currently the only publication it produces. It is a family business, and although the original Woody died many years ago, the founder's personality lives on. This has proved a successful formula in the past and should be reflected in the new publication.

SOLUTION A 16-page brochure in a 6 x 9in/A4 format is proposed, and this will be displayed in dispensers at the check-out counter, as well as being mailed to potential customers. Headlines and text are in a chatty style, and the layout is bold, using plenty of solid black areas with dropped-out white type. The new logo is used extensively. White, 100% recycled, uncoated stock has been chosen, with the four-page cover on #93 and the 12 pages of text on #68. It will be printed as eight pages full-color with the remainder, including the cover, black only. This is effective and economical.

I Butem vel eum iriure do lor in hen dre rit in vulp utate velit esse illum The text throughout is set in Gill Sans Bold, which reinforces the robustness of the design. It also allows bold, 1pt column rules to be used. The work of novice designers is often marred by

the use of bold column rules with light type, which results in a clumsy layout.

The cover immediately establishes the design styling. The Gill Sans Ultra Bold head, dropped-out white on a solid black background, is just about the boldest possible combination.

The heading, occupies the lefthand and center columns. It is ranged left and stacked, a style that is followed on subsequent pages,

but with the headings set in a smaller size and in a single column.

Lorem ipsum dolor sit amet consectetuer adipiscing elit, sed 1 C diam nonummy nibh euismod tincidunt ut laoreet dolore magna aliquam erat volutpat. Ut wisi enim ad minim veniam, quis nostrud exerci tation ullamcorper suscipit lobortis nisl ut aliquip ex ea commodo dolore consequat. Duis autem vel eum iriure dolor in ees at

3

hendrerit in vulputate velit esse

molestie consevel illum dolore eu feugiat nulla facilisis at vero eros et accumsan Et iusto odio dignissim qui blandit praesent luptatum zzril delenit augue duis dolore te feugait nulla facilisi.

The black background extends over the back cover, where the logo and address details in the outer column are enclosed within

Noody

Tel (666) 777-3761 Fax (666) 777-3762

two rules. "Black" space can be as effective as white space in creating a dramatic layout.

The uncoated stock will give the 16-page brochure considerable bulk. but the print quality will not be as good as on a coated paper. Uncoated stock was chosen because it is appropriate for the subject matter the brochure will have a chunky look and feel – and also because it is cheaper. The choice of stock is one of the most important factors in the creation of any publication. Paper merchants will be

only too pleased to send you samples, and some will even make up blank dummies for you, free of charge.

• I •)

Positioning the logo just below the center of the page establishes a grid line that will feature throughout the publication. Although this is not as dominant as a hangline, a publica-

tion such as this, in which each spread has a different layout, will benefit from having a constant point of reference.

67

intermediate BROCHURES

The left-hand column is reserved for the headline. Following the style established on the front cover, it is separated into two statements. The headline face, Gill Sans Ultra Bold, has unusuallysmall ascenders, so the top of the x-height does not provide a clearly

Sustainable trees

Vel illum dolore eu feugiat nulla facilisis at vero eros

et accumsan et iusto odio

praesent luptatum zzril

delenit augue duis dolore te feugait nulla facilisi.

Lorem ipsum dolor sit

adipiscing elit, sed diam

nonummy nibh euismod

tincidunt ut laoreet dolore

volutpat. Ut wisi enim ad

dignissim qui blandit

amet, consectetuer

magna aliquam erat

minim veniam, quis

nostrud exercitation

ullamcorper suscipit

lobortis nisl ut aliquip ex

ea commodo conseguat.

iriure dolor in hendrerit in

Duis autem vel eum

molestie conseguat, vel

illum dolore eu feugiat

dignissim qui blandit

nulla facilisis at vero eros

et accumsan et iusto odio

vulputate velit esse

defined line on which to range text horizontally. In this instance headlines and text are ranged on the top of the cap-height.

The 40 day month

Praesent luptatum zzril

delenit augue duis dolore te feugait nulla facilisi.

Lorem ipsum dolor sit

adipiscing elit, sed diam

nonummy nibh euismod

tincidunt ut laoreet dolore

utpat. Ut wisi enim ad

amet, consectetuer

magna aliguam erat

minim veniam, quis

nostrud exerci tation

ullamcorper suscipit

The biggest choice of hard and soft woods, all fully seasoned and ready to use.

All this plus Woody's legendary service and easy to open credit facilities

Duis autem vel eum iriure

When a subhead

Tried and tested

Lorem ipsum dolor sit

molestie consequat, vel illum dolore eu feugiat nulla facilisis at vero eros et accumsan et iusto odio dignissim qui blandit praesent luptatum zzril delenit augue duis dolore te feugait nulla facilisi nam liber tempor cum soluta nobis eleifend option.

The best buy

Lorem ipsum dolor sit amet, consectetuer adipiscing elit, sed diam nonumny nibh euismod tincidunt ut laoreet dolore magna aliguam erat volutpat ut wisi enim ad consequat. Duis autem vel eum iriure dolor in hendrerit in vulputate velit esse molestic consequat.

falls in the middle of a column, the total space it and the rule occupy is $31\frac{1}{2}$ points – that is, $3 \times 10\frac{1}{2}$ pt. This ensures that the text aligns in all columns. Some DTP programs have a vertical justification function that will adjust the leading to ensure that all columns align at the foot. A more professional approach is to spend time making sure that all spaces, headings, and rules add up to multiples of the text leading. They will then align properly.

The subheads have a thick, 4pt black rule beneath them. This is set to the width of each head and sits on a line 6 points below the baseline of the head. Make sure that subheads do not align horizontally across the spread, particularly in adjacent columns. Like the subheads, photographs should be staggered across the spread to create an asymmetric yet balanced layout. The first spread starts on the inside front cover. Although the cover stock is #169 and the text is printed on #68, this is acceptable because they are different weights of the same stock.

Lobortis nisl ut aliqu ex ea commodo consequat. Duis autem vel eum iriur

dolor in hendrerit in vulputate velit esse molestic consequat, vel illum dolore eu feugiat nulla facilisis at vero eros et accumsar et iusto odio dignissim qui blandit praesent luptatum zzrii delenit augue duis dolore te feugait nulla facilisi. Lorem ipsum dolor sii amet, consectetuer adipiscing elit, sed diam nonummy nibb

7 Day opening

A one-line space has been left between the bottom of the text and the picture, and the picture is ranged with the top of the cap-height. When the text is below a picture, a one-line space is left, and the picture aligns with the baseline of the

previous line. Boxed text is used occasionally to highlight a piece of text and to add variety to the layout.

The logo is repeated rather more often than usual. In this, the first publication to use

the new identity, this repetition will help to establish the new image.

ectet

am erat

at, ve

na aliquam erat Itpat. Ut wisi enim ad n, quis Duis m vel eum iriure

r in hendrerit in utate velit esse

trud everci tation

et. consectetue ipiscing elit, sed dia nmy nibh euis t ut laoreet de

scing elit, sed diam onummy nibh euismoo ncidunt ut laoreet dol

tpat. Ut wisi enim ad

m veniam, quis

n ipsum dolor sit et. consectetuer

cing elit, sed diam

nmy nibh euisr

One for one hard wood re-planting scheme ensures supply of timber can be sustained with no ecological damage

Sawn or planed. ood 5 G you the videst choice of grain and width

Woody

The logo is repeated at the foot of the headline column. This feature is used consistently throughout the brochure and also at the head of the caption column.

The photographs butt together, which adds visual impact by creating a single mass. When you butt pictures in this way, make sure that the images do not appear to run

into each other, and only do it when they form a symmetrical block. An alternative is to leave a 1 or 2 pt space between pictures.

In a 16-page publication different layouts can be used to add variety and change the pace. Here the doublepage spread, with its black, bleed background, is used to dramatic effect.

The caption heads do not have rules beneath them because rules would look clumsy under two lines of text. The caption heads are set in 9/101/2 pt, and the

captions themselves are in 81/2/101/2 pt, with an additional 7pt space after the last line of the caption. The pictures are keyed in by number to the captions.

Intermediate BROCHURES

insurance broker

CLIENT

A Shand Davy broker is trained to think on his feet.

A Shand Davy insurance broker 2 is a man of many parts

There influences are subject to the second s

SPECIFICATIONS

Format

The folded cover panel

8½ x 11in or A4 3-panel, 2-fold **Grid**

4-column Space between – 1p10

Margins i 2p11 o 2p11 t 2p11 b 2p11

Fonts Century Old Style

Track loose

- I Body text 11/15pt2 Headline 30/36pt
- 3 Subhead 12pt
- Century Old Style bold Track very loose
- 4 Logo 16pt

BRIEF Shand Davy, an insurance broker with 30 branches, sells mostly domestic, building, and automobile insurance. The competition for business – from banks, from insurance companies themselves, and from other brokers – is fierce, and Shand Davy feels compelled to embark on a campaign to win new business. A direct mail shot will form part of this strategy. It will need to stress the independence of the advice given – the fact that Shand Davy can offer policies from a range of companies and is not tied to one company, so that policies can be more closely tailored to the clients' individual needs.

SOLUTION A single sheet, rolling-fold leaflet has been chosen. The inside spread opens out to read vertically, and the leaflet is both convenient for mailing and offers an unusual format to catch the attention. The folded leaflet will be dispatched in a standard-size envelope. Commissioned photographs of a mime artist create the visual theme to support the headline, which expresses Shand Davy brokers' versatility and flexibility. The fairly large amount of text is broken up by the photographs. Full-color printing is used on a lightweight, #57, gloss-coated stock.

Abc

 Butem vel eum iriure do lor in hen dre rit in vulp utate velit esse illum A two-fold leaflet is normally used in a horizontal format, providing three

The cover (opposite) will form the

bottom panel on the reverse of the leaflet so that the

text orientation remains the same as it is unfolded.

The headline is set

in Century Old

extended face.

which fills the

type area.

Although the

space to within

about 2p11 of the

headline could be

made to fit the

maximum width

more impact with

this extra space on

The text is set in

11/15pt Century

Old Style, and it has

been positioned so

that the folds come

text. Achieving this

between lines of

requires some

it is worth the

is sometimes

although this is

outside fold.

more likely on an

experimentation

with the leading, but

effort because type

broken up by a fold,

exactly, it has

either side.

Style bold, a fairly

vertical panels. The vertical format and horizontal folds used here offer an

opportunity to create an unusual layout. Front cover.

A Shand Davy insurance broker is a man of many parts

Lorem ipsum dolor sit amet, consectetuer adip iscing elit, sed diam nonummy nibh euismod tincidunt ut laoreet dolore magna aliquam erat volutpat. Ut wisi enim ad minim veniam, quis nostrud exerci tation

ullamcorper suscipit lobortis nisl ut aliquip ex ca commodo consequat. Duis autem vel eum iriure dolor in hendrerit in vulputate velit esse molestie consequat, vel illum dolore eu feugiat nulla facilisis at vero eros et accumsan et iusto odio dignissim qui blandit praesent luptatum zzril delenit augue duis dolore te feugait nulla facilisi.

Lorem ipsum dolor sit amet, consectetuer adipiscing elit, sed diam nonummy nibh euismod tincidunt ut laoreet dolore magna aliquam erat volutpat. Ut wisi enim ad minim veniam, quis nostrud exerci tation ullamcorper suscipit lobortis nisl ut commodo iriure dolor consequat.

Duis autem vel eum iriure dolor in hendrerit in vulputate velit esse molestie consequat, vel illum dolore eu feugiat nulla facilisis at vero eros et accumsan et iusto odio dignissim qui blandit praesent luptatum zzril delenit augue duis dolore

te feugait nulla facilisi. Nam liber tempor cum soluta nobis eleifend option congue nihil imperdiet doming id quod

mazim placerat facer

Lorem ipsum dolor sit

adipiscing elit, sed diam

nonummy nibh euismod

tincidunt ut laoreet dolore

Ut wisi enim ad minim

eniam, quis nostrud exerci

amet, consectetuer

magna aliquam erat

volutpat.

possim iriure dolor assum.

tation ullamcorper suscipit lobortis nisl ut aliquip ex ea commodo consequat. Duis autem vel eum iriure dolor in hendrerit in vulputate velit esse molestie consequat, vel illum dolore eu feugiat nulla facilisis at vero eros et accumsan et iusto odio dignissim qui blandit praesent luptatum zzril delenit augue duis dolore te feugait nulla facilisi.

Lorem ipsum dolor sit amet, consectetuer adipiscing elit, sed diam nonummy nibh euismod tincidunt ut laoreet dolore magna aliquam erat volutpat. Ut visi enim ad minim veniam, quis nostrud exerci tation ullamcorper suscipit lobortis nisl ut aliquip ex ea commodo consequat duis autem vel eum iriure dolor in hendrerit in vulputate velit esse molestie consequat, vel illum dolore eu feugiat praesent luptatum zril delenit augue duis dolore

tincidunt ut laoreet dolore magna aliquam erat Nulla facilisis at vero

eros et accumsa a vero odio dignissim qui blandit praesent luptatum zzril delenit augue duis dolore te feugait nulla facilisi.

Lorem ipsum dolor sit amet. consectetuer adipiscing elit, sed diam nonummy nibh euismod tincidunt ut laoreet dolore magna aliquam erat volutpat. Ut wisi enim ad minim veniam, quis nostrud exerci tation ullamcorper suscipit lobortis nisl ut aliquip ex ea commodo consequat. tincidunt ut Duis autem vel eum iriure dolor in hendrerit in vulputate velit esse molestie consequat, vel illum dolore eu feugiat

SHAND DAVY

Service is our best policy

This text has been indented to allow for the photograph. It could have run around the shape of the picture, and if you are using DTP software, running text around shapes is easy. If you are not using a DTP program, an accurate cast-off, and a little trial and error, will be necessary. The logo is set in 16pt Century Old Style bold with very loose track, while the headline and text are both set loose. In general, capital letters, especially serif capitals, require more letter space to allow for the variations in spacing required to produce visually even spacing. Note how the V and Y almost touch, yet the A and V are quite far apart. The logo is always accompanied by this strap line. The folded leaflet will be despatched in a standard size envelope. The text runs around the cut-out photographs. Take care with the line breaks so that no ugly holes are left, and so that, of course, the resulting text reads well.

The main purpose of a layout is to persuade the reader to read the text. This design relies on the visual interest created by the off-beat photographs to offset the large unbroken run of text. Subheads could be added but they might compete for attention with the photographs.

intermediate BROCHURES

medium-sized college

CLIENT

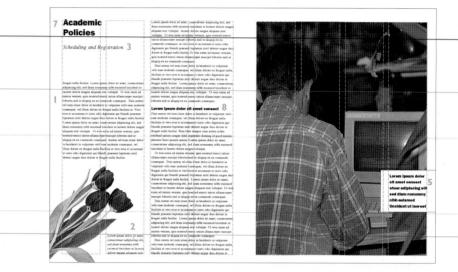

A typical spread.

, Abc

Butem vel eum iriure do lor in hen dre rit in vulp utate velit esse illum **S**PECIFICATIONS

Format

6 x 9in or A5 4-page cover, perfect-bound 32 pages 4-color, 32 pages black Printed 4/1

Grid

- 4-column Space between – 1p2
- Margins i 2p2 o 2p2
- t 2p2 b 2p2

Fonts Times Roman

- Track loose
- I Body text 7/9pt Times italic
 - Track loose
- 2 Captions 7/9pt
- 3 Subhead I2pt
- Franklin Gothic Heavy Track loose
- Cover headlines 4 42pt
- 5 18pt
- 6 Cover intro and quote 8½/13pt
- 7 Spread headline 18/21pt
- 8 Subhead 81/2 pt

,

BRIEF Langton Wells is a medium-sized college offering a wide range of courses, although its reputation is based mainly on the excellence of its science faculty. A new brochure/prospectus giving detailed descriptions of the courses on offer is commissioned annually. The format can vary from year to year, but the objective remains the same: to attract new students. The design should be dynamic and youthful, therefore, but should also be capable of delivering a considerable amount of complex information.

SOLUTION A 6 x 9in / A5 format with a substantial 64 pages of text printed on #68 silk finish, coated paper has been selected. This extent, with a four-page, laminated, #111 cover, enables perfect (square-backed) binding to be used. The outside cover and 32 pages of text are printed in full color; the remainder is printed black. The brochure's theme is established on the cover in the form of an unfinished statement – a formula, a quotation, or a bar of music – which will be used for section breaks. This is combined with an appropriate illustration or photograph in the background. Typography of the text is clean and strong.

The cover will be critical in forming the reader's first impression. The overall design, layout style, choice of typeface, illustration, and color all

contribute to the look that will be followed throughout the entire prospectus.

A drop shadow prints 60% black over the illustration.

A typical inside spread (see opposite) will have two pictures and at least one subhead to break up the text. Where appropriate, pictures smaller than the full page should be cut out, with the caption fitting into the available space. If a squared-up picture is used, the caption should be broken into two equal blocks and placed side by side. Every 6-8 pages a full-page picture of a college activity will be used. This will feature an inset, boxed quotation from a student. Devices of this kind are essential to enliven a long publication. The spread headings always hang from the top line of the grid. The Times Italic subhead aligns with the seventh line of text. The text extends over two columns. and the first line aligns with the

fifteenth line of text.

comodo consequat duis autem vel eum. EXCELLENCE AT LANGTON WELLS COLLEGE

> The illustration of Einstein, with his head to one side, contrasts with the otherwise very angular layout of the other elements and emphasizes his benign expression.

The background colors have been selected so that both white and black headlines will read clearly. They butt together, with one ranging to the left, the other to the right.

50% yellow. 50% magenta. 75% cyan.

Lorem ipsum dolo

sit amet consect

etuer adipiscing elit

sed diam nonummy

tincidunt ut laoreet

aliquam at volutpat.

minim veniam quis

tation ullamcorper

nisl ut aliquip ex ea

suscipit lobortis

nibh euismod

dolore magna

Ut wisi enim ad

nostrud exerci

35% yellow. 35% magenta. 50% cyan.

The stylized illustration of Albert Einstein is reproduced in two colors that, although different in hue, are similar in tone, and this provides a muted background to the "E=." To emphasize the unfinished nature of the equation, the conclusion -Excellence - is positioned at the bottom of the page. The space also contributes to the success of the idea, as does the recessive nature of the illustration. If it had been reproduced in stronger colors, the image would have dominated this space and damaged the layout. The "E=" is filled with a subtle graduated tone, created by laying magenta – 10% at the top and 30% at the bottomon a flat tint of 10% yellow.

The introduction sits on a line ranged with the top of the headline.

advanced BROCHURES

horseback riding school

CLIENT

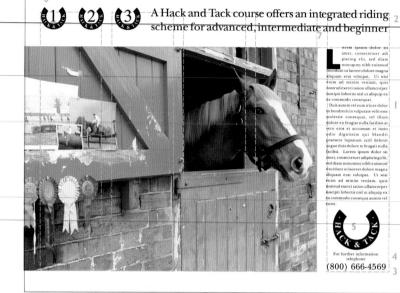

A Hack and Tack course offers an integrated riding scheme

for advanced, intermediate and

- **Fonts** New Baskerville Track loose
 - I Body text 9/11pt Headlines

The first spread.

81/2 x 11 in or A4

Format

(landscape)

Grid

5-column

Margins i 2p11 o 4p7

t 2pll b 4pl

SPECIFICATIONS

20 pages, saddle-stitched

Space between - Ip10

- 2 Cover 36/42pt
- 3 Spread 24/29pt
- 4 Phone number/Box 18pt
- 5 Information 9/10pt
- **Times Bold** Track force justify
- 6 Logo 18pt
- 7 Logo numerals 37pt Franklin Gothic Heavy
- 8 Drop cap 60pt

BRIEF Hack & Tack are franchised riding schools, usually situated in the countryside close to the suburbs. They offer training in all aspects of riding and horse care, organized in three levels of expertise. Exploiting the popularity of riding, Hack & Tack aim to keep ahead of competition by publishing a "glossy" brochure promoting their basic, intermediate, and advanced riding instruction. This strategy also includes the creation of a new visual identity, for which a considerable budget has been established.

SOLUTION An 8½ x 11in / A4 format, but used horizontally, has been selected because it offers an opportunity for the impressive use of numerous, specially commissioned photographs, and allows the headlines to spread across the top of the page. A new logo, which will also be used on posters, key rings, and so on, has been devised. This not only incorporates the three skill levels, but is also used in perspective form on the cover, where the "hoof prints" will be embossed into a mat-laminated, #130 cover stock, printed in two colors. The 16-page text section is printed in full color on #118 silk-finish coated, 75% recycled stock.

Abc

Butem vel eum iriure do lor in hen dre rit in vulp utate velit esse illum

The horizontal format offers an opportunity for some expansive layout. The text will start on the right-hand page because the inside front cover will bear the impression of the embossed "hooves" showing through from the front. The inside of the cover, back and front, and the back cover will be printed a dark green.

The logo has been created so that it can be adapted to contain the numerals I, 2 and 3 to indicate the three levels. These are set in 37pt Times roman.

The layout makes use of a strong hangline. Above the hangline are the spread heads and the logos indicating the level of the course.

A Hack and Tack course offers an integrated riding scheme for advanced, intermediate and beginner

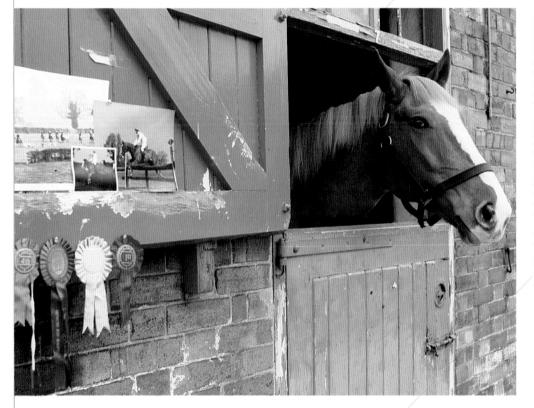

orem ipsum dolor sit amet, consectetuer adi piscing elit, sed diam nonummy nibh euismod tincidunt ut laoreet dolore magna aliquam erat volutpat. Ut wisi enim ad minim veniam, quis nostrud exerci tation ullamcorper suscipit lobortis nisl ut aliquip ex ea commodo consequat.

Duis autem vel eum iriure dolor in hendrerit in vulputate velit esse molestie consequat, vel illum dolore eu feugiat nulla facilisis at vero eros et accumsan et iusto odio dignissim qui blandit praesent luptatum zzril delenit augue duis dolore te feugait nulla facilisi. Lorem ipsum dolor sit amet, consectetuer adipiscing elit, sed diam nonummy nibh euismod tincidunt ut laoreet dolore magna aliquam erat volutpat. Ut wisi enim ad minim veniam, quis nostrud exercitation ullamcorper suscipit lobortis nisl ut aliquip ex ea commodo consequa autem vel

 $(800) \begin{array}{c} 666-4569 \end{array}$

The cover is entirely graphic without any photographs. The temptation to use a large, bleed photograph was strong, but it was resisted because the design is very dramatic and unconventional and helps to establish Hack & Tack's completely new approach in creating and marketing a franchised riding school: It will also be adapted for use on posters. The logos on the cover were created using the perspective function of a graphics program, which is the only practical way of achieving this effect. If this option is not available, try using the sequence without the perspective, but still. travelling from top right to bottom left. Apart from the logo and drop cap, all other copy is set in New Baskerville. This is similar to Times but is more extended, which makes it a more appropriate face for the extreme width of the headlines. The logo, set in Times bold, which works better in the semicircle than New Baskerville, will be used for many years to come. New Baskerville, however, may be superseded by other typefaces in future publications.

The master logo is simply formed by creating a black circle and a smaller overlapping white circle. A larger, white quartercircle cuts into the black one to form the horseshoe.

advanced BROCHURES

The single logo indicating the level appears on the lefthand page only. When circular or irregular objects are ranged with a

The drop cap is set in Franklin Gothic Heavy, a very bold sans serif face, which contrasts strongly with all the other copy. <u>Because the text</u> does not always start immediately below the related headline, the drop cap signifies that a new text theme has begun. Conversely the absence of a drop cap implies that the text continues from the previous page.

aliquam erat volutpat. Ut wisi

enim ad minim veniam, quis

nostrud exerci tation ullam

corper suscipit lobortis nisl ut

Dolor in hendreo vulputate

velit esse molestie consequat, vel

illum dolore eu feugiat nulla

facilisis at vero eros et accumsan

et iusto odio dignissim iriure

dolor in hendrerit in vulputate

velit esse molestie consequat, vel

illum dolore eu feugiat nulla

facilisis at vero eros et accumsan

luptatum zzril delenit augue duis dolore te feugait nulla facilisi.

Nam liber tempor cum soluta

nobis eleifend option congue

nihil imperdiet doming id quod

mazim placerat facer possim

Dignissim qu bland praesent

aliquip ex iriure

et iusto odio

Hack and Tack Level 2 Intermediate program for riders wishing to improve their skills

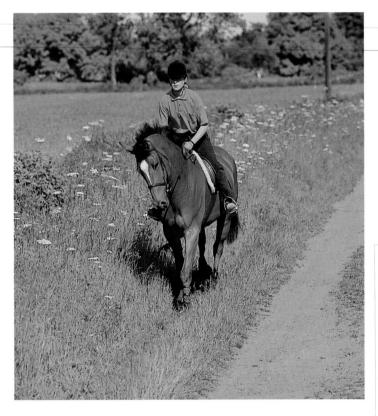

orem ipsum dolor sit amet, consectetuer adi piscing elit, sed diam nonummy nibh euismod tincidunt ut laoreet dolore magna aliquam erat volutpat. Ut wisi enim ad minim veniam, quis nostrud exerci tation ullamcorper suscipit lobortis nisl ut aliquip ex ea commodo conseouat.

Duis autem vel eum iriure dolor in hendrerit in vulputate velit esse molestie consequat, vel illum dolore eu feugiat nulla facilisis at vero eros et accumsan etiusto odio dignisism qui blandit praesent luptatum zzril delenit augue duis dolore facilisi.

Lorem ipsum dolor sit amet, consectetuer adipiscing elit, sed diam nonummy nibh euismod tinciduntut laoreet dolore magna

The headlines on inside pages are ranged left. They should not extend to the full width of the page, even though the space is available, because such long headlines would be both ugly and difficult to read. The smaller pictures align across the gutter. Although this is not a feature of the design, it is unattractive to see pictures that almost, but not quite, align. If perfect alignment is not possible, it is better to arrange the illustrations so that they do not align at all. The top of the 60pt drop cap ranges with the picture and the top of the x-height of the first line of text. The bottom of it ranges with the baseline of the fourth line of text. The text is set in 9/ I 2pt New Baskerville with loose track, which gives the page a light, open look. Less leading and closer letter spacing would result in a less desirable, heavier, and more dense appearance.

A light green box (50% yellow, 20% cyan) containing a summary of the course appears at the end of each section, and the logo and telephone number always appear beneath it. The heading and text in the box are set within margins of Ip. The I8pt heading and 9/I2pt text are both set in New Baskerville and ranged left.

A structured course consisting of jumping, crosscountry riding and horse-care for owner-riders

orem ipsum dolor sit amet, consectetuer adi piscing elit, sed diam nonummy nibh euis mod tincidunt ut laoreet dolore magna aliquam erat volutpat. Ut wisi enim ad minim veniam, quis nostrud exerci tation ullamcorper suscipit lobortis nisl ut aliquip ex ea commodo consequat.

Duis autem vel eum iriure dolor in hendrerit in vulputate velit esse molestie consequat, vel illum dolore eu feugiat nulla facilisis at vero eros et accumsan etiusto odio dignissim qui blandit praesent luptatum zzril delenit augue duis dolore facilisi.

Lorem ipsum dolor sit amet, consectetuer adipiscing elit, sed diam nonummy nibh euismod tincidunt ut laoreet dolore magna aliquam erat volutpat ut wisi enim ad minim veniam, quis nostrud exercitation ullamcorper suscipit lobortis nisl ut aliquip ex ea iriure dolor in hendrerit in vulputate velit esse molestie consequat, vel illum dolore eu

Feugiat nulla facilisis at vero eros et accumsan et iusto odio dignissim qui blandit praesent luptatum zzril delenit augue duis dolore te feugait nulla facilisi. Nam liber tempor cum soluta nobis eleifend option congue nihil imperdiet doming id quod mazim placerat facer possim assum. Lorem ipsum dolor sit

In Brief

Iriure dolor in hendrerit in vulputate velit esse molestie consequat, vel illum dolore eu feugiat nulla facilisis at vero eros et accumsan et iusto odio dignissim qui blandit praesent luptatum zzril delenit augue duis dolore te feugait nulla facilisi. Nam liber tempor cum soluta nobis eleifend option congue nihil imperdiet doming id quod mazim placerat facer possim assum. Lorem ipsum dolor sit amet, consectetuer adipiscing elit, sed diam nonumm nibh euismod tincidunt ut laoreet dolore magna aliquam erat volutpat. Ut wisi enim ad minim veniam, quis nostrud

The space between columns and between photographs is a generous 1p10. The five-column grid allows the layout of a double page spread to have some flexibility – one full or two part-full columns of text, and a variety of picture sizes and shapes, for example –but it is a fairly rigid framework that will give the publication a strong, unified style. There are no absolute rules for using grids; sometimes a very regimented design will work, while on other occasions a looser framework will be appropriate - it all depends on the function of the publication, the target audience, the size and number of pages and, of course, the flair shown by the designer in putting it all together.

advanced BROCHURES

travel company

CLIENT

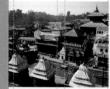

HONG KONG Corrent jesum skoke sit anert, convertenere aslip inclug efte, soch nommung nihlt existend introductor ut jässeret dokor nangua ala errera volkgatt. Ot visie erning al nindis restim, gain noration tiannon statuncopre sancepat kolocusi issal et alangen es es a conser convergeat. Das assesses et end nindi moli kon hendretta na visilerette ere molente conseguat, kei di mutanta en disente conseguat, kei di mu-

NEPAL Jorney types do not server, ser

SPECIFICATIONS

BE WISE, BE SMART

BEFORE YOU START

WITH TRAVELWISE

TRAVELWISE

CHECK IT OUT

Format

8½ x 22in or A4 (double-depth) 20 pages, saddle-stitched 6 panels, 5-fold **Grid**

4-column Space between – 1p5

Margins

ilp5 olp5 tlp5 blp5

Fonts

Garamond Track loose

Body 9/12pt

Lithograph Track loose

2 Headlines / Cover / Logo 27/43pt

3 Destinations 16pt

BRIEF Travelwise sells vacations to a wide range of unusual and exotic locations. The company wants to create a brochure with a novel format emphasizing this difference. A new identity has been commissioned to position the company more accurately in the marketplace. Travelwise specializes in vacations for the independent traveler (but not backpackers), and offers help at the destination from trained staff, allowing flexibility in the itinerary. The publication must be compact since it will be mailed, used in counter displays, and as a loose insert in magazines.

TRAVELWISE

SOLUTION An accordion-pleat leaflet of $8\frac{1}{2} \times 11$ in / A4 vertical format, double the depth has been chosen, allowing for six panels on each side. Two panels will be taken up by the cover and contact information, leaving the remainder for 10 destinations. For maximum impact, the layout has been arranged in checkerboard fashion, with tinted and untinted panels and photographs alternating to left and right. The copy provides a taster for each location. A detailed fact sheet will be provided for customers requiring further information. Printing is in full color on both sides on #68 gloss-coated stock.

ABC

Butem vel eum iriure do lor in hen dre rit in vulp utate velit esse illum This leaflet is unusual because it reads down the vertical format and

SRI LANKA

is of double depth with six panels, four of which are shown on this page.

The cover (see opposite) prints on the opposite side of the "Egypt"

panel, although it will be upside down, so that when the leaflet is folded

it will have the same orientation as the six inside panels.

FGYPT

Lorem ipsum dolor sit amet, consectetuer adip iscing elit, sed diam nonummy nibh euismod tincidunt ut laoreet dolore magna aliquam erat volutpat. Ut wisi enim ad minim veniam, quis nostrud exerci tation ullamcorper suscipit lobortis nisl ut aliquip ex ea commodo consequat. Duis autem vel eum iriure dolor in hendrerit in vulputate velit esse molestie consequat, vel illum duis dolore facilisi.

Lorem ipsum dolor sit amet, consectetuer adipiscing elit, sed diam nonummy nibh euismod tincidunt ut laoreet dolore magna aliquam erat volutpat. Ut wisi enim ad minim veniam, quis nostrud exerci tation ullamcorper suscipit lobortis nisl ut dolor

Duis autem vel eum iriure dolor in hendrerit in vulputate velit esse molestie consequat, vel illum dolore eu feugiat nulla facilisis at vero eros et accumsan et justo odio dignissim qui blandit praesent luptatum zzril delenit augue duis dolore te feugait nulla facilisi

nobis eleifend option congue nihil imperdiet doming id quod TRAVELWISE

Lorem ipsum dolor sit amet, consectetuer adip iscing elit, sed diam nonummy nibh euismod tincidunt ut laoreet dolore magna aliquam erat volutpat. Ut wisi enim ad minim veniam, quis nostrud exerci tation ullamcorper suscipit lobortis nisl ut aliquip ex ea commodo consequat. Duis autem vel eum iriure dolor in hendrerit in vulputate velit esse molestie conseguat, vel illum duis dolore facilisi.

Lorem ipsum dolor sit amet, consectetuer adipiscing elit, sed diam nonummy nibh euismod tincidunt ut laoreet dolore magna aliquam erat volutpat. Ut wisi enim ad minim veniam, quis nostrud exerci tation ullamcorper suscipit lobortis nisl ut dolor

Duis autem vel eum iriure dolor in hendrerit in vulputate velit esse molestie conseguat, vel illum dolore eu feugiat nulla facilisis at vero eros et accumsan et iusto odio dignissim qui blandit praesent luptatum zzril delenit augue duis dolore te feugait nulla facilis Nam liber tempor cum soluta

nobis eleifend option congue nihil imperdiet doming id quod

TRAVELWISE

The address details are on the bottom panel and, together with four more vacation panels, will all be the opposite orientation to the cover. If this is difficult to visualize. try folding a sheet of paper into six accordion pleat panels to see how it will work

The logo is formed from the owl illustration plus the orange sun device, a circle 5p10 across, and the name is set to the same specification as the main heading.

The travel tag (see opposite) is a novelty mailed with the leaflet. It is 18p x 9p7 and uses the logo at 74%.

The destination heads are set in 16pt Lithograph, and they sit 12pt above the baseline of the first line of text. Lithograph is somewhat unusual and acts as a foil to the regimented nature of the overall layout.

20% cyan.

70% yellow. 25% magenta.

The logo is used at 62%, which is roughly half the width of the text and the last three lines of text run around it. The rule beneath the logo ranges with the baseline of the text and the bottom of the pictures; the sun device extends into the margin.

The design is symmetrical and repetitive, giving a very dramatic checkerboard display when unfolded An accordion pleat is used in preference to a rolling fold, in which each fold tucks into the previous one. If a rolling fold were used with such a long sheet, each panel after the second one would need to be progressively smaller, making a difference in width between the largest and smallest of approximately 1p2, an unacceptable amount for this design.

The margins around each panel and down the center are all equal at Ip5.

The justified text aligns with the pictures at the center, reinforcing the very angular design. Ranged-left text was not selected because it would loosen the layout by creating uneven rivers of space to the right of each text block

The text has been set in 9/12pt Garamond, but Times or Baskerville would do just as well. At 18pt, the paragraph indents are slightly wider than usual, and this helps to break up the text blocks a little, making them easier to read but without affecting the design.

Lorem ipsum dolor sit amet, consectetuer adip iscing elit, sed diam

nonummy nibh euismod tincidunt ut laoreet dolore magna aliquam

erat volutpat. Ut wisi enim ad minim veniam, quis nostrud exerci

tation ullamcorper suscipit lobortis nisl ut aliquip ex ea commodo

consequat. Duis autem vel eum iriure dolor in hendrerit in vulputate

diam nonummy nibh euismod tincidunt ut laoreet dolore magna

aliquam erat volutpat. Ut wisi enim ad minim veniam, quis nostrud

Lorem ipsum dolor sit amet, consectetuer adipiscing elit, sed

velit esse molestie consequat, vel illum duis dolore facilisi

exerci tation ullamcorper suscipit lobortis nisl ut dolor

HONG KONG

Lorem ipsum dolor sit amet, consectetuer adip iscing elit, sed diam nonummy nibh euismod tincidunt ut laoreet dolore magna aliquam erat volutpat. Ut wisi enim ad minim veniam, quis nostrud exerci tation ullamcorper suscipit lobortis nisl ut aliquip ex ea commodo consequat. Duis autem vel eum iriure dolor in hendrerit in vulputate velit esse molestie consequat, vel illum duis dolore facilisi.

Lorem ipsum dolor sit amet, consectetuer adipiscing elit, sed diam nonummy nibh euismod tincidunt ut laoreet dolore magna aliquam erat volutpat. Ut wisi enim ad minim veniam, quis nostrud exerci tation ullamcorper suscipit lobortis nisl ut dolor

Duis autem vel eum iriure dolor in hendrerit in vulputate velit esse molestie consequat, vel illum dolore eu feugiat nulla facilisis at vero eros et accumsan et iusto odio dignissim qui blandit praesent luptatum zzril delenit augue duis dolore te feugait nulla facilisi Nam liber tempor cum soluta

nobis eleifend option congue nihil imperdiet doming id quod

Nam liber tempor cum soluta

advanced BROCHURES

investment services

CLIENT

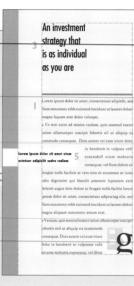

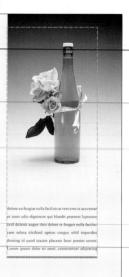

SPECIFICATIONS

Format

Single insert sheets: 81/2 x 81/2 in Slipcase: 8.7 x 8.7 x 0.5in or 52p2 x 52p2 x 3p Grid

2-column Space between - 2p2

Margins i 8d o 5d t 2pll b 4p4

Fonts Caslon

- Track loose
- Body text 9/19pt T
- 2 Logo 460pt Futura Condensed
- Track loose 3 Headlines 24/30pt
- 4 Cover 30pt
- Futura Extra Bold Track loose
- 5 Quote 8/16pt
- 6 Logo 420pt

Abc

Butem vel eum iriure do lor in hen I. dre rit in vulp utate velit esse illum

BRIEF Bamber Grey are stockbrokers offering a wide range of investment services, and they have commissioned a new brochure to sell these products. A primary requirement is flexibility: clients receive information specific to their own investment circumstances. Bamber Grey produce a plethora of publications, newsletters and factsheets, and wish to bring all of these under the umbrella of the recently created visual identity. The brochure will be the flagship and first of the new generation of publications.

SOLUTION A series of single-sheet inserts within a slender slipcase has been selected. This is a more expensive solution than a conventional brochure, and the slipcase, an open-ended box, made from #540 board covered in #101, laminated, coated stock and printed full color, is particularly expensive. It does, however, offer the great advantage of flexibility; the appropriate sheets can be selected for insertion so that each client receives a customized package. These sheets will be printed in full color on a #169 silk finish, coated board. The client appreciates the power of superbly produced presentation, and is willing to pay for it.

A new approach to Investment

The logo is square, and this has been influential in the choice of format for this publication. Enlarging it to bleed off a square format slipcase has created a very powerful design.

50% yellow.

65% yellow. 100% magenta. 70% cyan. 50% cyan. 20% cyan. 25% yellow. 50% magenta. 20% cyan.

The insert sheets follow a fairly standard format, including the 2p1 I strip down the side, the position of the headline and logo, and rules at the beginning and end of the text. The position of the inset subhead and picture are flexible.

The headline face is Futura Condensed. Because it is a condensed face, a space is created to the right of the head, and this should be retained on all inserts.

The subhead is ranged left and aligned with the edge of the tint strip. It is set within a white box I 5p2 wide, and to a depth that aligns with the top of the x-height of one line and to the baseline two lines below.

The logo is composed of a "B" set in a 24p square. The logo, reduced to 4p10, is positioned at the foot of the first column, with the last 4 lines of text running around it.

The slipcase is 53p square and 2p11 thick; the printed and laminated paper cover is pasted onto it. A small semicircular hole is die-cut in the side so that inserts can be removed.

The insert sheets are printed on #169 stock, which will make them quite rigid, and they have been machine varnished to protect them from scuffing.

The photograph of an off-beat flower arrangement has been commissioned to reinforce the individual theme established by the headline. A photograph of people would be more predictable and less attention grabbing.

The text, set in 9/18pt Caslon, hangs from a 4pt, 50% black rule, which sits on a line 15p10 from the top. Paragraph indents have been filled with square x-height bullets, tinted 50% black.

An investment strategy that is as individual as you are

Bamber Grey

Lorem ipsum dolor sit amet, consectetuer adipielit, sed diam nonummy nibh euismod tincidunt ut laoreet dolore magna liquam erat dolor volutpat.

» Ut wisi enim ad minim veniam, quis nostrud exerci tation ullamcorper suscipit lobortis nil ut aliquip ea commodo consequat. Duis autem vel eum iriure dolor

Lorem ipsum dolor sit amet otom ectetuer adipielit sedru rediam in hendrerit in vulputa velit essemdoll erum molestie consequat, vel llum dolore eu

feugiat nulla facilisis at vero eros et accumsan et iusto odio dignissim qui blandit praesent luptatum zzril delenit augue duis dolore te feugait nulla facilisi lorem ipsum dolor sit amet, consectetuer adipiscing elit, sed diam nonummy nibh euismod tincidunt ut laoreet dolore magna aliquam nonummy essum erat.

w Veniam, quis nostrud exercitation ullamcorper suscipit

lobortis nisl ut aliquip ex ecommodo consequat. Duis autem vel eum iriure dolor in hendrerit in vulputate velit ast esse molestie consequat, vel illum

dolore eu feugiat nulla facilisis at vero eros et accumsan et iusto odio dignissim qui blandit praesent luptatum zzril delenit augue duis dolore te feugait nulla facilisi. cum soluta eleifend option congue nihil imperdiet doming id quod mazim placerat facer possim assum. Lorem ipsum dolor sit amet, consectetuer adipiscing

published BROCHURES

Greener and more pleasant? Contrary to what many people believe, packaging witbout plastics

What's really going to waste?

Right and far right: Annual reports of companies with many subsidiaries have to combine several disparate elements in an overall, unifying way. The cover is a white textured stock, and small illustrations have been blind embossed into it. The typography is understated. Within the report, one spread is devoted to each of the subsidiaries, and each has a tint panel with small illustrations, several as cut-outs, dropped into the tint. There are no headings, but the eye is led into the page along a cutout photograph of the cow towards the italic introduction, which has a sanserif drop cap. The captions, which have a raised initial capital, are set in a con-

densed sanserif type.

Above and right: The extreme landscape format was selected to suit the proportions of the building development the brochure was produced to promote, and it offered the designer the opportunity to prepare some elegant layouts. The rarely seen typeface Cochin has been used throughout, printed white out of dark backgrounds. Column rules with small, diamondshaped heads have been added to the left of the unjustified text. The brochure is spiral bound.

Above, left and below: Finding new ways of presenting statistical data is always a challenge, and the use of food in these graphs has resulted in some strong and witty layouts. A square page is most suitable for this kind of material - a traditional portrait format would have left unwanted spaces above and below the graphs. The cover includes a clever invitation to turn the page in the form of a mock-up of a plastic cap, painted in BP's corporate green.

Making lighter work of things Improving the performance of polyethylene so that we consume le route towards saving a precious, finite resource.

Weight of 1976 polyethylene to make Iner Density a 1/2 litre washing-up Polyethylene 34 Excel bottle

> Figh Density Polyethylene 25

1991 Righ Density

BP CHEMICALS

Unwrapping the truth

TODE

Canadian manulacturer and dis tributor of consumer food prod ucts. Its Dairy Division is the l ing processor of fluid milk in Canada is the mumber one seller of yogurt in Ontario and is also that

Province's tecond largert up plier of fluid milk. Beatrice Food Products Division us a leading producer of chees and food ingredients. The Bakery Division markets products under the Colonial brand, and is the country's leading manufacturer of private-label

on is the leadinternational and the second term of the Second term international and the second term of the Second term yogart in the second term of the second term lists of that A 51 Billion Companyted largerst suptional term of the second term pairs also second term term of the second term term of term of the second term term of terms of terms of the second term term of terms of terms of the second term term of terms of terms of terms of the second term terms of terms of terms of terms of terms of terms of terms terms of terms of terms of terms of terms of terms of terms terms of terms terms of te

consistent constraints and and priority that in the store table, there is a strength of the store is the store table, the start between the store of the store is the store of the store of the given online is unreading priority or any store prior. As a many store and the store is the store of the store of the transfer of the store of the store of the store of the store is not one effects to perform any store of the store is not one effects to perform any store of the store is not one effects to perform any store of the store is not one effects to perform any store of the store is not one effects to perform any store of the store is not one effects to perform any store of the store is not one effects to perform any store of the Stark Dense and Otherson. Plants operations of the Alaba Dann's operation is non-thermal Metersa. Stark Dense and Otherson. Plants operations and opperation the store of the store and Otherson. Plants operations and other of the store of the

August. 1990, Bentrice competent the acquisition Man Dames' operations in southern Alberta, Akachewan and Oharano. Pallwi operations add wir Bentric the langust processour of hade milk in statistic structure of the southern of the southern and, The prochessi processour of hade milk in statistic structure in cash. Alf alaestodes of SU35 fluiding many Restruct managems, bought additional building many Restruct managems, bought additional tree of Bearans to provide the cash operation for the Palan is an excellent arrange fu with the Rutrics operations. It gives Beatrics an opportunity to the 3major factors in fluid mill, processing in wettern Canada – Palen has a strong share of these materiesand opens a distribution tertwork there for other Beatrice produces. We are pleased that Palary topquality management from has strayed on to manage the operations, and antesque that Beatrice will be able to adhere some important spreagers. The Palan Dary plant in Thundler Hay, Omario was closed after in the

The integration of Eplett has taken much moeffort than Beatrice antissparted, a situation or doexpect with Hard's postable, well numaged openations. Fylett's systemic problems were a result of its operating deficiencies prior to ma acquiristic th Beatrice. These have been difficult and expensive to correct, Neverthelese, the Epletr congruntation is r

errory Up Quality in a Competitive Markepipo, contex-continued in unitation and charact its sharecompetitive markets by introducing new products to the other consecution of the start of the method or the direc consecution constants: Relative USA hutterfat dis followed on its populative in Mantantole with a accessful kausch in Ottaria. A light create disease of the exercised lausch is conserve plaunched Bastrice-Usand dire signary, falsed with a disease of frame organic alcosing and the starting and diseases of the organic alcosing and the share games of the the handed of the disease of the disease of the disease of the diseases of the disease of the disease of the disease of the diseases of the organic alcosing and method share games in the dish handed diseases of the disease of the disease of the diseases of the diseases of the diseases of the disease of the disease of the disease of the diseases of the diseases of the disease of the disease of the disease of the disease of the diseases of the disease of the diseases of the diseases of the diseases of the disease of the disease of the diseases of efford and his fundamentals of the food preand havened to not change much in a dimese robot in the short trens, trace will gread more of 1941 transe beard great of the short trens, trace will gread more of 1940 the short of the short trens, "Bobs we do not annicipate an block we the productivity enhanceblock we the productivity enhance-

we will be a key factor in monitoriong in margins in more monitoriong is compared with the factor of one of the second second second second backs and of one performs in the restanded distrione system, during 1991, Colemail Brand coakinsor a good marker powerion which Breads we distriner to diverging in the coming years. In addition, rears will continue to give a scalarge role in the chopment of the percare label coakie bounces.

matheorem	14900	1989
centres/	746.1	672.1
BIAT		46.1
Actest expense	152.00	130.4
et carnings	6.3	4.4
ash proceeded by operations	30,5	20.8
stal assets	460.9	395.6
chi, current and lang-term	275.2	200.0
sarebolders' courty	Se. 9	40.0
nex ownership		73%
mplorees	3000	2400

ver me tonger trem, the company is firmly fixuased is 1093 target of 51 follows in revenues matched commensature levels of profitability. Given nardvet are growth, productivity gasta, and moderate price creases, Baarice belavest it can achieve in goal worth persent complement of operations. Novembrids, the mpany well continue to folds for wrategic equititizes in both Canada and the United Canas that robusce us core businesses.

ONEX CORPORATION 1998 ANNUAL REPORT

the state of the s

Right: Simplicity is often the key to good design. Here, however, it has been taken to an extreme, with a single line of type and one illustration. What makes the layout so effective is the visual relationship between the two elements and the fact that the line of type mimics the main element of the illustration.

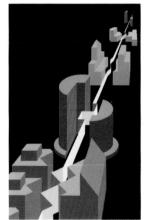

DSC Transmission Products

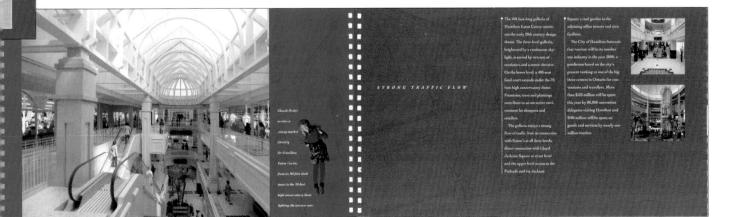

publishedBROCHURES

large headlines and dramatic use of space have a tremendous impact, but creating a publication that follows so few layout rules and has no consistent grid requires great skill. The desire to challenge convention and break new ground should, however, always be tempered by a sense of the overriding purpose of any publication the need to communicate.

Normal (Normal (N

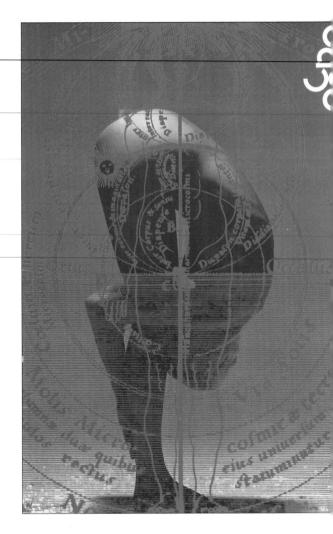

Companying and the second s

Indicates the two point of the Southern Doors, where the much intrake block according to the prevention form of the symptotic Frigm the basis of the periow and black boots acresses, all sold point whether was baseling boots there and the sold induced included control and the sold. All we all all works the much and and the sold the web all were much boots.

In the late 80s, the stable post-war arrangement of exchange rates

pegged to the U.S. dollar began to disintegrate.

In the Home...

In 1990, Ontario Hydro launched several successful

of international finance in the turbulent late 70%, as oil and gold prices soured.								
	Chicago Mercantile Exchange. The proce dig crept encode a period of extreme lhu- tern, Rangean tilliod world made even the traditional soft made even the traditional soft within an earlier of the specific soft model as the "ultimate carrency" encertain, and its price because solitect to sudden adiusments reflecting the edy and livo of interna- tional financial relationships in lipo a constant, when Cernnary and Ispan continued to push the currencies of those countris	soared to a temporary peda US 8873 per soarce. At this point, the volume sharply a the hedging of sharply a the hedging of future exchange tare floats future exchange tare floats into because a pandear ne sity. International Joang- emposition of the start of the experiment soarce long term experiment transaction involving reduited unreare had to the hedging by more start start of the start of the offset in power shart in other start power shart in other shart on the shart of the start of the start of the shart of the effecting hear shart in						
Integrampiest 12 take jointy shop Over the next five years, currency exchange rates contin- ued to fluctuate, and currency investment moved from a peripheral to a central position in the mainstream of interna- tional finance. The growing importance of foreign exchange marktest was reflected in the merging of the international	while the British pound and the Canadian dollar declined. To facilitate radie within the European Economic Commu- nity, the European Monetary System (EMS) was established in 1979 to replace cariler, losser arrangements for regularing EEC currency exchanges. Then carse the second "oil shock" receivated by the	the international balance of payments between industri ized and oil-exporting cours with the Swiss france, Japan yen and even the West Get mark began to runn downw The Canadian delilar went a steep decline, while the British pound, buoyed by t development of North Sca revolucition, turned unware						

he nominal price of oil jump about U.S.\$30 a barrel, and while a war the price of cold

5

Currency investment moved into the mainstream

1

Above and right: Centering the elements of a design will often result in a harmonious layout. Here, both text and illustrations occupy the same area. The top and bottom margins and the inner and outer

margins are equal, and the text hangs from a line about one-third of the way down the page. The three text columns are not the same length, which both helps to lighten the lower section of the page

and balances the extreme letter spacing of the dates at the top of the page. Visual interest has been added by the use of the black and white horizontal rules.

Above and right: When this water utility was planning its annual report, it wanted to avoid the usual formal approach and aim, instead, for a magazine-style layout with large, human-interest photographs, bright graphics, and an underlying theme of energy conservation. The cover establishes the style that runs throughout the publication.

Partnership

Ontario Hydro and the municipal electric utilities are encouraging customers to become partners in conserv.

A constraint of the second sec

16/7	/95	
Your	Ref.	Blu7803

Dear Kevin,

THEATRE
4 MUSIC
VISUAL ARTS

Lorem ipsum dolor sit amet, consecte dolore magna aliquam erat volutpat. suscipit lobortis nisl ut aliquip ex ac o uulputate velt esse molestic consequa odio dignissim qui blandit praesent le ipsum dolor sit amet, consecteuter ad magna aliquam erat volutpat. Ut wisi lobortis nisl ut aliquip ex ea commod

REAL ESTATE AGENTS LOCAL TRADESMAN CAB COMPANY RELAXATION GROUP CRAFT SHOP SANDWICH BAR REGIONAL ARTS CENTER

DESIGN GROUP

FREELANCE WRITER

YSANDWICH

S T A T I O N E R Y

CHAPTER

od tincidunt ut laoreet dolore magna aliquam erat volutpat. Ut wisi enim ad minim n, quis nostrud exerci tation ullamcorper suscipit lobortis nisl ut aliquip ex ea odo consequat. Duis autem vel eum iriure dolor in .

sincerely

Franklin

1068 PLANEDALE ROAD

tationery is often a company's primary point of contact with its customers and clients. For a multi-national company, the stationery design may be the result of a massive corporate identity program; for a small business or organization the redesign of the stationery may be a very personal matter. Most companies commission a new design at a time of change – for example, on moving to a different address, on the appointment of a new chief executive, or on the take-over of another company – and therefore, before any fundamental design work is undertaken, it is important that the designer understands how the company is perceived, both externally and from within, and what the company's future strategy is likely to be.

The choice of paper is of particular importance. The effect created by a well-designed letterhead printed on an attractive stock will have a positive and lasting impression on the recipient. Business cards and other items such as invoices, fax headers, and order forms will probably also be required. Paper manufacturers and merchants will normally be pleased to supply enough samples for you to prepare dummies of a full range of stationery for presentation to your client.

Most letterheads are constrained by the convention, which has been followed on the examples on pages 90-111, that the recipient's address should be positioned on the left-hand side of the letter, above the salutation. If window envelopes are used, the position of the address is further restricted to ensure that, when the letter is placed into the envelope, the address registers exactly with the window. The position of the folds is also relevant to the layout, and the main text of the letter should begin just below the first fold. Yet another factor is the possibility that letters may be hole-punched for filing in ring binders; if this is likely, the left margin should always be at least 4p4.

The examples in the basic section demonstrate the three most natural layout options for the position of the logo on the page – that is, in the upper right-hand area, in the upper left-hand area, and centered.

The intermediate section explores other layout options, including positioning the logo at the foot of the page, creating a logo from a customized font, and using a vertical format for a business card.

The advanced level examples include an overall pictorial background to the letterhead, an invoice designed specifically to fit a window envelope, and a multi-logo design that can be adapted for use on purchase order forms and fax headers.

> On the following pages the examples are reproduced at approximately 63% of the actual size. A sample of the address text is shown actual size on the left-hand page, together with a miniversion of the letterhead with the grid overlaid in blue.

basic

CLIENT

STATION ERY

Molloy Fred Molloy

Writer 1068 Planedale Road Amhurst Anystate 45207

freelance writer

axim spoon muce all deel, conservations applicating all, and dam hopping hild definition of the second second second second second second second second et all second second second second second second second second second set is eservative consequer. Duis autem vel even triure dolor in herdreri in subjacate et all second s

nd regards,

SPECIFICATIONS

Format

8½ x 11 in or A4 Letter margins 1 4p7 r 2p11

t 2p11 b 2p11 **Envelope** Standard business

Business Card 3³/8 x 2¹/8 in

Font

- **New Baskerville** Track loose
- I Logo 24pt/21pt
- 2 Address 8/10pt Letterhead 6/8pt Business Card / Envelope Stock White bond #23/#67

BRIEF Fred Molloy, a freelance writer and journalist, wants a new look for his stationery. He specializes in consumer affairs, and his main clients are newspapers, magazines and, occasionally, television. In addition, he has a clear idea of what he likes and dislikes. He values simplicity and wants the layout of his letterhead, envelope, and business card to reflect the direct, straightforward style of his writing.

Molloy Fred Molloy Writer 1068 Planedale Ro Amhurst Anystate 45207 Tel (666) 754-2876 Fax (666) 754-2876

SOLUTION It is often more difficult to design for an individual than for an organization. The design needs to reflect Fred's personality, and he must feel comfortable with the result. Because he is best known by his last name, his first name has been omitted. An acrylic portrait reflects his personality better than a photograph would, and reinforces the personalized design theme. Insetting the name partially within the painting evokes a signature without resorting to a handwritten form, which would be fussy and difficult to read.

Abc

2 Butem vel eum iriure do lor in hen dre rit in vulp utate velit esse illum

On the envelope (opposite) the illustration is dropped and the name "Molloy" positioned in the

top-left corner.

On the business card (opposite), the word "Molloy" has not been reduced by the same amount as the painting. This would have made it too small, and insetting it in the painting at this larger size would look clumsy.

FOLD

The recipient's address should always be on the left side of the page, but despite this constraint it is still possible to create a wide

variety of letterhead designs, as the following pages demonstrate.

Frank Carson Leroy and Bean 1675 Campion Avenue Brompton Anystate 63809

7/16/95

Molloy

Fred Molloy Writer 1068 Planedale Road Amhurst Anystate 45207 Tel (666)754-2876 Fax (666)754-4532

Dear Frank,

Lorem ipsum dolor sit amet, consectetuer adipiscing elit, sed diam nonummy nibh euismod tincidunt ut laoreet dolore magna aliquam erat volutpat. Ut wisi enim ad minim veniam, quis nostrud exerci tation ullamcorper suscipit lobortis nisl ut aliquip ex ea commodo consequat. Duis autem vel eum iriure dolor in hendrerit in vulputate velit esse molestie consequat, vel illum dolore eu feugiat nulla facilisis at vero eros et accumsan et iusto odio dignissim qui blandit praesent luptatum zzril delenit augue duis dolore te feugait nulla facilisi. Lorem ipsum dolor sit amet, consectetuer adipiscing elit, sed diam nonummy nibh euismod tincidunt ut laoreet dolore magna aliquam erat volutpat. Ut wisi enim ad minim veniam, quis nostrud exerci tation ullamcorper suscipit lobortis nisl ut aliquip ex ea commodo consequat.

Duis autem vel eum iriure dolor in hendrerit in vulputate velit esse molestie consequat, vel illum dolore eu feugiat nulla facilisis at vero eros et accumsan et iusto odio dignissim qui blandit praesent luptatum zzril delenit augue duis dolore te feugait nulla facilisi. Nam liber tempor cum soluta nobis eleifend option congue nihil imperdiet doming id quod mazim placerat facer possim assum.

Lorem ipsum dolor sit amet, consectetuer adipiscing elit, sed diam nonummy nibh euismod tincidunt ut laoreet dolore magna aliquam erat volutpat. Ut wisi enim ad minim veniam, quis nostrud exerci tation ullamcorper suscipit lobortis nisl ut aliquip ex ea commodo consequat. Duis autem vel eum iriure dolor in hendrerit in vulputate velit esse molestie consequat, vel illum dolore eu feugiat nulla facilisis at vero eros et accumsan et iusto odio dignissim qui blandit praesent luptatum zzril delenit augue duis dolore te feugait nulla.

Kind regards,

The letter will be folded twice to fit a standard business envelope, and the fold marks are indicated on the page. The text should always be started just, below the first fold, and the Dear ... just above it. This leaves a third of the page for the letter.

The strong vertical

the address ranging

on the left side of

name "Molloy" in

appropriate for a writer's letterhead

and New Basker-

ville, with its large

x-height and good

legibility, has been

used throughout.

the portrait is

broken by the

the ½pt box.

A serif face is

line produced by

The left margin is wider than the other margins so that the letter can be holepunched for filing if required. The traditional text size for letters is based on 12pt leading, which originated from the limitations of the typewriter. Today, with laser, ink-jet, and even dotmatrix printers, there is no such limitation. It is,

however, important to decide on the availability of text fonts before creating the design.

All items print black only.

print

basic

CLIENT

STATIONERY

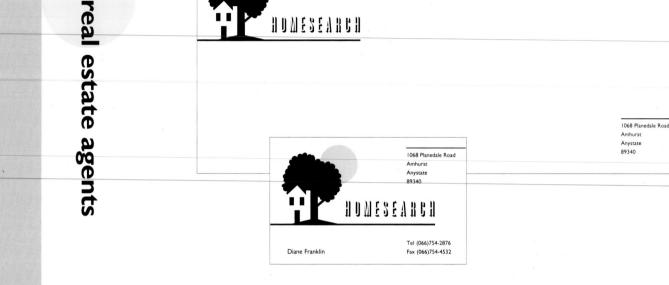

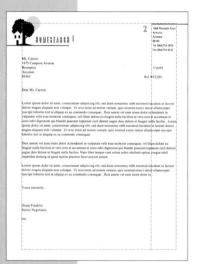

SPECIFICATIONS

Format

8.5 x 11 in or A4 Letter margins 1 4p7 r 2p11

t 2p11 b 2p11 **Envelope** Standard business

Business Card $3^{3}/_{8} \times 2^{1}/_{8}$ in

Fonts Graphik Shadow

- Track force justify I Logo
- 24pt

Gill Sans Track normal

- 2 Address
- 9/13½pt Letterhead 7/10½pt Business Card / Envelope
- 3 Name on business card 8pt

Stock

Pale cream laid #27/#67 **BRIEF** A small chain of residential real estate agents has commissioned a new visual identity that will be used on stationery as well as on shop sale boards, and property details. Because the customers are the public, rather than other businesses, it is important that the design conveys the company's friendly and reassuring, yet efficient, approach. The letterhead will also be used for mailing property details, so an adaptable layout is essential.

SOLUTION A simple graphic symbol and logo have been devised to create a strong identity, and the typeface chosen for the name of the company, with its drop-shadow and no outline, reflects the style of the house illustration. Property details, unlike letters, require the maximum page area to be available, so the logo and address have been kept to the top one-sixth of the page. Positioning the logo on the left of the page restricts the space available for the recipient's address, and so the date and reference information have been placed on the right.

A B G

ı

2 Butem vel eum iriure do lor in hen dre rit in vulp utate velit esse illum

The right side of the white house aligns with the left side of the text, which helps to unify the design. The logo echoes the illustration style with a shadow but

no outline. Both are anchored by a 2pt rule.

Amhurst

Anystate

89340

The symbol is a simple line illustration with the sun emerging from behind the tree. It has been tinted 20% black. If a second color was available, orange or red spot color could be used to great effect.

On the envelope (opposite) the logo is reduced to 50%. If it were used full size it would clash with the address.

FOLD

On the business card (opposite), the symbol, logo, and rule are the same size as on the letterhead and envelope, but the address is smaller and the telephone and fax numbers are separated from the rest of the address. The cardholder's name aligns with imagined left edge of the house illustration. The top and bottom margins are Ip2.

HOMESEABCH

Ms. Carson 1675 Campion Avenue Brompton Anystate 89362

7/16/95

Ref.WCL001

Dear Ms. Carson,

Lorem ipsum dolor sit amet, consectetuer adipiscing elit, sed diam nonummy nibh euismod tincidunt ut laoreet dolore magna aliquam erat volutpat. Ut wisi enim ad minim veniam, quis nostrud exerci tation ullamcorper suscipit lobortis nisl ut aliquip ex ea commodo consequat. Duis autem vel eum iriure dolor in hendrerit in vulputate velit esse molestie consequat, vel illum dolore eu feugiat nulla facilisis at vero eros et accumsan et iusto odio dignissim qui blandit praesent luptatum zzril delenit augue duis dolore te feugait nulla facilisi. Lorem ipsum dolor sit amet, consectetuer adipiscing elit, sed diam nonummy nibh euismod tincidunt ut laoreet dolore magna aliquam erat volutpat. Ut wisi enim ad minim veniam, quis nostrud exerci tation ullamcorper suscipit lobortis nisl ut aliquip ex ea commodo consequat.

Duis autem vel eum iriure dolor in hendrerit in vulputate velit esse molestie consequat, vel illum dolore eu feugiat nulla facilisis at vero eros et accumsan et iusto odio dignissim qui blandit praesent luptatum zzril delenit augue duis dolore te feugait nulla facilisi. Nam liber tempor cum soluta nobis eleifend option congue nihil imperdiet doming id quod mazim placerat facer possim assum.

Lorem ipsum dolor sit amet, consectetuer adipiscing elit, sed diam nonummy nibh euismod tincidunt ut laoreet dolore magna aliquam erat volutpat. Ut wisi enim ad minim veniam, quis nostrud exerci tation ullamcorper suscipit lobortis nisl ut aliquip ex ea commodo consequat. Duis autem vel eum iriure dolor in .

Yours sincerely,

Diane Franklin Senior Negotiator

enc

1068 Planedale Road Tel (066)754-2876 Fax (066)754-4532

A 2pt rule ranges with the address details and balances the rule on the other side. It is positioned so that the space between it and the first line is visually equal to the spaces between the lines of the Homesearch addross

The word processor will need to be set up so that the tabs for the date and reference align exactly with the printed address details.

Because the client makes extensive use of Times Roman, this face has been used for the letter text. It complements the Gill used for the stationery.

All items print black only.

basic

STATION E R Y

CLIENT		The Plumber		
	loca			
	ul tr			
	ade		Larry Winkler The Plumber	
	Sm		1068 Planedale Amhurst Anystate 45207	Road
	lan			

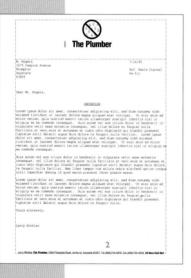

SPECIFICATIONS

Format

8½ x 11 in or A4 Letter margins 1 4p7 r 2p11 t 2p11 b 2p11

Envelope Standard-business

Business Card 3³/8 x 2¹/8 in

Fonts

Helvetica Black Condensed Track normal

- I Logo 27pt/23pt
- Helvetica Condensed
- 2 Address etc. 9pt Letterhead 7/12pt Business Card / Envelope Stock White bond #27/#67

BRIEF Larry Winkler is a self-employed plumber. New business comes mainly by word-of-mouth, but he has decided to test a strategy of posting business cards through mailboxes in his neighborhood. He has, therefore, commissioned a range of stationery, including business cards. Much of his work involves responding quickly to emergencies such as burst pipes, but he also does routine jobs such as fitting new appliances. He prides himself on reliability and efficiency, and would like his stationery to reflect these qualities.

SOLUTION The customer's response to an emergency is to "call the plumber," so with this in mind an identity consisting of a "no drips" symbol reminiscent of a traffic sign and a logo that says, simply, "The Plumber" has been devised. This looks professional, but also reassuring. His name appears only in the address line at the bottom of the page. The typographical style is uncomplicated, and the centered format gives the design a simple strength.

Abc Butem vel eum iriure do lor in hen

dre rit in vulp utate velit esse illum

The symbol is easily formed from a circle and diagonal rule, both 5pt thick. The

droplet shape is created by using a graphics program or line artwork, and is

repeated 11 times in a random arrangement. The droplets are then tinted 40% black.

7/16/95

Re-fit

Ref. Waste Diposal

M. Rogers 1675 Campion Avenue Brompton Anystate 63809

Dear Mr. Rogers,

OUOTATION

Lorem ipsum dolor sit amet, consectetuer adipiscing elit, sed diam nonummy nibh euismod tincidunt ut laoreet dolore magna aliquam erat volutpat. Ut wisi enim ad minim veniam, quis nostrud exerci tation ullamcorper suscipit lobortis nisl ut aliquip ex ea commodo consequat. Duis autem vel eum iriure dolor in hendrerit in vulputate velit esse molestie consequat, vel illum dolore eu feugiat nulla facilisis at vero eros et accumsan et iusto odio dignissim qui blandit praesent luptatum zzril delenit augue duis dolore te feugait nulla facilisi. Lorem ipsum dolor sit amet, consectetuer adipiscing elit, sed diam nonummy nibh euismod tincidunt ut laoreet dolore magna aliquam erat volutpat. Ut wisi enim ad minim veniam, quis nostrud exerci tation ullamcorper suscipit lobortis nisl ut aliquip ex ea commodo consequat.

Duis autem vel eum iriure dolor in hendrerit in vulputate velit esse molestie consequat, vel illum dolore eu feugiat nulla facilisis at vero eros et accumsan et iusto odio dignissim qui blandit praesent luptatum zzril delenit augue duis dolore te feugait nulla facilisi. Nam liber tempor cum soluta nobis eleifend option congue nihil imperdiet doming id quod mazim placerat facer possim assum.

Lorem ipsum dolor sit amet, consectetuer adipiscing elit, sed diam nonummy nibh euismod tincidunt ut laoreet dolore magna aliquam erat volutpat. Ut wisi enim ad minim veniam, quis nostrud exerci tation ullamcorper suscipit lobortis nisl ut aliquip ex ea commodo conseguat. Duis autem vel eum iriure dolor in hendrerit in vulputate velit esse molestie consequat, vel illum dolore eu feugiat nulla facilisis at vero eros et accumsan et iusto odio dignissim qui blandit praesent luptatum zzril delenit augue duis dolore te feugait nulla.

Yours sincerely,

Larry Winkler

Larry Winkler, The Plumber, 1068 Planedale Road, Amhurst, Anystate 45207, Tel (666)754-2876, Fax (666)754-4532, 24 Hour Call-Out

Hour Call-Out,"

and adds a sales statement to the

too intrusive.

copy without being

Combining the

faces in the

light and very bold

address highlights

Plumber" and "24

the words "The

Helvetica Condensed and Helvetica Black Condensed are specified for all items. This allows for a reasonably large type size to be used for the address, which is particularly important when it is set in a single line.

The words "The

Helvetica Black Condensed. The

23pt letter forms

same thickness as

the circle and rule

of the symbol,

which helps to

unify the identity.

On the envelope

(opposite) the logo

is reduced to 50%

and dropped into

the top left-hand

The business card

uses the symbol/

logo reduced to

85% and centered

on a line 6p8 from

the left edge of the card. The address

is ranged left and

6p from the right

edge. The top and

bottom margins are

Ip4

positioned on a line

corner.

are roughly the

Plumber" are set in

With a centered main image, it is desirable to position the address at the bottom of the page. If it were in a block at either the top left or the top right, it would unbalance the layout; if it were in a block centered below the logo, it would become confused with the addressee copy; and if it were set as a single line immediately below the logo, it would have to be uncomfortably close to the logo to leave enough space for the recipient's

The letter, which will be created using a basic word processing system, will be used mainly for supplying quotations. The invoice will follow the same format.

address.

The business cards that are used for the mail drop will be laminated on both sides in a plastic "sandwich." This makes them totally waterproof, a quality the client hopes will not be lost on his customers.

Larry Winkler

The Plumber

Amhurst

Anystate

45207

1068 Planedale Road

Tel (666)754-2876

Fax (666)754-4532

24-Hour Call-Out

All copy prints black.

intermediate STATIONERY

BLUECABCO

1068 PLANEDALE ROAD Amhurst Anystate 45207

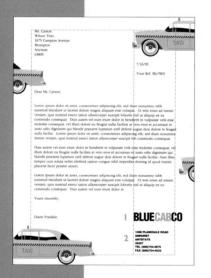

cab company

CLIENT

SPECIFICATIONS

Format 8½ x || in or A4 Letter margins | 5p r 5p

t 4pl b 2pll Envelope

Standard business Business Card

3³/8 x 2¹/8 in Fonts

Helvetica Black Condensed Track normal

I Logo 36pt

2 Address 8½/12pt Letterhead 6½/9½pt Business Card / Envelope

Helvetica Regular Job Title on business card 8½pt Stock White bond #27 Cast-coated board #80 **BRIEF** The Blue Cab Company has taken the bold decision to paint all its cabs blue in an attempt to distinguish itself from its rivals. This new color scheme is to be accompanied by new stationery. The brief is clear: the company wants an unusual, striking, and memorable design that can be extended at a later date to include items such as flyers, posters, and other promotional pieces. The budget is sufficient to allow for a creative approach that is not necessarily restricted to a single color.

......

SOLUTION The company name has been shortened to BLUECABCO, and this is made legible by introducing a second color – blue. A line illustration of a cab has been commissioned, and this uses the second color on the body panels. The device has been used four times on the letterhead to imply a fleet of cabs, and the staggered images, all partly cropped, bleed off the page help to create a sense of movement. The envelope and business card both incorporate adaptations of this novel approach.

Abc

2 Butem vel eum iriure do lor in hen dre rit in vulp utate velit esse illum Several illustrators presented their work before the most appropriate style was chosen. To achieve a strong graphic effect the cab was drawn exactly side-on and used as a cut out, with no background tone.

Lorem ipsum dolor sit amet, consectetuer adipiscing elit, sed diam nonummy nibh

veniam, quis nostrud exerci tation ullamcorper suscipit lobortis nisl ut aliquip ex ea commodo consequat. Duis autem vel eum iriure dolor in hendrerit in vulputate velit esse molestie consequat, vel illum dolore eu feugiat nulla facilisis at vero eros et accumsan et iusto odio dignissim qui blandit praesent luptatum zzril delenit augue duis dolore te feugiat

euismod tincidunt ut laoreet dolore magna aliquam erat volutpat. Ut wisi enim ad minim

nulla facilisi. Lorem ipsum dolor sit amet, consectetuer adipiscing elit, sed diam nonummy

Duis autem vel eum iriure dolor in hendrerit in vulputate velit esse molestie consequat, vel

illum dolore eu feugiat nulla facilisis at vero eros et accumsan et iusto odio dignissim qui

blandit praesent luptatum zzril delenit augue duis dolore te feugait nulla facilisi. Nam liber

tempor cum soluta nobis eleifend option congue nihil imperdiet doming id quod mazim

Lorem ipsum dolor sit amet, consectetuer adipiscing elit, sed diam nonummy nibh euismod tincidunt ut laoreet dolore magna aliquam erat volutpat. Ut wisi enim ad minim

veniam, quis nostrud exerci tation ullamcorper suscipit lobortis nisl ut aliquip ex ea

commodo consequat. Duis autem vel eum iriure dolor in .

minim veniam, quis nostrud exerci tation ullamcorper suscipit lob commodo consequat.

7/16/95

Your Ref. Blu7803

The date and reference at the top align with the logo at the bottom of the page, and are 16p5 from the right edge. The car at the top also aligns visually with the logo, adding an element of uniformity to an asymmetrical layout.

Garamond has been chosen as the text face for the letter. Its elegant, slightly extended characters complement the bolder, condensed face used elsewhere.

The business card follows the design theme, but with the cardholder's job title in normal weight rather than extra bold. The margins are 1p2 all round.

DIANE FRANKLIN VICE PRESIDENT 1068 PLANEDALE ROAD AMMURST ANYSTATE 45207

blue. The cab illustration is in black line, with a flat 30% blue tint added. The word CAB also prints blue. Wilson Tires 1675 Campion Avenue Brompton Anystate 63809

Dear Ms. Carson,

Ms. Carson

FOLD

The envelope (opposite) follows the design of the business card, but the illustrations are reduced to 75%

The unusual layout

places a number of

constraints on the

restricted space for

letterhead. The

justified because

of the impact of

BLUECABCO's

letters are seldom

blank continuation

is required on the right so that the letter does not

overlap the

illustration.

sheets are available. A large margin, 5p,

longer than this,

and if they are.

the letter is

the design.

Printing is in two colors – black and blue. The cab

FOLD

placerat facer possim assum.

Yours sincerely,

Diane Franklin

The printers must take especial care to trim all items accurately because the wheel of the car at the foot of the page must sit exactly on the trimmed edge. The robust design requires a bolder than normal face for the address, particularly as it is at the bottom of the page.

1068 PLANEDALE ROAD tit AMHURST we ANYSTATE ex

> TEL (666)754-2876 FAX (666)754-4532

AMHURST ANYSTATE 45207 TEL (666)754-2876 FAX (666)754-4532

BLUECABCO

.....

intermediate STATIONERY

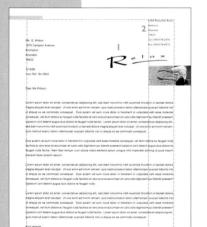

relaxation group

CLIENT

SPECIFICATIONS

1068 Planedale Road

Amhurs

Anystat

19403

ela

Richard Mellors

Sales Executive

Tel (066)754-2876 Fax (066)754-4532

Format 8½ x 11 in or A4

Letter margins | 4p10 r 4p10 t 2p11 b 2p11

Envelope Standard business

Business Card 3³/₈ x 2¹/₈ in

Fonts President

Track: see opposite I Logo

15pt, 36pt initial cap Goudy Old Style

- Track very loose 2 Address
- 9/15pt Letterhead 7/11pt Business Card /
- Envelope 3 Name on business card
- 9pt **Stock**

Pale green parchment-effect #27/#67 **BRIEF** Relax is a relaxation group that uses yoga, biorhythms, diet, exercise, and other techniques to promote personal well-being. It has commissioned a new look for its stationery in an attempt to increase membership by shedding a rather eccentric, hippy image in favor of a modern, business-like one. Because image is so important, the client provided a budget that allows for the possibility of full-color production.

1068 Planedale Road

Amhurst

Anystate

19403

SOLUTION A fresh, clean design approach has been devised, incorporating a distinctive logo with a handwritten style (although it is, in fact, a distorted font). This is associated with a color photograph of a client in an exercise group. The layout is formal and restrained, but the formality is interrupted by the logo, with its large initial cap and extra letter spacing. It is set on a shallow arc, and the face has been stretched horizontally to 250%, creating a visual metaphor for the exercise taken by the members.

2 Butem vel eum iriure do lor in hen dre rit in vulp utate velit esse illum A 12pt rule, printing 20% black, bleeds off at the top left, balancing the photograph that bleeds off on the right.

Goudy Old Style has been selected for all copy apart from the logo. It is set with very loose spacing, which contributes to the open look of the layout.

The logo is used on the envelope (opposite) and is reduced to 75%.

The logo and photograph, reduced to 75%, are used on the business card (opposite). The margins are Ip at top and bottom, and Ip2 at the left. The address is ranged left on a line 8p6 from the right edge. The name of the cardholder is 2pt larger than the address and job description, and the 8pt rule is 6p wide.

The logo has been created using a graphics package, although it could be

accomplished by using Letraset or by cutting up the e letters of a typeset proof, reconstituting them in the desired positions, retouching the joins and making a PMT of the resulting artwork.

Dear Ms Wilson,

Lorem ipsum dolor sit amet, consectetuer adipiscing elit, sed diam nonummy nibh euismod tincidunt ut laoreet dolore magna aliquam erat volutpat. Ut wisi enim ad minim veniam, quis nostrud exerci tation ullamcorper suscipit lobortis nisl ut aliquip ex ea commodo consequat. Duis autem vel eum iriure dolor in hendrerit in vulputate velit esse molestie consequat, vel illum dolore eu feugiat nulla facilisis at vero eros et accumsan et iusto odio dignissim qui blandit praesent luptatum zzril delenit augue duis dolore te feugait nulla facilisi. Lorem ipsum dolor sit amet, consectetuer adipiscing elit, sed diam nonummy nibh euismod tincidunt ut laoreet dolore magna aliquam erat volutpat. Ut wisi enim ad minim veniam, quis nostrud exerci tation ullamcorper suscipit lobortis nisl ut aliquip ex ea commodo consequat.

Duis autem vel eum iriure dolor in hendrerit in vulputate velit esse molestie consequat, vel illum dolore eu feugiat nulla facilisis at vero eros et accumsan et iusto odio dignissim qui blandit praesent luptatum zzril delenit augue duis dolore te feugait nulla facilisi. Nam liber tempor cum soluta nobis eleifend option congue nihil imperdiet doming id quod mazim placerat facer possim assum.

Lorem ipsum dolor sit amet, consectetuer adipiscing elit, sed diam nonummy nibh euismod tincidunt ut laoreet dolore magna aliquam erat volutpat. Ut wisi enim ad minim veniam, quis nostrud exerci tation ullamcorper suscipit lobortis nisl ut aliquip ex ea commodo consequat. Duis autem vel eum iriure dolor in hendrerit in vulputate velit esse molestie consequat, vel illum dolore eu feugiat nulla facilisis at vero eros et accumsan et iusto odio dignissim qui blandit praesent luptatum zzril delenit augue duis dolore te feugait nulla.

Lorem ipsum dolor sit amet, consectetuer adipiscing elit, sed diam nonummy nibh euismod tincidunt ut laoreet dolore magna aliquam erat volutpat. Ut wisi enim ad minim veniam, quis nostrud exerci tation ullamcorper suscipit lobortis nisl ut aliquip ex ea commodo consequat. Duis autem vel eum iriure dolor in hendrerit in vulputate velit esse molestie consequat, vel illum dolore eu feugiat nulla facilisis at vero eros et accumsan et iusto odio dignissim qui blandit praesent luptatum zzril delenit augue duis dolore te feugait nulla facilisi. Lorem ipsum dolor sit amet, consectetuer adipiscing elit, quis nostrud exerci tation ullamcorper suscipit lobortis nisl ut aliquip ex ea commodo consequat.

Kind regards

Richard Mellors

A #27 pale green, parchment-effect paper has been chosen, with a matching #67 board used for the business card. The color photograph prints four-color onto the pale green, which changes its color balance, but in a way that is pleasing and attractive. Care should always be taken when color images are printed on a colored stock – a white bird on a brown paper might, for example, look dirty and unpleasant. A sans serif face, Univers Light, is used for the text. It gives the letter a lighter appearance than a more traditional face, such as Times. The photograph, which was taken in the exercise studio. is one of a sequence of shots taken for the stationery and other publicity purposes. Because photographers are expensive to hire, it is important to anticipate possible future requirements so you can avoid having to repeat the expense a few months later

The letter text is set justified rather than ranged left, which reinforces the formality of the design but requires wide - 4p10 margins at the sides and considerable leading of the text.

The logo is set in 36pt and 15pt President, expanded to 250% and letter spaced to the desired amount. The cap "R" is then lowered to align visually with the underline. This underline is a lower case "l." rotated through 90 degrees and stretched to the desired length. This is used in preference to a rule as it retains the handdrawn character of the name. Finally, the completed logo is bent around a shallow arc using the software program's envelope function.

intermediate STATIONERY

The

Needlepoint Shop

1068 Planedale Road Amhurst Anystate 19650

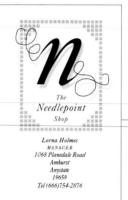

Jerni tyum diote si une, concertere adpisoing effic, sed dam nonnomy tibb daimod incident se atternet dolver maps deletation en en valogate. Une intern ad naimi sension, admosfied aceteri ciano gliansosper suscipi laborin niu si raligori se sa connodo connegati. Diai suscen jel en niura dalo in executiva dalo in discontrato deletationa deletationa della suscente la deletati ad deletati ad della dalo atterneta dalo in discontrato della suscente la della suscente della della della della discontrato della della della suscente la della suscente la della della della della della della della discontrato della discontrato della della

craft shop

Data uter met el em iniur de loui às hendrein in subparse visit esse moteries consequie, se il line adore en desegneral da licelità esse en est a econsost e into de degatione qui ballecta persenta lipetana autodigitaria da licelità esse en est a econsost e into de degatione qui ballecta persenta lipetana autodigitaria da licelità esse esta de la licelità de licelità de licelità de licelità de licelità qui ballecta esse esse essenta de licelità de la licelità de la licelità de licelità de la licelità de licelità della de licelità de lice de licelità della de la licelità de licelità de

jaren nyenn door ni ainet, consectedur alipineng etir, sed dain nomanny nih eşinmed tuscdara tu laneret dolore magazi alışamı ene veludara. U vivii etiran da minim venian, quri onişarıd exerci tution illimoneyre vasciple lobortis nil ut aligaip ex a commodo consequat. Dols autom yel emi ifuse dolor in bendreti ti vulquatare velit esse molectic consequat, wel ilum obiore us frugita tuliğ facilinis at vero ense contana et i sitosi odio diginisim qui blandit praseent lapatarın razil delenit azgot të frugiti nulla.

2 tester

SPECIFICATIONS

Format

8½ x 11 in or A4 Letter margins 1 4p10 r 4p1 t 2p5 b 2p11

Envelope Standard business

Business Card 3³/8 x 2¹/8 in

Font

- Caslon Italic Track loose
- I Logo
- 10pt, 15pt, 10pt 8pt, 12pt, 8pt
- See opposite for "n" 2 Address
- 8/10pt Letterhead
- 7/9pt Business Card /
- Envelope 3 Job Title on business card 6pt
 - Stock

lvory bond #24/#74

BRIEF The Needlepoint Shop requires a new image – one that retains the traditional craft identity, but that also conveys the impression of a modern, well-organized business. The owner would like to create a franchised chain of similar shops using The Needlepoint Shop brandname, and so the new design has an added significance. A strong, memorable design, which can be exploited in future promotional and point-of-sale items and advertising, is essential.

SOLUTION Careful consideration has been given to the development of the logo. The result is a device combining a graphic representation of a canvas frame combined with a large lower case "n," with the linking strokes tapered into fine lines, which become strands of "thread." A drop shadow is included behind the "n," and this gives the design a three-dimensional quality. The words "The Needlepoint Shop" are included within the border. An unusual feature is the vertical format of the business card.

Abc

2 Butem vel eum iriure do lor in hen dre rit in vulp utate velit esse illum The envelope (opposite) uses the logo reduced to 50%. "The Needlepoint Shop" is taken out of the decorative border and positioned below; type size is as for business card.

The business card (opposite) uses the logo device reduced to 93% and centered on the width of the card, which is used vertically. The margins are Ip5 at the top and Ip10 at the foot.

The face used throughout is Caslon italic, a traditional serif face. Caslon roman is used for the text of the letter. Although they are from the same font family, the italic face looks very different from the roman, and is very much more condensed. FOLD

Elspeth Tweedle Debden Yarns 1675 Campion Avenue Brompton Anystate 19622

7/16/95

Dear Elspeth,

Lorem ipsum dolor sit amet, consectetuer adipiscing elit, sed diam nonummy nibh euismod tincidunt ut laoreet dolore magna aliquam erat volutpat. Ut wisi enim ad minim veniam, quis nostrud exerci tation ullamcorper suscipit lobortis nisl ut aliquip ex ea commodo consequat. Duis autem vel eum iriure dolor in hendrerit in vulputate velit esse molestie consequat, vel illum dolore eu feugiat nulla facilisis at vero eros et accumsan et iusto odio dignissim qui blandit praesent luptatum zzril delenit augue duis dolore te feugait nulla facilisi. Lorem ipsum dolor sit amet, consectetuer adipiscing elit, sed diam nonummy nibh euismod tincidunt ut laoreet dolore magna aliquam erat volutpat. Ut wisi enim ad minim veniam, quis nostrud exerci tation ullamcorper suscipit lobortis nisl ut aliquip ex ea commodo consequat.

Duis autem vel eum iriure dolor in hendrerit in vulputate velit esse molestie consequat, vel illum dolore eu feugiat nulla facilisis at vero eros et accumsan et iusto odio dignissim qui blandit praesent luptatum zzril delenit augue duis dolore te feugiat nulla facilisi. Nam liber tempor cum soluta nobis eleifend option congue nihil imperdiet doming id quod mazim placerat facer possim assum. Ut wisi enim ad minim veniam, quis nostrud exerci tation ullamcorper suscipit lobortis nisl ut aliquip ex ea commodo consequat. Duis autem vel eum iriure dolor in hendrerit in vulputate velit esse molestie consequat, vel illum dolore eu feugiat nulla facilisis. Lorem ipsum dolor sit amet, consectetuer adipiscing elit, sed diam nonummy nibh ut laoret dolore magna aliquam erat volutpat.

Lorem ipsum dolor sit amet, consectetuer adipiscing elit, sed diam nonummy nibh euismod tincidunt ut laoreet dolore magna aliquam erat volutpat. Ut wisi enim ad minim veniam, quis nostrud exerci tation ullamcorper suscipit lobortis nisl ut aliquip ex ea commodo consequat. Duis autem vel eum iriure dolor in hendrerit in vulputate velit esse molestie consequat, vel illum dolore eu feugiat nulla facilisis at vero eros et accumsan et iusto odio dignissim qui blandit praesent luptatum zzril delenit augue te feugait nulla.

Kind regards,

Lorna Holmes

Because the client wants to project an environmentally responsible image, a 100% recycled paper – containing no virgin pulp, only

post-consumer waste – has been chosen, with a matching #74 board used for the business card.

The border is made from 4pt squares separated by 1½pt spaces.

15pt space

The device featuring the lower case "n" has been created by using a graphics program to taper the letter forms and add the "thread." An alternative method is to set the "n" oversize - e.g., 300% - to draw in the trailing ends at Ipt line width, and then to paint them out so that they taper smoothly. The drop shadow is simply a duplicate, offset to the bottom right and printed 100% medium-blue.

The address is positioned at the bottom of the page but still centered on the width of the logo device. Both are set in Caslon italic, which creates a visual link between them, and although they are separated it is clear the address refers to The Needlepoint Shop.

Printing is black and medium-blue. The border device and drop shadow print blue; everything else prints black.

1068 Planedale Road

Amhurst

Anystat 19659

Tel (666)754-2876

advanced

sandwich bar

CLIENT

STATIONERY

SANDRA DEAN

CITYSANDWICH

CITY SANDWICH 1068 PLANEDALE ROAD AMHURST ANYSTATE



1

SPECIFICATIONS

Format 8½ x 11 in or A4 Letter margins

l 7p8 r 2p11 t 2p11 b 2p11 Envelope

Standard business

Business Card $3^{3}/_{8} \ge 2^{1}/_{8}$ in

Font Franklin Heavy Gothic

Track very loose

Logo: see opposite
 44pt

Track normal 2 Address etc.

8/10pt Letterhead/Envelope 7/9pt Business Card

Stock Brilliant white ultra-smooth #24 Cast-coated board #80 **BRIEF** City Sandwich is a well-known chain of sandwich bars, specializing in take-out, lunchtime food. A new visual identity, including the stationery, is required, and although the brief is fairly open, this is a competitive market, and every opportunity must be seized to distinguish City Sandwich from other companies offering the same service. A design that could be adapted for use on menus, both the printed version and a large whiteboard display, would be an advantage.

SOLUTION A business selling low-value products such as sandwiches cannot generally afford to spend money on advertising, and so it was decided that the name, City Sandwich, should be printed on the bags, which would make every customer a potential advertisement. The name is set conventionally on the bags, but a graphic illustration of the bag has been created using attractive pastel colors. This is the visual identity. The bag device is repeated in more muted tones as an overall bleed illustration covering the entire letterhead.

Butem vel eum iriure do lor in hen dre

On the envelope (opposite) the logo is used the same size as on the business card, but without the overall background.

On the business

card both illustra-

tions are reduced

relative positions

remain the same as

on the letterhead,

to 75%. Their

but the large

illustration is

cropped on all

sides except the

top so that it fits

the card. The

within the shape of

margin to the right

of the small illustra-

tion is 1p10, as are

the margins to the

left and below the

address. Allow one line space between the cardholder's name and the address.

FOLD

FOLD

The address is set Franklin Gothic Heavy caps and ranged left to align with the smaller illustration. It overprints 100% black on the

background illustration.

There is no keyline around the edge of the illustration.

Nancy Richter Landon Foods 1675 Campion Avenue Brompton Anystate 63809 Tel (777)893-4747 Fax (777)893-4848

CITY SANDWICH

CITY SANDWICH 1068 PLANEDALE ROAD Amhurst ANYSTATE 45207 TEL (666)754-2876 FAX (666)754-4532

Dear Nancy

Lorem ipsum dolor sit amet, consectetuer adipiscing elit, sed diam nonummy nibh euismod tincidunt ut laoreet dolore magna aliquam erat volutpat. Ut wisi enim ad minim veniam, quis nostrud exerci tation ullamcorper suscipit lobortis nisl ut aliquip ex ea commodo consequat. Duis autem vel eum iriure dolor in hendrerit in vulputate velit esse molestie consequat, vel illum dolore eu Ut wisi enim ad minim veniam, quis nostrud exerci tation ullamcorper suscipit lobortis nisl ut aliquip ex ea commodo consequat.

Duis autem vel eum iriure dolor in hendrerit in vulputate velit esse molestie consequat, vel illum dolore eu feugiat nulla facilisis at vero eros et accumsan et iusto odio dignissim qui blandit praesent luptatum zzril delenit augue duis dolore te feugait nulla facilisi. Nam liber tempor cum soluta nobis eleifend option congue nihil imperdiet doming id quod mazim placerat facer possim assum.

Lorem ipsum dolor sit amet, consectetuer adipiscing elit, sed diam nonummy nibh euismod tincidunt ut laoreet dolore magna aliquam erat eros et accumsan et iusto odio dignissim qui blandit praesent luptatum zzril delenit augue duis dolore te feugait nulla.

Yours sincerely

Sandra Dean

CITYSANDWICH

vertical white shape in the background

illustration. Even though the background colors are pale tints and the letter text will read clearly when it is overprinted on them, this would look a little messy.

40% blue 40% pink 40% blue + 15% pink

CITY SANDWICH 1068 PLANEDALE ROAD AMHURST AMHURST ANYSTATE 45207 TEL (666)754-2876 FAX (666)754-4532

The bag illustration has been drawn using a graphics program. The simple shapes have been created with the freehand drawing tool, and the name, set in Franklin Gothic Heavy and letter spaced slightly, has been distorted by means of the envelope editing tool to mimic a crumpled shape. The bag shape could be made by using roughly cut sheets of black paper to create line artwork, and this would, in fact, be quicker than using the graphics program. Distorting the name would be more difficult, however, although it could be typeset and digitally created, before being pasted down on the artwork.

The smaller bag illustration uses the two spot colors. blue and pink, at 100% strength. Pink, at 30%, has been added to the blue to create a slightly deeper, third color - purple - for the name.

Blue+ Pink 30% Pink

CITYSANDWICH

Blue

101

The letter text is set in Franklin Gothic Roman. There is an extra-wide margin on the left so that the letter does not fall within the long.

advanced STATIONERY

CLIENT _			ARTS CENTER
regional a	WITH COMPLIMENTS		PLANEDALE PLAZA AMMURST ANYSTATE 45207 TEL (666)754-2876
arts	AMANDA COLE ADMINISTRATOR	CENTER	FAX (666)754-4532
<u>e</u>	Land Control of Contro		
Iter	PLANEDALE PLAZA Anhurst Anystate 45207 TEL (464)54-1876 FAX (466)74-4532	BflY	

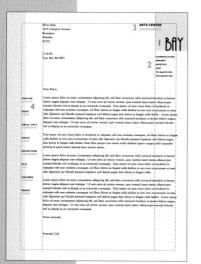

fBC

2 Butem vel eum iriure do lor in hen dre rit in vulp utate SPECIFICATIONS

Format

8½ x 11 in or A4 Letter margins

l4p7 r4p2 t2p11 b2p11

Compliment Slip 33% letterhead depth

Envelope Standard business

Business Card $3^{3}/8 \times 2^{1}/8$ in

Fonts

- Plaza Track: see opposite
- I Logo 55pt

Gill Bold

- Track normal
- 2 Address
- 6/12pt Letterhead / Comp Slip5/12pt Business Card / Envelope3 Arts Center, With Compliments
- 15pt
- 4 List 7/42pt

7/42pt

- Gill Sans 5 Job Title 5/10pt
 - Stock

White 100% cotton #24 Recycled board #80 **BRIEF** The Bay Arts Center, an important regional center for the visual and performing arts, is situated in an impressive coastal location. A new visual identity and stationery have been commissioned, and it is important that the center's international reputation is reflected in the design solution. A comprehensive range of stationery will be needed, and so flexibility is an important factor, while an indication of the variety of arts on offer would be an advantage.

SOLUTION A cool, refined, and elegant design using a purely typographical approach, with colored panels and rules to provide visual interest, is proposed. Achieving such simplicity, which creates a classic and timeless effect, is a severe test of layout skills, as proportion, use of white space, and typography are the primary design tools to be employed. This uncomplicated approach has the additional advantage that it makes the design easier to adapt for use on a wide variety of items. This flexibility extends to the logo, which can be bled off on either the left or right side. Printing is in black plus two non-process colors. The panels on the left and behind the logo print midolive green, while the horizontal rules print burgundy red.

ARTS CENTER

AMHURST

ANYSTATE

TEL (666)754-2876

FAX (666)754-4532

45207

The compliments slip (opposite) repeats the layout of the letterhead, with the words "With Compliments" being aligned horizontally with the word "Bay." The rule hangs a 6pt space beneath it and 4p7 from the left edge.

The business card (opposite) also follows the layout of the letterhead, but the panel on the left has been deleted and the name and iob title are set in 5pt with margins of 7pt at the top, left, and bottom. To distinguish it from the name, the job title is set in roman rather than bold.

FOLD

FOL

THEATRE

MUSIC

DANCE

FILM

CHILDREN

FRINGE

VISUAL ARTS

EXHIBITIONS

The thick rules – 8pt and 6pt – are a feature of the design. Not only do they add visual interest, but they are essential for strengthening the small size of the copy set in Gill Bold. 1675 Campion Avenue Brompton Anystate 45310 7/16/95 Your Ref. Blu7803

Kevin Ryan

Dear Kevin,

Lorem ipsum dolor sit amet, consectetuer adipiscing elit, sed diam nonummy nibh euismod tincidunt ut laoreet dolore magna aliquam erat volutpat. Ut wisi enim ad minim veniam, quis nostrud exerci tation ullamcorper suscipit lobortis nisl ut aliquip ex ea commodo consequat. Duis autem vel eum iriure dolor in hendrerit in vulputate velit esse molestic consequat, vel illum dolore eu feugiat nulla facilisis at vero eros et accumsan et iusto odio dignissim qui blandit praesent luptatum zzril delenit augue duis dolore te feugait nulla facilisi. Lorem ipsum dolor sit amet, consectetuer adipiscing elit, sed diam nonummy nibh euismod tincidunt ut laoreet dolore magna aliquam erat volutpat. Ut wisi enim ad minim veniam, quis nostrud exerci tation ullamcorper suscipit lobortis nisl ut aliquip ex ea commodo consequat.

Duis autem vel eum iriure dolor in hendrerit in vulputate velit esse molestie consequat, vel illum dolore eu feugiat nulla facilisis at vero eros et accumsan et iusto odio dignissim qui blandit praesent luptatum zzril delenit augue duis dolore te feugait nulla facilisi. Nam liber tempor cum soluta nobis eleifend option congue nihil imperdiet doming id quod mazim placerat facer possim assum.

Lorem ipsum dolor sit amet, consectetuer adipiscing elit, sed diam nonummy nibh euismod tincidunt ut laoreet dolore magna aliquam erat volutpat. Ut wisi enim ad minim veniam, quis nostrud exerci tation ullamcorper suscipit lobortis nisl ut aliquip ex ea commodo consequat. Duis autem vel eum iriure dolor in hendrerit in vulputate velit esse molestie consequat, vel illum dolore eu feugiat nulla facilisis at vero eros et accumsan et iusto odio dignissim qui blandit praesent luptatum zzril delenit augue duis dolore te feugait nulla.

Lorem ipsum dolor sit amet, consectetuer adipiscing elit, sed diam nonummy nibh euismod tincidunt ut laoreet dolore magna aliquam erat volutpat. Ut wisi enim ad minim veniam, quis nostrud exerci tation ullamcorper suscipit lobortis nisl ut aliquip ex ea commodo consequat. Duis autem vel eum iriure dolor in hendrerit in vulputate velit esse molestie consequat, vel illum dolore eu feugiat nulla facilisis at vero eros et accumsan et iusto odio dignissim qui blandit praesent luptatum zzril delenit augue duis dolore te feugait nulla facilisi. Lorem ipsum dolor sit amet, consectetuer adipiscing elit, sed diam nonummy nibh euismod tincidunt ut laoreet dolore magna aliquam erat volutpat. Ut wisi enim ad minim veniam, quis nostrud exerci tation ullamcorper suscipit lobortis nisl ut aliquip ex ea commodo consequat.

Yours sincerely,

Amanda Cole

The wide left margin -10p4 - forthe letter text allows the list of the various art forms to run down the side, partly overprinting the panel. This list is ranged left, 4p l from the left edge of the paper, which still allows for punched holes if the letters are to be filed in ringbinders. The relative size of all text elements is always important in the creation of an effective layout, but the absolute size is important too – smaller sizes generally give a more up-market impression. The logo comprises the word "Bay" set in 55pt Plaza, and this has been duplicated to form a shadow, 20% black, offset vertically to the right by the thickness of one character. The three characters have been kerned to give exactly the letter spacing desired Alternatively, they could easily be set, cut, and pasted to the same positions. The remaining words, "Arts Center," are set in 10pt Gill Bold caps.

Gill Bold has been chosen for most other copy. A bold sans serif face is necessary for good legibility when text crosses from a white background to a tint panel. Gill is one of the older sans serif faces, and it fits comfortably with the Art Deco style of Plaza.

The designer checked with the client to make sure that the specified layout and font would be practically applied. The letter text is 10/13pt Goudy Old Style, set loose. This is a fairly small size for letter text, but a larger size would overwhelm the rest of the design.

advanced STATIONERY

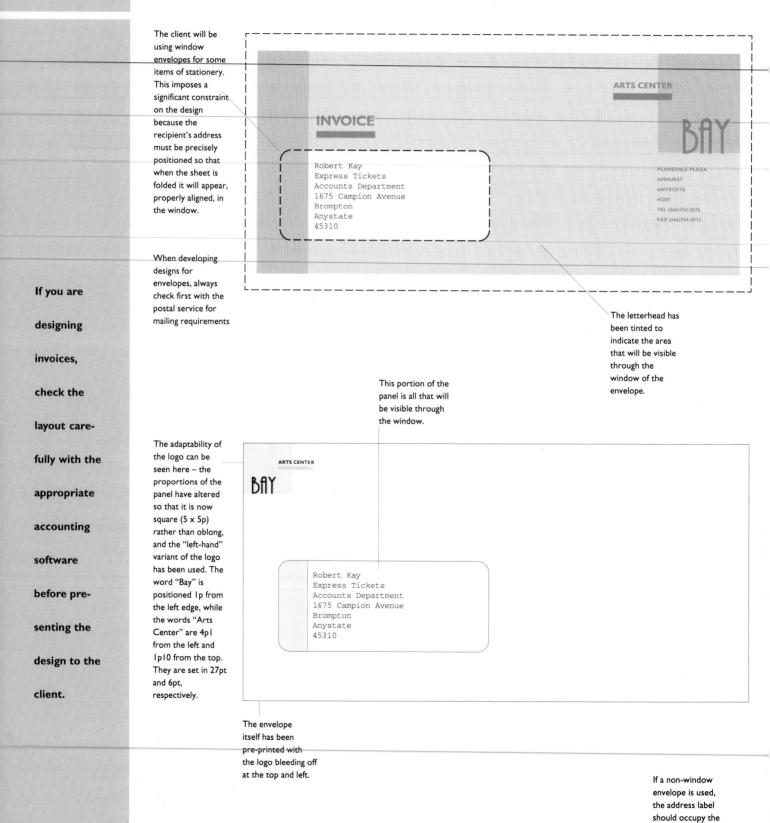

same position as

the window.

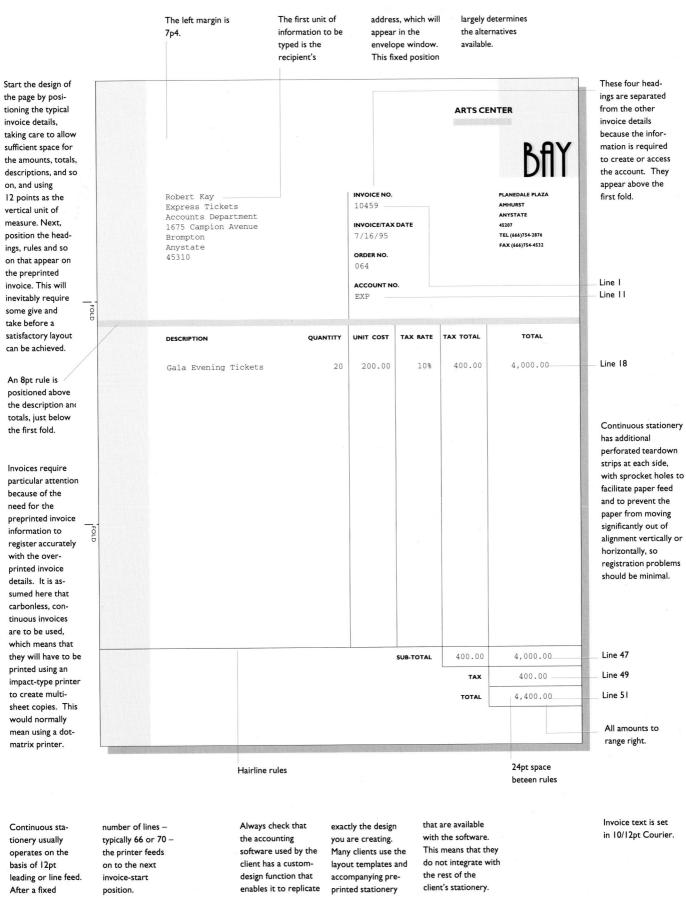

advanced STATIONERY

		~														
at the second																
CLIENT	•															
	les	•	Gr .													
	ign															
	gro		Q										EDALE ROAD			
	pup	2		, ,	ςυ	I N	ΤE	s	S	E N	с	E	1068 PLAN	AMHURST	ANY STATE	19422

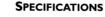

Format 8½ x 11 in or A4

Q

Q

Letter margins | 4p7 r lp2 t lp10 b 2p5

Envelope Standard business

Business Card $3^{3}/_{8} \times 2^{1}/_{8}$ in Font

Gill Sans Track force justify

I Logo

- 10pt, 7pt • Track extra loose
- 2 Address 6/27pt Letterhead 5/22pt Business Card / Envelope
- Track force justify 3 Name on business card 6pt Stock
- Brilliant white ultra-smooth #24/#80

BRIEF Five designers who work in a loose collaboration have decided to formalize the arrangement by creating a partnership called Quintessence. A new identity and stationery are required. The multi-disciplinary team wants to identify the various areas of specialization – e.g., graphic, product, environmental – while retaining the corporate identity. Being their own client is the best way of appreciating the problems associated with creating a new identity.

SOLUTION A symbol using the letter Q has been designed, based on Futura, which has a perfectly round Q. This simple device is capable of many adaptations, and could easily be animated if required. The letterhead uses all five letter forms, positioned vertically down the right side, while the business card and some other items bear only the symbol specific to that partner. Gill Sans is used for all text; when it is set with loose spacing it gives a light, spacious look to the page.

ı Abc

2

2 Butem vel eum iriure do lor in

The name Quintessence is handled very discreetly, being force justified over a wide measure. The layout relies on the sum of the parts for its overall impact.

different spot color

- (from top to

bottom) purple,

single second

appropriate color.

The primary component of the letterhead is composed of all five forms of the symbol, each in its specific spot color. It is this version that will be used on self-promotional material, in exhibitions and so on.

The date and reference are positioned so that they range right with the last line of the address.

A feature of the design is the vertically positioned address details. A small amount of text in this position is acceptable – larger amounts would be difficult to read.

A hairline vertical rule bleeds off at top and bottom, creating a separate space in which the five symbols are contained.

advanced STATIONERY

	×															
	5															
		Q	U	I ,	Ν	т	E	S	S	E		Ν	C	2	E	
	The fax header follows the format	ATTN:										Ę				
	of the letterhead but is printed in	Dept:														
	black only. The	DEPT:														
	To and From text is divided by	DATE:												× Mess		
	hairline horizontal rules, which												FA.	X MESS	AGE	
	partition the															
	space available for completing the															
	details.															
	9 a a															
ulti-																\cap
																X
version																
when			L	$\langle \rangle$												
inications																
		$\overline{\langle } \rangle$			7											
m the		-117				7	104									
rship	The five versions of															
	the symbol will be															_
ole	used individually on specific pages of the															
	company brochure.								_							
than		FROM:								0 V D						
ie indi-		NO. OF	PAGES:							ALE RC				-2876	-4532	
									_	1068 PLANEDALE ROAD	S T	TE		TEL (066)754-2876	FAX (066)754-4532	
lesign		Ref.								068 P	AMHURST	A N Y STATE	19422	90) IJ.	AX (06	
										-	*	4	-	F	u.	A
nes.	L															

The central portion of the page is for the message. This is likely to be handwritten, and so the maximum area has been left blank.

The m

symbo

is used

comm

are fro

partne

as a wh

rather

from th

vidual

discipli

The purchase order will need to be in a form that leaves a duplicate after the order is sent. In smaller companies this has traditionally meant using a printed duplicate pad. However, some businesses now insist that all orders are typed on a word processor or set up within their accounting software systems.

The first entry, the order number, will start on line 27 of the continuous stationery. FOLD

FOLD

101

A horizontal rule is used to define the area to be used for the order details. There is sufficient space below for the signature of the partner confirming the order.

1arketing CBSP 675 Camp Brompton Anystate	Director										
Brompton	ion Avenue										
9422						PURC	HASE	ORDER	ł		
PURCHASE	DRDER NO		Job N	10.				DA	TE		
GD 00657			CPBS	004				7/1	L6/95		
PLEASE SUPP	LY										
ó Boxes	Lorem ip:	sum dolor	sit amet,	consec	tetuer						
1,500	Sheets ad idunt ut		elit, sed	diam no	nummy r	nibh (euis	nod t	inc		
24	Dolore ma	agna aliqu	uam erat v	olutpat							
10 Packs	Ut wisi ullamcor	enim ad m: per suscij	inim venia pit lobort	am, quis is nisl	nostru ut ali	d exe quip	erci ex e	tati ea co	on mmod	0	
18		em vel eur se molest	m iriure d ie	lolor in	hendre	erit :	in vı	lput	ate		
Signed											
Signed					17 12	068 PLANEDALE ROAD				TEL (066)754-2876	FAX (066)754-4532

establishing a system, new to them, that will keep a record of time sheets and all boughtin costs to enable more efficient drafting of invoices. This means that purchase orders have to be input on the computer and printed-out using a dot-matrix (impact) printer. This requires the purchase order text to be set on a 12pt leading (line-feed) on the preprinted continuous stationery.

Quintessence is

As always, when the layout involves printing onto preprinted stationery, the design should take into account the demands of the over-printing from the outset, and the layout should be carefully tested to check the registration of line-feed, tabs and so on.

The name should be ranged with the recipient's address. A #19 white paper has been chosen for the continuous stationery. As the purchase order will be seen only by suppliers and not by clients, printing in black only will be sufficient.

publishedSTATIONERY

Right and far right: This housing exchange service has chosen a simple centered design. The logo is formed from an acronym of the full name, and the symbol cleverly evokes both housing and moving home. The symbol sits within a pale tint panel, and the name is letterspaced to this width. Miniversions of the arrow device are centered between each character

ON 24TH MAY, N·M·O, L·A·M·S, AND H·A·L·O ARE MOVING TOGETHER TO SET UP⇒

Telephone 071-233 7077 26 Chapter Street, London SWIP 4ND Facsimile 071-976 6947 H.O.M.E.S., incorporating NMO, LAMS and PALO, is registered as a limited company, No. 19903

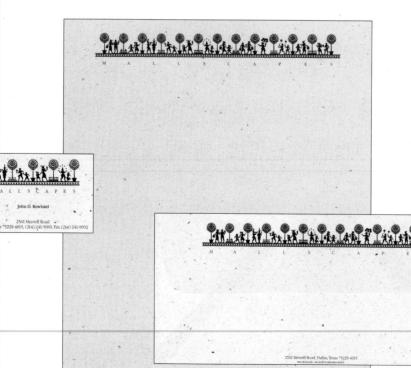

Left: The design of a visual identity, logo or symbol is always inextricably linked with the layout of the letterhead, whose design will be constrained by the shape of the logo. Placing the long, narrow illustration

for Mallscapes at the top of the page, with the letterspaced name below it, means that the address has to be placed at the foot of the page. This combination is also used on the back of the envelope, but only the central portion of the illustration is used on the business card, and the name is letter-spaced to this narrower measure. The flecks in the paper are the result of the recycling process.

As the examples on this page show, design companies have a high regard for distinctive and well-conceived visual identities. They also set great store in devices that are sufficiently adaptable to be used on a range of stationery beyond the usual letterhead, business card, and envelope. The cockerel is the main symbol of a design group, and it is used on the letterhead together with the border and other graphic devices, including two marks to indicate the position of the recipient's address and the beginning of the

letter. The group's name and address are positioned at an angle, and a sanserif face is used on all items of stationery. The border is repeated on the continuation sheet, although in a lighter tone, and there is no address or symbol. Other animals are also used in the repertoire of symbols that comprise the entire group identity, and these are used on business cards and even on party invitations. The group's address label also has marks as a guide to the position of the address.

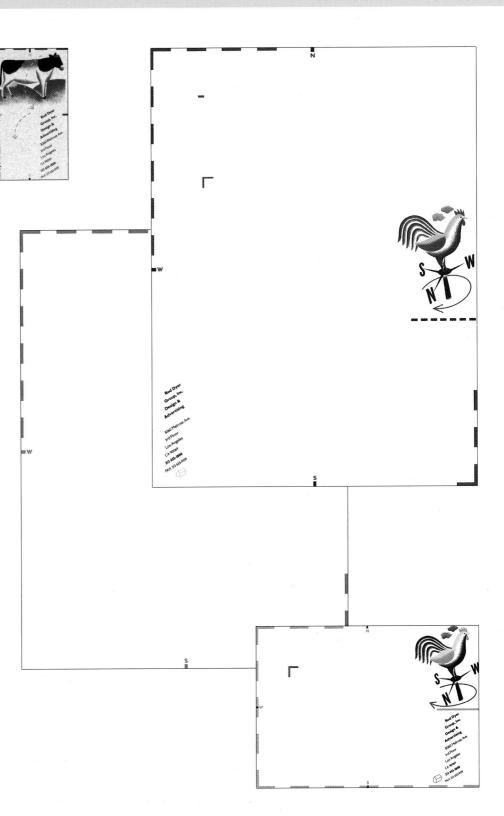

published <u>STATION</u>ERY

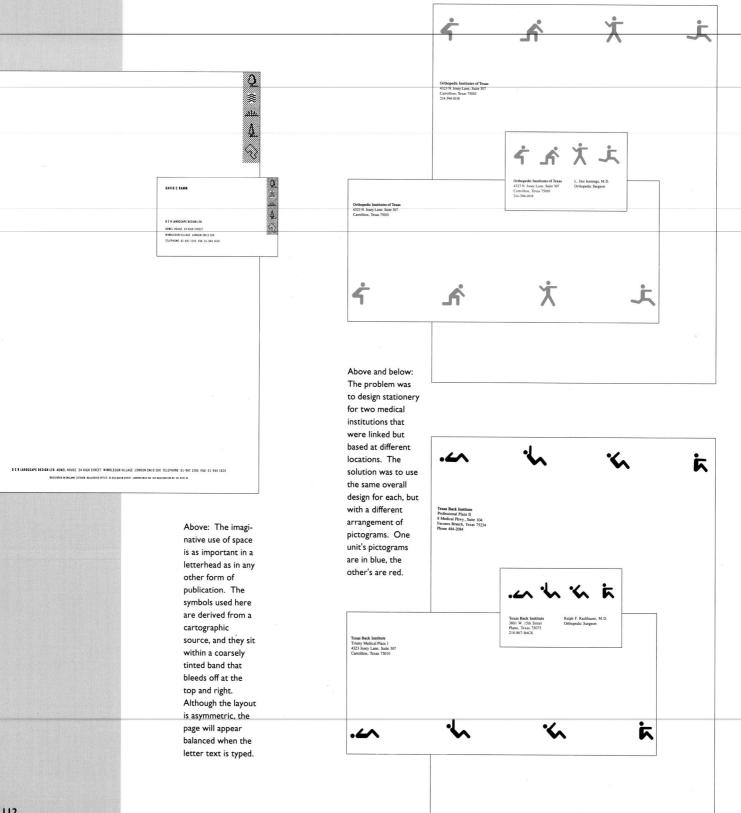

the MARKET BAR

Hillcrest Construction, Inc 3402 McFarlin Suite 210 Dallas, Texas 75205

Above and right: The main elements of this asymmetric design are the name and the illustration, which bleeds off on the right. The uneven edge of the

> Hillcrest Construction, 3402 McFarlin Suite 210 Dallas, Texas 75205 214-522-5094 Fax 214-522-5095

> > .

1

the decorative panels at the top and bottom give an off-beat look, which is appropriate to the subject. The name is set in

illustration and

a serif face, and the word "the" is lower case. In contrast, the address is set in a condensed sanserif face.

240A PORTOBELLO ROAD - LONDON W11 1QR - TELEPHONE: 01-229 6472

Left and below: The ruler device bleeds across the top of the construction company's letterhead and business card. However, this layout is not used on the envelope, where it would conflict with the stamp. The name and address are set in a small serif face because a bolder face or more complex typography would conflict with the delicate appearance of the ruler device.

4 Hillerest Construction, Inc. Jim Kick 3402 McFarin Suite 200 Project Manager Dullas, Texas 7205 214:522-5093 Fax 214:522-5093

ng to

in

vulputa

molestie vel illur feugiat

at vero

LOCAL PET STORE

- CHARITY APPEAL
- DISCOUNT TRAVEL
- **BOTANICAL GARDENS**
- **DISCOUNT SHOPPING CENTER**
- **ADVISORY GROUP**
- SELF-HELP GROUP
- INTERIOR DESIGN STORE
- SPECIALIZED CLOTHES RETAILER
- SHOE MANUFACTURER
- **BUSINESS EXECUTIVES CLUB**

VISIT THE TIMELESS SPLENDOUR OF RUTLAND CASTLE GARDENS

dolore magna aliquam erat volutpat. Ut wisi enim ad minim veniam, quis nostrud exerci tation ullamcorper suscipit lobortis nisl ut aliquip ex ea commodo consequat. duis autem vel eum iriure dolor in hendrerit in vulputate velit esse molestie consequat, vel illum dolore eu feugiat nulla facilisis at vero eros et accumsan et iusto odio dignissim qui landit praesent luptatum zzril delenit augue duis dolore te igait nulla facilisi. Lorem ipsum dolor sit amet.

sectetuer adipiscing elit, sed diam nonummy nibh euismod int ut laoreet dolore magna aliquam erat volutpat. Ut wisi minim veniam, quis nostrud exerci tation ullamcorper portis nisl ut aliquip ex ea commodo consequat. Duis

hendrerit in vulputate velit esse molestie consequat. Vel illum dolore eu feugiat nulla facilisis at vero eros et accumsan et iusto odio ignissim qui blandit praesent zzril delenit augue

facilisi. Lorem ipsum dolor sit amet, consectetuer adipiscing elit, sed diam nonummy nibh euismod tincidunt ut laoreet dolore magna aliquam erat volutpat wisi enim ad minim veniam. Quis nostrud exerci tation ullamcon

suscipit lobortis nisl ut aliquip ex commodo consequat. Duis auten eum iriure dolor in hendrerit in vul

velit esse molestie consequat, vel illum dolore eu feug facilisis at. Vero eros et accumsan et justo odio digi blandit praesent luptatum zzril delenit augue dy feugait nulla facilisi lorem ipsum dolor sit amet.

Consectetuer adipiscing elit, sed diam nonun tincidunt ut laoreet dolore magna aliquam o enim ad minim veniam, quis nostrud e suscipit lobortis nisl ut aliquip ex eas vel eum iriure dolor in hendrerit in vulputate velit esse mol consequat, vel jll

ADVERTISEMENTS

dvertising is traditionally the domain of the specialized agency, with its separate departments managing not only the creative aspects of the individual advertisements but also the research, media buying, PR, and production. Those organizations requiring the full service will naturally choose such an agency. Many smaller companies and organizations, however, know their market and the media in which they wish to advertise, and a smaller design group, an in-house department, or even an accomplished freelance designer may suit them better.

Because the printing and paper quality will be outside your control, you will need to ascertain the technical data relating to the publications in which the advertisements will appear. Most will require film separations for color and camera-ready artwork for black and white. It is important to be able to adapt a basic advertisement to a variety of formats without changing radically the relationship between the various elements, and generating the layout on a DTP system is a great help here. Collaborating with a good copywriter is essential if you are to produce properly integrated written and visual ideas.

Unlike newsletters, brochures and stationery, which are generally read in isolation, advertisements normally appear within a newspaper or magazine, where they have to compete not only with other advertisements but also with editorial matter. This means that the layout has to work much harder than that of a newsletter or brochure to arrest the reader's attention – and retain it. The basic level examples deal with the adaptation to different sizes of a small black-and-white, semidisplay advertisement; the development of a blackand-white single-page advertisement – which follows the classic picture, headline, body copy, and logo layout that is used in a large number of magazine and newspaper advertisements but is still effective; and the preparation of a robust typographic advertisement for a cut-price travel company.

The intermediate level uses more typographical refinement and introduces color. There is a more demanding adaptation, a complex multi-featured editorial-styled layout, and an advertisement that uses a specially commissioned still-life photograph.

The advanced level includes an uncompromising headless layout, a design based on the style of the 1940s, a split-headline design with a composite photographic main image, and an unusual multi-page, advertisement feature that uses a long, typographically manipulated quotation as its headline.

At all levels the purpose of the advertisement remains the same – that is, to capture the reader's attention and communicate the message. The advertisement, usually a single page or less, must overcome the limitations of space by being clearly focused. The layout should be simple and uncomplicated, and should normally avoid type that is too small and headings that are too long. The following pages show a range of layout options, each of which was created to address a particular brief, but many of which could be adapted to suit the requirements of other clients, too.

> The advertisements on the following pages are reproduced at about 63% of the actual size. A sample of the headline and text is shown actual size on the left-hand page, together with a mini-version of the advertisement with the grid overlaid in blue.

115

basic

ADVERTISEMENTS

The two-column version of the advertisement shown in a typical newspaper environment.

OPENING MAY 12²

OPENING

MAY 12

Lorem ipsum dolor sit amet, co

pat's . pets

pat's

Lorem ipsum dolor sit innet, consectetuer adipis cing elit, sed diam no nummy albh euismo idun aliquam erat volutpat. Il Ut visi enim ad minim yeniam, quis nostrud exerci tation ullamcorper suscipit loboriti nisi ut aliquip ex ea commodo. Duis autem vel eum triure dolor in hndrerit in yulputate velit esse

C

Lorem ipsum dolor sit amet, consect tuer adipis cing ellit, sed diam no numa nibh euismo idunt ut laoreet dolore magna aliquam erat volutpat. Ut visi enim ad minim veniam, quis nostrud exerci tation ullamcorper susci lobortis nist ut aliquip ex ea commodo. Duis autem vel eum iriure dolor in hudrerit in vulputate vulputate velit esse **OPENING MAY 12**

Lorem ipsum dolor sit amet, co ipis cing elit, sed diam no numn euismo idunt ut laoreet dolore magna aliquan

euismo idunt ut laoreet dolore magna aliquam erat volutpat. Ut wisi enim ad minim veniam, quis nostrue exercitation ullameorper suscipit Jobortis nisl ut aliquip ex ea commodo. Duis autem vel eum iriure dolor in hndrerit in vulputate velit esse

SPECIFICATIONS

Format

A 17/8 x 41/2 in B 3¼ x 4½in C 51/4 x 21/2 in

Grid

I-column Space between - none

Margins

llp5 rlp5 tlp5 blp5

Fonts **Times Bold**

Track loose

- I Body text
 - A 10/11/2pt
- B II/I3pt C 101/2/12pt
- 2 Helvetica Black
- Track normal 3 Headlines
- A 32/35pt
- B/C 59/59pt 4 Logo
- Customized leading Logo Master 30/19pt
- A 100%
- B 94%
- C 81%

BRIEF A neighborhood pet store wants to advertise the opening of a second shop in a nearby town. There will be one-, two-, three-, or fourcolumn advertisements in local newspapers and specialized breed newsletters, together with some posters and flyers. Pat's Pets intends to develop a mail-order service for some more unusual animals. With this in mind, a new identity has been created using the zebra graphic, a striking image, which offers the opportunity for some amusing headline puns in future advertisements.

SOLUTION Since the newspaper advertisements will be of poor print quality, a small amount of fairly large body text will be appropriate as legibility will be a critical factor. A layout that can be easily adapted to suit a variety of newspaper column widths is required. The headline is pared down to the basic announcement and used as large as the width of the advertisement will allow. No formal grid is employed, but the margins around each adaptation remain constant. Ideally, the relative proportion of headline to text should remain

In most

circumstances,

caps-only headlines

require less leading

than upper/lower

case type because

the space between

descenders. As all-

caps headlines get larger they need

progressively less

leading, as the

reveal:

specifications for

these two versions

A 32/35pt (109%)

B 60/60pt (100%)

each line is not

interrupted by

constant when an advertisement is adapted to other sizes and formats.

В

The examples on this page are all shown actual size.

OPENING MAY 12

Lorem ipsum dolor sit amet, consectetuer adipis cing elit, sed diam no nummy nibh euismo idunt ut laoreet dolore magna aliquam erat volutpat.

Ut wisi enim ad minim veniam, quis nostrud exerci tation ullamcorper suscipit lobortis nisl ut aliquip ex ea commodo.

Duis autem vel eum iriure dolor in hndrerit in vulputate velit esse

erat volutpat.

in vulputate velit esse

It is not always possible to keep the relative size of headline to text constant, as example C shows. If this headline had been set with the relative sizes used in example B, the headline would have been much smaller and would not have stretched across the full width, which would have made the layout much weaker.

OPENING MAY 12

Lorem ipsum dolor sit amet, consecte tuer adipis cing elit, sed diam no nummy nibh euismo idunt ut laoreet dolore magna aliquam erat volutpat.

Ut wisi enim ad minim veniam, quis nostrud exerci tation ullamcorper suscipit lobortis nisl ut aliquip ex ea commodo.

Duis autem vel eum iriure dolor in hndrerit in vulputate velit esse

OPENING MAY 12

Headlines are set in Helvetica Black, the same face as the logo, although in capitals rather than lower case. This helps to maintain the simple yet strong identity.

The ruled boxes surrounding each advertisement are 1/2 pt. Avoid using heavy ruled boxes, which invariably look clumsy.

The identity - that is, the name, the zebra device, and the rule - must always remain constant. Never vary the component parts. Enlarge or reduce the whole, within reason, to suit the particular needs of the layout, and always position it in the same place here, it is always in the bottom righthand corner of the layout.

Brevity is a prime requirement for the text. Three short paragraphs set in a bold face

Lorem ipsum dolor sit amet, consectetuer

Duis autem vel eum iriure dolor in hndrerit

euismo idunt ut laoreet dolore magna aliquam

Ut wisi enim ad minim veniam, quis

nostrud exerci tation ullamcorper suscipit

lobortis nisl ut aliquip ex ea commodo.

adipis cing elit, sed diam no nummy nibh

are easy to read, even in the smallest example. A. Paragraph indents should be generous, with wider measures having larger indents.

These three adaptations of the advertisement retain the family feel but at the same time are sufficiently flexible for a variety of formats to be used.

117

A D V E R T I S E M E N T S

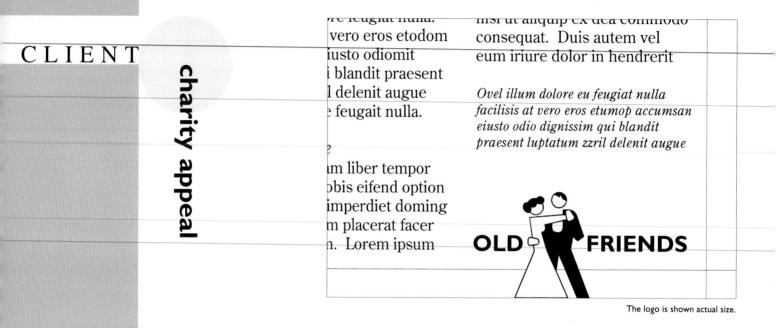

"Old friends sit on the park 2 bench like book-ends"

Lorem ipsum dolor sit amet, consectetuer adipiscing elit se diam nonumny nibh euismod incidunt ut laoreet dolore magna aliquam erat volutpat. Ut wisi enim ad minim veniam guis nostrud exerci tation.

basic

URE DOOR-CENTS
URE DOOR-CENTS
Inditional utilization in the second se

Format 8½ x I lin or A4 Grid

3-column Space between – 1p5

Margins | 2p|| r 2p||

t 2pli b 2pli Fonts

Century Old Style Track loose

I Body text 12/14pt

Century Old Style italics Track loose

2 Headlines 40/40pt

Subheads

Gill Sans

Track loose

Logo 17pt **BRIEF** A recently launched charity has been charged with the task of alleviating loneliness among the elderly. It requires an advertising campaign to increase awareness of the problem and to enlist voluntary helpers. The advertisements will appear in specially selected magazines, and the layout will have to incorporate a fairly large amount of text. The target audience is defined as middle-class and middle-aged.

SOLUTION A single page bleed, black and white advertisement with a headline from a Simon and Garfunkel song accompanied by a poignant photograph are combined to evoke a sympathetic response from the reader. The face chosen for both headline and text is Century Old Style, roman and italic. The italic provides the necessary contrast with the text, and is also used for the subheads. The crossed rules border is of hairline thickness, and the motif overlaps it, focusing attention on the logo. A three-column grid provides the underlying structure.

Butem vel eum iriure do lor in hen dre rit in vulp utate This design follows the classic advertisement layout of stacked picture, headline, and body text, with the logo in the bottom right-hand corner. The single photograph should catch the reader's eye, while the headline focuses attention and the body copy delivers the message.

A harmonious layout can be achieved by maintaining equal spaces between the elements. This is not, however. always a simple matter of measurement. These rivers of space are visually equal, but, because the text is ranged left, the actual margin of IpI is less than the space above and below the headline. Similarly, the ascenders of the first line of the heading create an uneven space. Because there are no descenders, the second line of the heading creates an even channel of space.

"Old friends sit on the park bench like book-ends"

Lorem ipsum dolor sit amet, consectetuer adipiscing elit sed diam nonumny nibh euismod tincidunt ut laoreet dolore magna aliquam erat volutpat. Ut wisi enim ad minim veniam, quis nostrud exerci tation.

Loneliness

Ullamcorper suscipit lobortis nisl ut aliquip ex ea commodo consequat. Duis autem el eum iriure dolor in hendrerit in vulputate velit waness molestie consequat, vel illum dolore.

Feugiat nulla facilisis at vero eros et accumsan et iusto odi dignissim qui blandit praesent luptatum zzril delenit augue duis dolore te feugait nulla facilisi. Lorem ipsum dolor sit amet, consectetuer adipiscing elit, sed diam nonummy nibh euismod tincidunt ut laoreet dolore magna aliquam haerat volutpat ult wisi enim ad.

Minim veniam, quis nostrud exerci tation ullam corper suscipit lobortis nisl ut aliquip ex ea commodo consequat. Duis autem vel eum iriure dolor in hendrerit in vulputate velit esse molestie consequat, vel illum dolore feugiat nulla.

Facilisis at vero eros etodom accumsan et iusto odiomit dignissim qui blandit praesent luptatum zzril delenit augue duis dolore te feugait nulla.

Self reliance

Facilisi: Nam liber tempor cum soluta nobis eifend option congue nihil imperdiet doming id quod mazim placerat facer possim assum. Lorem ipsum dolor sit amet, consect aetuer adipiscing elit, omsed diam nonummy nibh enim euismod tincidunt ut laoreet dolore magna aliquam erat volutpat.

A helping hand

Ut wisi enim ad minim venia quis nostrud exerci amrtation ullamcorper suscipit lobortis nisl ut aliquip ex dea commodo consequat. Duis autem vel eum iriure dolor in hendrerit

Ovel illum dolore eu feugiat nulla facilisis at vero eros etumop accumsan eiusto odio dignissim qui blandit praesent luptatum zzril delenit augue

The subheads are 2 points larger than the body text, but retain the same 14pt leading.

The headline is set solid - that is, there is no additional leading. On its own it might have benefited by a little extra leading, but in the context of this layout more space would have been required between the photograph and the body text, and this would have weakened the design, as would the alternative solution of reducing the headline size.

If the advertisement has been successful, the reader will require some contact information. This is set as text, but in italics to differentiate it from the other text.

The logo must include an extra allowance for the bleed. Check the mechanical data with the magazine to determine this space.

The page margins are equal on all four sides so that the hairline crossed ruled box forms an exact square at each corner.

basic ADVERTISEMENTS

CLIENT

discount travel

o eros et accumsan et iusto gnissimblandit praesent m zzril delenit augue duis feug null qui nisl ut

R PROMISE om ipsum dolor sit

et consect etuer adip ng elit, sed diam ummy nibh euismod dunt ut laoreet dolore na aliquam erat tpat. Ut wisi enim ad im veniam, quis nostrud rci tation ullam corper cipit lob ortis nisl ut aliip

The logo is shown actual size.

SPECIFICATIONS

Format 8½ x 11in or A4

Grid 7-column

Space between - 1p2

Margins ||p|0 r|p|0

t 6p b 2p7 Fonts

Helvetica

- Track loose I Body text
- 9/11pt Helvetica Black
- Track loose
- Expanded to 130% 2 Headline/Prices
- 36/36pt
- 3 Headline/Our Promise 8/11pt
- Times bold
- Track tight Expanded to 170%
- 4 Headline/Destinations
- 18/22pt
- Track force justified
- Expanded to 170%
- 5 Logo and phone number 48pt

BRIEF A discount travel company wants a new design styling for its numerous advertisements, which are placed mainly in selected magazines and, occasionally, newspapers. Advertising is the sole vehicle for selling the company's products, so the look has to be aggressive yet avoid the clutter often produced by competitors. The company sells tickets for popular routes at discount prices, and this should be reflected in the layout.

SOLUTION The client prefers single-page advertisements, although the same information could be delivered in a smaller space. A bold, nononsense layout, emphasizing destinations, prices, and a contact phone number, is selected. The seven-column grid allows each text column to occupy two grid columns, leaving a space on the left in which the company name can run vertically. Both fonts, Helvetica and Times, have been optically distorted so that they extend beyond their normal width. This may offend typographical purists, but it does allow the prices to fill almost the full text column width.

- Abc Abc
- Butem vel eum iriure do lor in hen dre rit in vulp utate velit esse illum

The longest destination name – Amsterdam – determines the type

The words "Flight

Express," which are

set in the same size

extended to 170%.

vertically Ip2 from

the left side of the

words do not align

with the far left grid

line because this

would leave them

floating too near

the center of the

otherwise crowded

"empty" first

column. In an

page, the white

space between

these words and

the first column of

text is a vital visua

The prices, set in

Helvetica Black and

extended to 130%.

are the dominant

feature. Care has

they do not align

The text comes

close to the edge

of the advertise-

ment, and this

reinforces the

boldness of the

design. This is

advertisement does not bleed.

when, as here, the

possible only

stagger them so that

been taken to

horizontally.

element.

are positioned

ruled box. The

as the phone number and also size of the rest. Here, the face, Times Bold, is e extended to 170%. The advertisement does not bleed, but fits within the type area of the page.

(800) 888–888

Amsterdam **\$249**

Lorem ipsum dolor sit amet, consectetuer adipiscing elit, sed diam nonummy nibh euismod tincidunt ut laoreet dolore magna aliquam erat volutpat. Ut wisi enim ad minim veniam, quis nostrud exerci tation ullamcorper suscipit lobortis nisi ut aliquip ex ea commodo consequat. Duis autem vel eum iriure dolor in hendrerit in vulputate veli tesse molestie onsequat vel illum dolore eu feugiat

Nulla facilisis at vero eros et accu msan et iusto odio dignissim qui blandit praesent luptatum zzril delenit augue duis dolore te feugait nulla facilisi. Lorem ipsum dolor sit amet, consectetuer adipiscing elit, sed diam nonummy nibh euismod tincidunt ut laoreet dolore magna aliquam erat volutpat wisi enim

Ad minim veniam, quis nostrud exerci tation ullamcorper suscipit lobortis nisi ut aliquip ex ea commodo consequat. Duis autem vel eum iriure dolor in hendrerit in vulputate velit esse molestie consequat, vel illumdolore eu feugiat nulla facilisisblandit praesent luptatum zzril delenit augue duis dolore feug null at vero eros et accumsan et iusto odio dignissim qui blandit praesent luptatum zzril

Soluta nobis eleifend option congue nihil imperdiet doming id quod mazim placerat facer possim assum. Lorem ipsum dolor si amet, consectetuer adipiscing elit, sed diam nonummy nibh euismod tincidunt ut laoreet dolore magna exerci tation ullamcorper suscipit lobortis nisl ut aliquip ex ea commodo consequat. Duis autem delenit delenit augue duis dolore te feugait nulla facilisi. Nam liber tempor cumaugue duis dolore te feugait nulla facilisi. Nam liber tempor cumvulputate velit esse molestie consequat, vel illum dolore

^{Dublin}

Commodo consequat. Duis autem vel eum iriure dolor in hendrerit in vulputate velit esse molestie co sequat vel illum dolore eu feugiat nulla facilisis at vero eros et accu msan et iusto odio dig nissim qui blandit praesent luptatum zzril delenit augue duis dolore feug nulla facilisi. Lorem ipsum dolor sit amet, consectetuer

London **\$199**

Wobortis nisl ut aliquip ex ea commodo consequat. Duis autem vel eum iriure dolor in hendrerit in vulputate velit esse molestie consequat, vel illum dolore eu feugiat nulla facilisis at vero eros et accumsan et iusto odio dignissim qui blandit praesent luptatum zzril delenit augue duis dolore te feugait

Tation ullamcorper suscipit lobortis nisl ut aliquip ex ea commodo consequat. Duis autem vel eum iriure dolor in hendrerit in vulputate velit esse molestie consequat, vel illum dolore eu feugiat nulla facilisis at. Vero eros et accumsan et iusto odio odignissimblandit praesent luptatum zzril delenit augue duis dolore feug null qui

OUR PROMISE

Lorem ipsum dolor sit amet consect etuer adip iscing elit, sed diam / nonummy nibh euismod tinci dunt ut laoréet dolore magna aliquam erat volutpat. Ut wisi enim ad minim vériam, quis nostrud exercí ration ullam corper suscipit lob ortis nist ut aliip

The minimum space between text and graphic should be 7pt. With ranged-left setting, most lines will fall well short of this. ^{Oslo} \$279

Exerci tation ullamcorper suscipit loboriis nisi ut aliquip ex ea commodo consequat. Autem vel eum iriure dolor in hendrerit in vulputate velit esse molestie consequat, vel illum dolore eu feugiat nulla facilisis at vero eros delenit augue duis dolore te feugait nulla facilisi. Lorem ipsum dolor sit a consectetuer adipiscing elit, sed diam nonum my beuismod tincidunt ut laoreet dolore magna aliquam

Erat volutpat. Ut wisi enim ad minim veniam, quis nostrud exerci tation ullamcorper suscipit lobortis nisl ut aliquip ex ea commodo consequat. Duis autem vel eum iriure dolor in hendrerit in vulputate velit esse molestie con sequat, vel illum dolore eu feugiat nulla facilisis at vero eros et accumsan et iusto odio dignissim qui blandit praesent

Luptatum zzril delenit augue duis dolore te feugait nulla facilisi. Lorem ipsum dolor sit amet, consecteture adipiscing elit, sed diam nonummy nibh euismod tincidunt ut laoreet dolore magna aliquam erat volutpat. Ut wisi enim ad minim veniam, quis nostrud exerci tation ullamcorper suscipit lobotis nisi ut The telephone number is vital, so it has been placed, white out, within a black, 4p10 deep panel. The face, Times Bold, is extended to 170% width. It extends over the three text columns and helps to create a strong block.

The only graphic interest in an otherwise typographical layout is the suitcase device. The sense of movement is enhanced by the speed lines. Note how the top line provides a boundary for the Vienna text, the last few lines of which need to be edited to fit the required shape.

A lpt rule surrounds both the layout and the "Our Promise" box.

A 12pt rule at the foot is necessary to balance the black panel at the top.

intermediate ADVERTISEMENTS

i

r

n t

t

h

t

suscipit lobortis nisi ut aliquip ex ea commodo consequat. Duis autem vel eum iriure dolor in hendrerit in vulputate

velit esse molestie consequat, vel illum dolore eu feugiat nulla facilisis at. Vero eros et accumsan et iusto odio dignissim qui blandit praesent luptatum zzril delenit augue duis dolore te feugait nulla facilisi lorem ipsum dolor sit amet.

Consectetuer adipiscing elit, sed diam nonummy nibh euismod tincidunt ut laoreet dolore magna aliquam erat volutpat. Ut wisi enim ad minim veniam, quis nostrud exerci tation ullamcorper suscipit lobortis nisl ut aliquip ex ea commodo consequat. Autem

vel eum iriure dolor in hendrerit in vulputate velit esse molestie consequat, vel illum dolore eu feugiat nulla facilisis at vero eros

The logo is shown actual size.

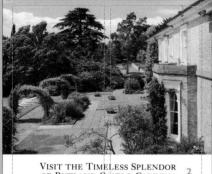

botanical gardens

VISIT THE TIMELESS SPLENDOR OF RUTLAND CASTLE GARDENS

CLIENT



SPECIFICATIONS

Format 8½ x I lin or A4 Grid 2-column Space between - Ip10 Margins

l 2pll r 2pll t 2pll b 2pll

Caslon

Track loose Body text 9/11½pt Drop cap 56pt Track very loose

- 2 Headlines
 Small caps
 28/28pt
 3 Logo
- 14/14pt

BRIEF Rutland Castle Gardens plan an early spring advertising campaign to encourage visitors during this, the Gardens' most magnificent season. The Castle houses an important collection of botanical illustrations of international renown. This has resulted in Rutland Castle Gardens becoming a mecca for painters wishing to take advantage of both the historical and living flora. The advertisement will appear in a variety of magazines – general interest, leisure, and special interest, such as gardening.

RUTLAND CASTLE

GARDENS

SOLUTION Full-color, single-page bleed advertisements are planned, and the layout, to reflect the elegance and status of the Gardens, uses a combination of caps and small caps set in Caslon for the heading. The crispness of these letter forms evokes carved stone, thus reinforcing the "Timeless Splendor" of the headline. The broad, two-column grid allows for the other two photographs to be inset, together with the drop cap and the logo.

² **A**BC

Butem vel eum iriure do lor in hen dre rit in vulp utate velit esse illum The large color photograph, which bleeds on three sides, is 39p7 deep. It dominates the page.

An effective design invariably relies on achieving a harmonious balance of all the different elements. So many factors - the size of the image, the choice of typeface, the margins, the overall proportions, the position of the headlines, the color - affect the design that it is impossible to give hard and fast rules for a successful layout.

The upright of the

drop cap is aligned

with the left side of

the text, allowing

protrude into the

Align the top and

photographs with

of the x-height of the adjacent text.

the top and bottom

bottom of the

the serifs to

margins.

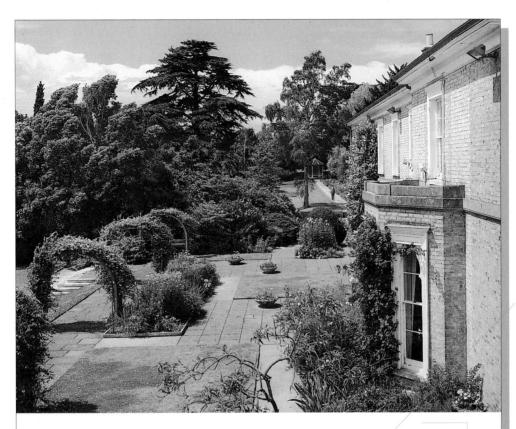

The generous margins contrast with the tight block of justified text and inset photographs, creating a formal design. Note how the positions of the drop cap, photographs, and logo are staggered across the text.

The centered headline is set in 28/28pt Caslon 540. The small caps are 80% of full size and set very loose track.

The spaces above and below the headline are visually equal.

The inset logo follows the typographical style of the headline. The hairline rules above and below, like the photographs, align with the top and bottom of the x-height of adjacent text. The rules are more elegant than the alternative of a closed box.

VISIT THE TIMELESS SPLENDOR OF RUTLAND CASTLE GARDENS

dolore magna aliquam erat volutpat. Ut wisi enim ad minim veniam, quis nostrud exerci tation ullameorper suscipit lobortis nisl ut aliquip ex ea commodo consequat. duis autem vel eum iriure dolor in hendrerit in vulputate facilisis at vero eros et accumsan et iusto odio dignissim qui blandit praesent luptatum zzril delenit augue duis dolore te feugait nulla facilisi. Lorem ipsum dolor sit amet.

Consectetuer adipiscing elit, sed diam nonummy nibh euismod tincidunt ut laoreet dolore magna aliquam erat volutpat. Ut wisi enim ad minim veniam, quis nostrud exerci tation ullamcorper suscipit lobortis nisl ut aliquip ex ea commodo consequat. Duis

autem vel eum iriure dolor in hendrerit in vulputate velit esse molestie consequat. Vel illum dolore eu feugiat nulla facilisis at vero eros et

nulla facilisis at vero eros et accumsan et iusto odio dignissim qui blandit praesent luptatum zzril delenit augue duis dolore te feugait nulla facilisi. Lorem ipsum dolor sit amet, consectetuer adipiscing elit, sed diam nonummy nibh euismod tincidunt ut laoreet dolore magna aliquam erat volutpat wisi enim ad minim veniam. Quis nostrud exerci tation ullamcorper

suscipit lobortis nisl ut aliquip ex ea commodo consequat. Duis autem vel eum iriure dolor in hendrerit in vulputate velit

esse molestie consequat, vel illum dolore eu feugiat nulla facilisis at. Vero eros et accumsan et iusto odio dignissim qui blandit praesent luptatum zzril delenit augue duis dolore te feugait nulla facilisi lorem ipsum dolor sit amet.

Consectetuer adipiscing elit, sed diam nonummy nibh euismod tincidunt ut laoreet dolore magna aliquam erat volutpat. Ut wisi enim ad minim veniam, quis nostrud exerci tation ullamcorper suscipit lobortis nisl ut aliquip ex ea commodo consequat. Autem vel eum iriure dolor in hendrerit

in vulputate velit esse molestie consequat, vel illum dolore eu feugiat nulla facilisis at vero eros

Wider text columns require a larger space between them. The hairline vertical rule reinforces the centered axis of the advertisement. Care should be taken to edit the last line of the text so that it extends to the full width. This creates a formal white rectangle in which the logo can be positioned.

intermediate ADVERTISEMENTS

CLIENT discount shopping center Five good reasons to join the megastore A team 08004567 5 0800 4567 NEYSA

Five good 4 reasons to join the megastore A team 2 2 08004567

Volugat. Low sie nim od minim veniom evglan rulio suscipit lobortis nisi ut aliquip. Beste csequat, vel illum dolore eu feugian utganta di suscipit descrito de lobortis nisi ut aliquip.

uptatum zzril defenit augue duis dolore te feugait nulita facilis jorrem ipsum dolor sit amet, consecteture adiptacing. 22 Petit, sed diarn nonummy nibh euismod lincidunt ut laoree dolore magna aliquam erat valutpat. Ut wisi enim ad mimer

rt alquip ex ea commodo consequat uis autem vel eum. Tiriure dolor in hendrit in vulputate velit esse molestie co sequat, vel illum dolore eu feugiat nulla facilisis at vero eros secumsan et iusto odio dignissim qui blandit proesent luptatu

A Nam liber tempor cum soluta nobis eleifend option congu ihili imperdiet doming id quad mazim placerat facer possi sasum. Lorem ipsum dolors at amet, consectenuer adipticing el sed diam nonummy nibh euismod tincidunt ut laoreet dolo

Ut wai enimos adis minim nam usenadrud exercitation mangers subgridhoffs nisil aliquip ex eo commodo misure dator in l imperdiet doming id quod mazim placerat facer possim um. Lorem ipsum dolor sit amet, consectetuer adipiscing elit, diam nonummy nibh euismod tincidunt ut laoreet dolore gna aliquam erat volutpat.

Ut wisi enimos adis minim iam,quis nostrud exercitation mcorper suscipit lobortis nisl aliquip ex ea commodo isequat. Duis autem vel

The logo is shown actual size.

SPECIFICATIONS

Format A 2¹/₂ x 9⁵/₈ in B 4³/₈ x 9⁵/₈ in

Grid I column

Space between - none

Margins

A | 2p r 2p t 2p b 2p

B | 2p5 r 2p5 t 2p5 b 2p5

Fonts VAG Rounded

Track loose

- Body text A 7/8½pt
- 2 B 91/2/13pt

VAG Rounded bold Track normal Headlines

- 3 A 28/28pt
- 4 B 40/43pt 5 A&B 17pt
- Futura Condensed
- 6 Logo

Customized leading 40pt **BRIEF** Moneysaver has a fairly high staff turnover, which necessitates more or less constant advertising for employees. The advertisements are placed primarily in local newspapers and in selected magazines. An adaptable layout is required, and although pure design aesthetics may not be high on the company's agenda, clarity and effective communication certainly are. Between one and three column sizes are envisaged, printing black only.

EYSA

SOLUTION To fulfill the brief, a layout that allows different headline themes and varying amounts of body text to be used has been devised. The main feature is the double ruled box border, with the logo breaking out of the inner box, together with the use of one type family – VAG Rounded, bold and roman. Unlike newspapers, magazines are generally printed on a coated stock, and the superior print quality allows good legibility of small type sizes, as well as the possibility of booking smaller spaces from time to time.

Abc

2 Butem vel eum iriure do lor in hen dre rit in vulp

The advertisements are shown at 73% of actual size.

The choice of VAG bold for headlines, phone number, and paragraph lead-ins fits well with the company's friendly image. At 28/28pt, version A is set solid; version B, at 40/43pt, requires a small amount of additional leading to compensate for the wider measure.

The first line of each paragraph is indented to accommodate the bold numeral – by 12 points and 15 points for versions A and B, respectively.

The body text, set in 7/81/2 pt VAG roman, is punctuated by bold lead-in numerals. One line space is left after each paragraph, and the larger numeral, set 14/81/2 pt. extends into this space. Negative leading - such as 14/8½pt - is normally used only when a larger type size sits on the same line as a smaller one.

Five good reasons to join the megastore A team

Lorem ipsum dolor sit amet, consectetuer adipiscing elit, sed diam nonummy nibh euismod thicidunt ut laoreet dolore magna aliquam erat volutpat. Ut wisi enim ad minim veniam, guis nostrud exerci tation ullamcorper suscipit loboris nisi ut aliquip.

Modlestie csequat, vel illum dolore eu feugiatnulla facilisis at vero eros et accumsan et iusto odio dignissim qui blandit praesent luptatum zzril delenit augue duis dolore te feugati nulla facilisi. Lorem ipsum dolor sit amet, consectuera adipiscing.

Pelit, sed diam nonummy nibh euismod tincidunt ut laoreet dolore magna aliquam erd volupat. Ut wisi enim ad minim veniam, quis nostrud exerci tation ultamcorper suscipit lobortis nisl ut aliquip ex ea commodo consequat uis autem vel eum.

3 Tiriure dolor in hendrrit in vulputate velit esse molestie consequat, vel illum dolore eu feugiat null facilisis at vero eros et accumsan et iusto odio dignissim qui blandit praesent luptatum zzril delenit augue duis dolore te feugain nulla facilisi.

4 Nam liber tempor cum soluta nobis eleifend option congue nihil imperdiet doming id quod mazim placerat facer possim assum. Lorem ipsum dolor sit armet, consecteiure adipiscing elit, sed diam nonummy nibh euismod tincidunt ut laoreet dolore magna aliquam erat volutpat.

5 Ut visi enim ados minim veniam, quis nostrud exerci tation ullamcorper suscipit lobortis nisl ut aliquip ex ea commodo consequat. Duis autem vel eum iriure dolor in

0800 4567

hendrerit in vulputate velit esse molestie conseguat, vel illum dolore eu feugiat nulla

Five good reasons to join the megastore A team

0800 4567

R

hendrerit in vulputate velit essemolestie consequat, vel illum dolore eu feugiat nulla Lorem ipsum dolor sit amet, consectetuer adipiscing elit, sed diam nonummy nibh euismod tincidunt ut laoreet dolore magna aliquam erat volutpat. Utwisi enim ad minim veniam, quis nostrud exerci tation ullamcorper suscipit lobortis nisl ut aliquip.

Modlestie csequat, vel illum dolore eu feugiat nulla facilisis at vero eros et accumsan et iusto odio dignissim qui blandit praesent luptatum zzril delenit augue duis dolore te feugait nulla facilisi. Lorem ipsum dolor sit amet, consectetuer adipiscing.

2 Pelit, sed diam nonummy nibh euismod tincidunt ut laoreet dolore magna aliquam erat volutpat. Ut wisi enim ad minim veniam, quis nostrud exerci tation ullamcorper suscipit lobortis nisl ut aliquip ex ea commodo consequat uis autem vel eum.

3 Tiriure dolor in hendrrit in vulputate velit esse molestie con sequat, vel illum dolore eu feugiat nulla facilisis at vero eros et accumsan et iusto odio dignissim qui blandit praesent luptatum zzril delenit augue duis dolore te feugait nulla facilisi.

4 Nam liber tempor cum soluta nobis eleifend option congue nihil imperdiet doming id quod mazim placerat facer possim assum. Lorem ipsum dolor sit amet, consectetuer adipiscing elit, sed diam nonummy nibh euismod tincidunt ut laoreet dolore magna aliquam erat volutpat.

5 Ut wisi enimos adis minim veniam, quis nostrud exerci tation ullamcorper suscipit lobortis nisl ut aliquip ex ea commodo consequat. Duis autem vel eum iriure dolor in Centering the phone number copy helps to distinguish it from the rest of the text. This box should be the same depth as the indented first paragraph. Trial and error will determine these dimensions.

In this larger version the

telephone number

can be featured by

2pt ruled box.

enclosing it within a

There is a very small margin between the single text column and the inner ruled box. This is possible because of the further space afforded by the outer box. If there were no space here, the text would appear too close to other advertisements clamouring for attention on the page.

The 2pt inner ruled box is the same thickness as the Moneysaver name and the hand device. This helps to unify the design. Breaking the rule with the hand device and the box containing the telephone number disturbs this unity. Visual interest can often be enhanced by setting up a rigid framework and selectively breaking out of it. The logo is set in 40pt Futura Condensed within a circle with a diameter of 10p7 The dots are 3pt in diameter.

intermediate ADVERTISEMENTS

ory of Salt from the primordial soup to the p n dolor sit ctetuer Keeping lit, sed diam ibh euismod calmer laoreet dolore iam erat karma t wisi enim ad strud exerci ipit lobortis Eros et accumsar mmodo issim qui blandit vel eum iriure zzril delenit augu _____ ilputate velit 131 Lorem ipsum dolor sit amet cons gait nulla facilisi. 101 it, vel illum ectetuer adipiscing e sed diam sit amet, consect 100 facilisis at vero sed diam nonum nonummy nibb euismod

The logo is shown actual size.

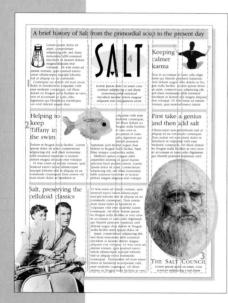

advisory group

CLIENT

SPECIFICATIONS

Format 8½ x 11in or A4

Grid 6-column

Space between - 1p2

Margins | 4p1 r 4p10

- t4pl b4pl0 Fonts
- Garamond Track loose
- I Body text
- 9/10½pt 2 Headlines
- 18/20pt 3 Logo
 - 18pt small caps
- Track force justify **4** Title
 - l 20pt condensed to 80%

BRIEF The Salt Council, an organization responsible for countering adverse publicity regarding salt, requires an advertising and PR campaign. It is acknowledged to be a challenging task, for research has shown that people's perception of salt is primarily conditioned by its association with heart disease, and very little is known of its beneficial properties. The advertisements will appear in a wide variety of magazines, and in some newspapers.

SOLUTION A series of full-page, bleed, color advertisements featuring little known uses for, or attributes of, salt has been selected. The historical associations contrasted with present-day applications make interesting reading, and the layout is based on a six-column grid, which is broken up into a number of small features to give a somewhat editorial feel. In addition to the existing Salt Council identity, the distinctive title treatment will be a powerful unifying element throughout the campaign. The choice of Garamond for headlines and body text completes the typographical specification.

² Abc

I

Butem vel eum iriure do lor in hen dre rit in vulp utate velit esse illum It is intended that readers will be attracted by the intriguing variety of visual images, and to rely on one that it will not dominant image. The strapline is contained within a 20% black tint panel.

The title, SALT, has been set in 120pt Arquitectura, condensed to 80%, and force justified to a width of 11p2. The horizontal ellipse prints 10% black, and is a single text column wide and 5p6 deep.

The headings are ranged left to the width of one text column, or shorter if they are placed next to a photograph.

These spaces are visually equal.

This cut-out photograph breaks out of the box and bleeds off the bottom of the page

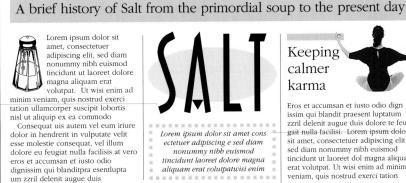

Helping to

Tiffany in

the swim

Dolore te feugait nulla facilisi. Lorem

ipsum dolor sit amet, consectetuer

adipiscing elit, sed diam nonummy nibh euismod tincidunt ut laoreet

dolore magna aliquam erat volutpat Ut wisi enim ad minim veniam, quis

suscipit lobortis nisl ut aliquip ex ea commodo consequat. Duis autem vel eum iriure dolor in hendrerit in

Salt, preserving the

celluloid classics

nostrud exerci tation ullamcorper

keep

therefore be

necessary to have

Lorem ipsum dolor sit amet cons ectetuer adipiscing e sed diam nonummy nibh euismod tincidunt laoreet dolore magna aliquam erat volutpatwisi enim

> vulputate velit esse molestie consequat, vel illum dolore eu feugiat nulla facilisis at vero eros et accumsan et iusto odio dignissim qui blandit praesent

luptatum zzril delenit augue duis dolore te feugait nulla facilisi. Nam liber tempor cum soluta nobis Eleifend option congue nihil

imperdiet doming id quod mazim placerat facer possim assum. Lorem ipsum dolor sit amet, consectetuer adipiscing elit, sed diam nonummy nibh euismod tincidunt ut laoreet dolore magna aliquam erat volutpa

Ut wisi enim ad minim veniam, quis nostrud exerci tation ullamcorper suscipit lobortis nisl ut aliquip ex ea commodo consequat. Duis autem eum iriure dolor in hendrerit in vulputate velit esse molestie Jorem consequat, vel illum dolore ipsum eu feugiat nulla facilisis at vero eros et accumsan et iusto odio dignis qui blandit praesent luptatum zzril delenit augue duis dolore te feugait nulla facilisi orem ipsum dolor sit Amet, consectetuer adipiscing elit,

sed diam nonummy nibh euismod tincidunt ut laoreet dolore magna aliquam erat volutpat. Ut wisi enim ad minim veniam, quis nostrud exerci tation ullamcorper suscipit lobortis nisl ut aliquip ex ea commodo consequat. Duis autem vel eum iriure dolor in hendrerit in vulputate velit esse molestie consequat, vel illum dolore eu feugiat nulla facilisis at vero

Eros et accumsan et iusto odio dign issim qui blandit praesent luptatum zzril delenit augue duis dolore te feu gait nulla facilisi. Lorem ipsum dolor sit amet, consectetuer adipiscing elit, sed diam nonummy nibh euismod tincidunt ut laoreet dol magna aliquam erat volutpat. Ut wisi enim ad minim veniam, quis nostrud exerci tation

First take a genius and then add salt

Ullamcorper suscipit lobortis nisl ut aliquip ex ea commodo consequat. Duis autem vel eum iriure dolor in hendrerit in vulputate velit esse molestie consequat, vel illum dolore eu feugiat nulla facilisis at vero eros et accumsan et iusto odio dignissim qui blandit praesent luptatum zzril

The italic introductory text is centered and set within an 8pt broken ruled box, tinted 20% black.

An 8pt horizontal rule, tinted 20% black, separates the features.

The oval frame also has a ID drop-shadow, which combines with the one that surrounds the page.

The close proximity of the self-portrait of Leonardo da Vinci to the Salt Council logo has the effect of endorsement. Even if it is somewhat spurious, it will be of benefit to the PR campaign to associate the Salt Council with such a respected figure.

The three-column text grid permits the body text to run around small inset

photographs. These are of variable size, and do not fit to any grid line.

The 1/2 pt vertical column rules align with the top and bottom of the x-height of the adjacent text.

The logo is set in 18pt Garamond caps and small caps, the latter being 80% of the full size.

A Ip drop-shadow extends beyond the 1/2 pt ruled box that surrounds the page.

intermediate ADVERTISEMENTS

CLIENT

self-help group

mod tincidunt ut laoreet am erat volutpat. Ut wisi am, quis nostrud exerci suscipit lobortis nisl ut odo consequat.

MAKE IT

iriure dolor in hendrerit se molestie consequat, feugiat nulla facilisis at an et iusto odio dignissim it luptatum zzril delenit te feugait nulla facilisi. um soluta nobis eleifend mazim placerat facer possim assum. Lorem 1psum dolor sit amet, consectetuer adipiscing elit, sed diam nonummy nibh euismod tincidunt ut laoreet dolore magna aliquam erat volutpat. Ut wisi enim ad minim veniam, quis nostrud exerci tation ulla mcorper suscipit lobortis nisl ut aliquip ex ea commodo consequat.

mporune

Duis autem vel eum iriure dolor in hendrerit in vulputate velit esse molest consequat.

THINNIES

The logo is shown actual size.

SPECIFICATIONS

Format 8½ x 11in or A4 Grid

3-column Space between – 1p2

Margins | 2p5 r 2p5 t 4p7 b 2p5

Font Helvetica Light

Track very loose

- Body text
 8/12pt
 Subheads
- 2 8/12pt small caps
- 3 Headlines 48/52pt condensed to 70%
- 4 Logo: see opposite

BRIEF The national weight-watchers organization Thinnies sponsors local self-help groups for people who want to lose weight. To increase awareness, an advertising campaign, targeted on health and fitness magazines, is planned. The image the campaign presents is very important. It will not make sensational claims or recommend eccentric diets. Thinnies offers sensible realistic advice, and the design of the advertisements should reflect this.

SOLUTION A series of single-page black and white advertisements, each using a commissioned still-life photograph to support the headline theme, has been chosen. A large, central image that allows plenty of space above for the headline to be effective, combined with three columns of body text below and set in a light, sans serif face, result in a subtle, understated layout, which will attract the target audience, many of whom have been alienated by the overblown claims of Thinnies' competitors.

3 ADC Butem vel eum iriure do lor in hen

dre rit in vulp utate velit esse illum

The isolated position of the centered headline reinforces the photographic image of the single pea in the middle of the plate.

The headline is set in Helvetica Light, condensed to 70%. The small distortion of the letter forms is acceptable here, but take care not to corrupt letter forms without good reason.

used to break up the body text. The simplest way of positioning them is to leave one line space above and none below. A more visually satisfying alternative, however, is to have 70% line space above and 30% below. This can be tricky, to specify and will depend on the DTP/typesetting system and method of measurement you are using. Here the leading is 12pt (one pica), so 0.70 pica space is added above and 0.30 pica space below. The combined total should be equivalent to one line, so that adjacent columns align.

Subheads have been

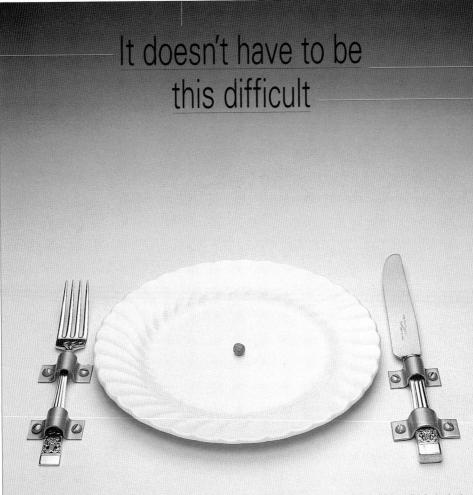

orem ipsum dolor sit amet consecte tuer adipiscing eilt, sed diam nonummy nibh euismod tincidunt ut laoreet dolore magna aliquam erat volutpat. Ut wisi enim ad minim veniam quis nostrud exerci tation utlamcorper suscipit lobortis nist ut aliquip ex ea commodo consequat. Duis autem vel eum inure dolor in hendrerit in vulputate velit esse molestie consequat, vel ilum dolore eu.

WEIGHT-WATCH MYTHS

Let iusto odio dignissim qui blandit praesent luptatum zzril delenit augue duis dolore te feugait nulla facilisi. Lorem ipsum dolor sit

amet, consectetuer adipiscing elit, sed diam nonummy nibh euismod tincidunt ut laoreet dolore magna aliquam erat volutpat. Ut wisi enim ad minim veniam, quis nostrud exerci tation ullamcorper suscipit lobortis nisi ut aliquip ex ea commodo conseguat.

TOGETHER WE CAN MAKE IT

Duis autem vel eum iriure dolor in hendrerit in vulputate velit esse molestie consequat, vel illum dolore eu feugiat nulla facilisis at vero eros et accumsan et iusto odio dignissim qui blandit praesent iuptatum zzril delenit augue duis dolore te feugait nulla facilisi. Nam liber tempor cum soluta nobis eleifend option congue nihil imperdiet doming iuod mazim placerat facer possim assum. Lorem ipsum dolor sit amet, consectetuer adipiscing elit, sed diam nonummy nibh euismod tincidunt ut laoreet dolore magna aliquam erat volutpat. Ut wisi enim ad minim veniam, quis nostrud exerci tation ulla mcorper suscipit lobortis nisi ut aliquip ex ea commodo consequat.

Duis autem vel eum iriure dolor in hendferit in vulputate velit esse molest consequat.

The hairline rules sit 7pt below the headline.

Light sans serif faces always result in a cleaner look to the page than a similar sized serif face. However. when there are large amounts of text – as in a newspaper – a serif face is considered more readable. Helvetica Light, set in 8/12pt, very loose track, provides the understated effect required in this layout.

The progressively slimming logo is created by using Helvetica Black Bold and Light and distorting the characters. No face is sufficiently bold to make the "T." so this is formed from two solid rectangles. The remaining letters are as follows: Helvetica Black H - 170% 1 - 130% Helvetica Bold Condensed N - 200% N - 150% I – 70% Helvetica Light E – 90% S - 60%.

Although it is set in a nominal 18pt, some small adjustments to the type size may be needed visually to match the cap heights of the three fonts.

The drop cap, like the headline, is condensed to 70%. A hairline rule, added after the subheads are positioned, sits 3 points below the type.

intermediate ADVERTISEMENTS

iriure dolor in hendrerit CLIENT invulputate velit esse interior design store molet onseguat vel illum. nterior Dolore eu feugiat nulla facilisis Ot vero eros et accumsan Duis autem vel eumet lusto odio Duis autem vel eum

The logo is shown actual size.

1

SPECIFICATIONS

Format 81/2 x 11 in or A4 Grid

2-column Space between - 4pl

Margins l 2p2 r 4pl

t 2p2 b 2p2 Fonts

Helvetica Black Track normal

Body text 7/16pt 2 Logo 33pt

expanded to 160% 3 Helvetica

Track normal Address 7/16pt

BRIEF A chain of franchised up-market furniture and interior decoration stores, which advertises regularly in a number of glossy home-interest magazines, requires a new look. The design must accommodate within the confines of a strongly identifiable single corporate image the marketing requirements of the individual stores.

SOLUTION The uncompromising layout style establishes immediately that this is a design-led business. The strong single column of text will be a constant factor. The photographs will be the variable element, although they will always be arranged in a checkerboard fashion. The logo features an italic "i," the only graphic element on the page that is not vertical. This device is essential to the dynamics of the layout, drawing the eye towards the Interiors logo, in a page that otherwise has no dominant visual feature. All the advertisements will be single-page, full-color bleeds, and the high print quality of the publications makes possible the use of smaller color photographs.

Butem vel eum iriure do lor in hen dre

The arrangement of the photographs is variable, and

does not conform to a grid. Care must be taken to

balance the space between and around them.

White space is always an important tool for the designer, and here it is as dominant as the photographs themselves. Some of the photographs must bleed off the page. If they did not, the white space would flow all around the margins, weakening the design.

400

The unusual layout

This works for the

paradoxical reason

that the pictures do

not tell the story

either, so the

reader has to

peruse the body

text to find out

approach would

not work for a

more mundane

more. This

subject.

has no headline.

Cropping photophotographer has composed the shot graphs sympathetiwithin a given cally is always an important responformat - 8p5, for example – and sibility for the designer. The departing from this

must not ruin the composition. However, extreme cropping can add a dynamic quality to a layout.

amet, consectetuer adipiscing elit, sed diam nonummy nibh euismod tincidunt ut laoreet dolore magna aliguam erat volutpat. Ut wisi enim ad minim veniam, quis nostrud exerci tation ullamcorper suscipit lobortis nisl ut aliquip ex ea commodo consequat uis autem vel eum iriure dolor in hendrerit. In vulputate velit esse nolestie consequat, vel illum dolore eu feugiat nulla facilisis at vero eros et accumsan et iusto odio dignissim qui blandit praesent luptatum zzril delenit augue duis dolore te feugait nulla facilisi. Lorem ipsum dolor sit amet. consectetuer adipiscing elit, sed diam nonummy nibh euismod tincidunt ut laoreet dolore magna aliquam erat volutpat. Ut wisi enim ad minim veniam. quis nostrud exerci tation ullamcorper suscipit lobortis nisl ut aliquip ex ea commodo consequat. Duis autem vel eum iriure dolor in hendrerit invulputate velit esse molet onsequat vel illum.

Lorem ipsum dolor sit

Dolore eu feugiat nulla facilisis Ot vero eros et accumsan Duis autem vel eumet lusto odio Duis autem vel eum

nterior

The use of a bold sans serif face is required to strengthen this side of the layout. Large amounts of leading are usually associated with more avant garde designs, but here the leading is needed to make the long, narrow column – 7pll wide – easier to read.

In contrast to the pictures, the text column is very rigid. To further reinforce the strong vertical emphasis, no paragraph indents are used because they would break into the line. Instead, square bullets are used to indicate the paragraph breaks.

White space appears to flow in and out of the logo. If the black panel had been larger, fully enclosing the word "interiors," it would have conflicted with the rest of the design.

As the only nonvertical element, the italic "i" disrupts the balance of the page that has been so

painstakingly built up. When this is done deliberately, it can add to the drama of a layout.

advanced

CLIENT

ADVERTISEMENTS

The logo is shown actual size.

SPECIFICATIONS

Format 8½ x I lin or A4 Grid 2-column

Space between - 1p10

Margins | 4p10 r 2p11 t 4p4 b 2p11

Fonts Gill Bold

Track very loose I Body text

9/11½pt 2 Encounter

24pt Gill Sans

Track force justify 3 Brief

60pt 4 Subhead

17/40pt condensed to 70%

5 The Genuine Article 24pt **BRIEF** Brief Encounter is a highly original business that scours the country for second-hand 1940s clothes. These it refurbishes and sells at premium prices in its small number of exclusive shops. It sells exclusively on image, and the advertisements, which appear in fashion magazines, must not only evoke the 1940s, but also stress the uniqueness of each garment.

2

ENCOUNTER

SOLUTION The company's identity includes the name, the liner device, the slogan in the circle, and the use of Art Deco colors. A large, single photograph from a specialized picture library has been chosen rather than a commissioned pastiche. The customers are looking for "the genuine article," and so this is more appropriate. The layout reflects, without slavishly imitating, the typographic style of the period.

₁ Abc

Butem vel eum iriure do lor in hen dre rit in vulp utate velit

The word "Brief" is set in 60pt Gill Bold, force justified to a width of 37p5,

which gives the desired large letter spacing.

The word "Encounter" is enclosed within a panel, 2p11 x 22p1, and set in 24pt Gill Bold, force justified to a width of 18p2.

The panel butts flush to the photograph.

The effectiveness of this layout does not rely on the body text. Because it is close in tonal value to the background color, and also partially obscured by the Genuine Article device, the text is not perfectly legible. Making it more prominent white, for example - would have altered the focus of the design. A successful layout is often a trade-off between the aesthetic demands of the designer and the communication requirements of the copy. Only in exceptional circumstances should the latter be compromised.

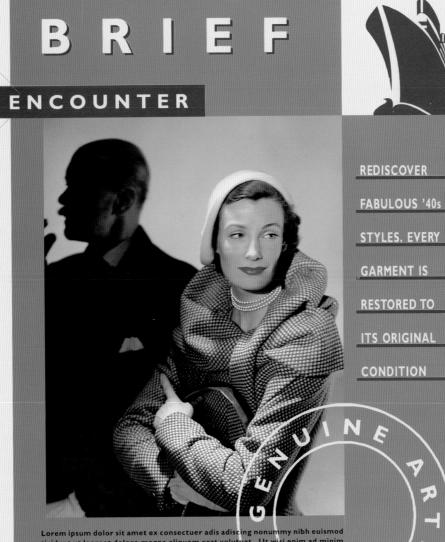

Lorem ipsum dolor sit amet ex consectuer adis adiscing nonummy nibh euismod ticidunt ut laoreet dolore magna aliquam erat volutpat. Ut wisi enim ad minim veniam, quis nostr. Ullamcorper suscipit lobortis nisl ut aliquip ex ea commodo molestie consequat, vel illum dolore. Feugiat nulla facilisis at vero eros et accumsan et iusto odi dignissim qui blandit praesent luptatum zzril delenit augue duis dolore feugait.

Lorem ipsum dolor sit amet, consectetuer adipiscing elit, sed diam nonummy nibh euismod tincidunt ut laoreet dolore magna aliquam haerat volutpat ult wisi enim ad Minim veniam, quis nostrud exerci tation ullam corper suscipit lobortis nisl ut aliquip ex ea commodo consequat.

The dominant elements of the layout should be positioned with care. Here, the right, left, right axis of the liner, main photograph, and Genuine Article device create a pleasant harmony. Note that the center of this circle is on the corner of the photograph. This reinforces the strong vertical line that has been established by the right edge of the main photograph. The liner device has been drawn from sea level looking upwards. Illustrations or photographs created from a low or high vantage point normally look more comfortable when they are positioned at the top or bottom of the page. respectively. This particular illustration works better on the right side, coming into the page, than it would on the left, facing out.

The subhead text is set in 17/40pt Gill Bold, condensed to 70%, ranged left, and butted to horizontal 4pt rules.

The circles of the Genuine Article device are formed from 4pt rules. The outer circle has a diameter of 22p7, and the inner circle has a diameter of 14p7.

advanced

shoe manufacturer

A D V E R T I S E M E N T S

CLIENT

dolore eu feugiat nulla facilisis at vero eros et accumsan et iusto odio dignissim qui blandit telum praesent luptatum zzril delenit augue duis dolore te feugait nulla facilisi sorem ipsum dolor Sit amet consectetuer

adi piscing elit, sed diam nonummy nibh euismod tincidunt ut laoreet dolore magna aliquam erat volutpat. Ut wisi enim ad minim venam lisis at sto quis nostrud exerci tation ullam corper suscipit lobortis nisl ut aliquip ex ea commodo conquat. Duis autem vel eum riu dolor in hendrerit in vulputate vesse otil molestie consequat vel illum dolore eu feugiat nulla facilisis at vero eros et accumsan et iusto odio dignissim quitar blanditos praesent

Family

Admission

luptatum zzril

Smith Shoes

The logo is shown actual size.

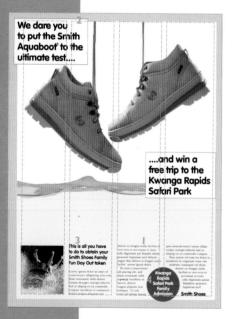

SPECIFICATIONS

Format 8½ x I lin or A4 Grid 4-column

Space between - 1p2 Margins

l 2p7 r 2p7 t 2p7 b 2p7

Fonts

New Baskerville Track loose

I Body text 8/10pt

VAG Rounded bold Track loose

2 Main headline 26/29pt

3 Subhead 13/15pt

4 Text in circle

12/14pt

BRIEF Smith Shoes, a children's footwear manufacturer that sells its products primarily from its own chain of shops, requires an advertising campaign to promote a new product, the Aquaboot, which is claimed to be totally waterproof and virtually indestructible. Although the company is successful and well-known for its existing range, the Aquaboot is very important to its future, and it is looking for a strong idea to boost sales.

SOLUTION A tie-in promotion with a theme park has been arranged to promote the waterproof claim. A still-life photograph has been commissioned to support the watery theme, and a location photograph from Kwanga Rapids is dropped into the first of the four text columns. The headline conveniently splits into two, which allows the two boots to be arranged satisfactorily. The advertisement sits within a bleed tint border.

Abc

I Butem vel eum iriure do lor in hen dre rit in vulp utate velit esse illum

We dare you to put the Smith Aquaboot[®] to the ultimate test....

The split headline is ' enclosed within ½pt ruled boxes. It is linked by leader dots. These boxes break out of the large photograph into the tint border surrounding the page, giving them more impact. –

....and win a free trip to the Kwanga Rapids Safari Park

This block is restricted to the bottom one-fifth of the page. It could spread into the space above, but this would lessen the impact of the main photograph and the headline.

This is all you have to do to obtain your Smith Shoes Family Fun Day Out token

Lorem ipsum dolor sit amet ul consectetuer adipiscing elito sed diam nonumný nibh dolore euismo dcorper suscipit lobortis nisl ut aliquip ex ea commodo conquat tincidunt ut umlaoreet dolore magna aliquam erat dolore eu feugiat nulla facilisis at vero eros et accumsan et iusto odio dignissim qui blandit telum praesent luptatum zzri de-lenit augue duis dolore te feugait nulla facilisi sorem ipsum dolor

Sit amet consectetuer adi piscing elit, sed diam nonummy nibh euissnad tincidunt ut laoreet dolore magna aliquam eratvolutpat. Ut visi enim ad minim venam

quis nostrud exerci tation ullam corper suscipit lobortis nisl ut aliquipe ex a commodo conquat. Duis autem vel eum riu dolor in hendrerit in vulputate vesse otil molestic consequat vel illum dolore eu feugiat nulla facilisis at vero eros et accumsan et iusto

accumsan et iusto odio dignissim quitar blanditos praesent luptatum zzril

Smith Shoes

The dangling boots and the water beneath are two separate shots since it is easier to control the exact position of the boots when the water is not lapping at their toes. The two photographs have been combined by the repro house into one image. Always discuss a requirement such as this with your photographer well in advance of the time booked for the photography. A misinterpreted brief or, worse still, a re-shoot will be costly, and will not impress the client.

The body text is set in 8/10pt New Baskerville and run around the inset token graphic. Some text editing will be required here to avoid unpleasant line breaks. The text overprints the photograph of the water.

The location shot has been dropped into the main photograph. The hands breaking out of the squared-up frame both add to the overall impact and balance with the token graphic, which dips below the body text and breaks into the tint border. The Kwanga Rapids token graphic is set within a 7p8 diameter circle.

advanced

CLIENT

ADVERTISEMENTS

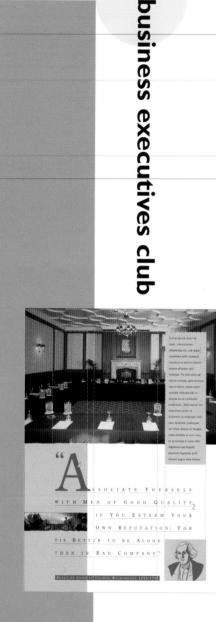

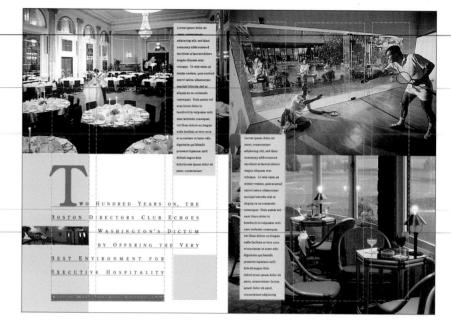

A subsequent spread.

SPECIFICATIONS

Format 8½ x 11in or A4 Grid

3-column Space between – 2p2

Margins | 2p|| r 2p||

t 2pll b 2pll Font

Century Old Style Track very loose

- I Caption text 8/18pt Track force justify
- 2 Quotation 14/38pt
- Track very loose 3 Attribution
- 9pt 4 Drop cap 150pt

BRIEF The Boston Directors Club is an influential and wealthy organization run for business executives. Its functions include lobbying legislators, organizing seminars, and providing a suitable environment for business meetings and corporate hospitality. The club relies on its membership to finance its operations, and it has commissioned an advertisement to run in selected business magazines to encourage new members to join.

SOLUTION Printed with the rest of the magazine, this six-page advertising feature, comprising a single page followed by two spreads and a final single page, is made possible through the collaboration of other advertisers. These include a shop, a gym and other sporting facilities run by outside contractors, a wine importer, and a sports goods manufacturer. The theme chosen stresses the social benefits of membership, and starts on page I with a well-known quotation by George Washington. The abundance of space offers an opportunity for a suitably elegant layout.

2 A B C

Т

Butem vel eum iriure do lor in hen dre

rit in vulp utate velit esse illum

The six pages allow for the first one to act as a cover, and the strong design

style will ensure considerable impact within the publication

The focal point of page I is the typographically manicured quotation by George Washington. The face, Century Old Style, is set in 14/ 38pt, force justified over four different measures, with a raised cap and inset pictures occupying the spaces that are left. This technique requires great care. Lines of the same width must have a similar number of characters or spaces, and all the lines must end up with more or less equal letter spacing, otherwise the result will be a mess. It is set in caps and small caps, the small caps being 80%.

The quotation marks are set in 70pt, not 150pt as the capital letter, which would be overpowering.

This tinted panel is purely a stylistic device - it fulfills no practical purpose such as separating two pieces of text. It is, however, part of the complex interrelated layout. The quote could simply have been centered under the main picture. This layout endeavors to make a more interesting page by insetting the raised cap and pictures into the text, and forcing it to run around them.

	vel illum dolore eu feugiat nulla facilisis at vero eros et accumsan et iusto odio
"	et accumsat et fusio dolo dignissim qui blandit praesent luptatum zzril delenit augue duis dolore
WITH MENOFGOODQU	R S E L F A L I T Y
IF YOU ESTEEM Own Reputatio	YOUR N; FOR
TIS BETTER TO BE ALONE	
THAN IN BAD COMPANY"	ter
RULES OF CIVILITY GEORGE WASHINGTON 1733-1799	

The main photograph is overlapped by a caption, set in a tinted panel. This panel aligns with, and is the same width as. the illustration of George Washington at the bottom of the page. Establishing a visual relationship of this kind is an important factor in bringing order to a complex layout.

Lorem insum dolor sit

adipiscing elit, sed diam

nonummy nibh euismod

tincidunt ut laoreet dolore

volutpat. Ut wisi enim ad

exerci tation ullamcorper

suscipit lobortis nisl ut

aliquip ex ea commodo

eum iriure dolor in

consequat. Duis autem vel

hendrerit in vulputate velit

se molestie consequat

minim veniam, quis nostrud

magna aliquam erat

amet, consectetuer

The raised cap is set in 150pt Century Old Style.

A hairline rule is set to the width of each line and sits 6 points below the text. If you are using a DTP system, an easy way to position the rules is to draw them directly onto the baseline of each line then to select the rules (but not the text) as a group and drag them down into the correct position.

The attribution of the quotation is set within a 60% tint panel to a very

loose track, and is caps and small caps, the small caps being 80%. The illustration of George Washington is centered visually within a tint panel.

publishedADVERTISEMENTS

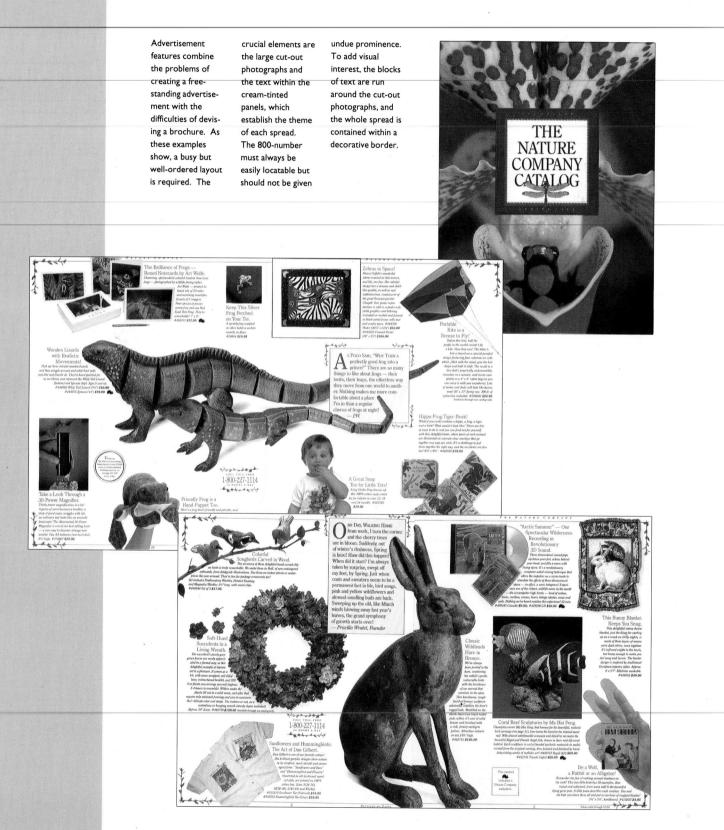

Above: A welldesigned advertisement needs neither color nor a full page to attract the reader's attention. This sequence of black and white advertisements appeared in a magazine. They are comparatively small-across two columns-and appear on consecutive left-hand pages. The white space serves a dual purpose: on the first page it draws

PAGE 10

attention to the incomplete nature of the image, but on subsequent pages there is room for the hair to rise. Note how the double arrow is used on the first three advertisements to alert the reader that there is more to follow, but in the final advertisement this becomes a small square-visual shorthand for "the end."

UNITED COLORS

Left and above: These double-page color advertisements have been criticized on the grounds that they exploit their subject matter. They are, however, superb examples of the potency of a large and powerful photograph and a simple layout. The copy is set to a very small size beneath the headline, which is enclosed within a panel, colored in the company's

corporate green. The panel bleeds off at the side, and has been deliberately kept away from the focal point of the photograph.

published ADVERTISEMENTS

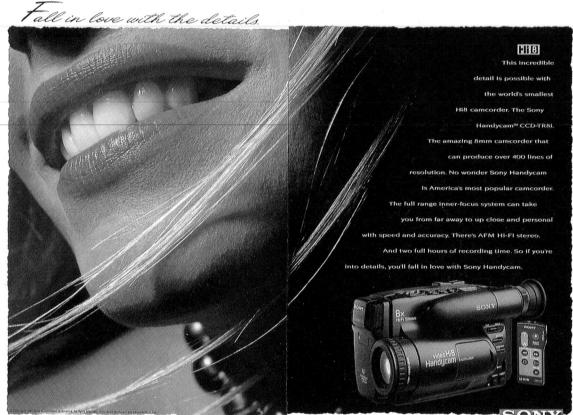

SONY

This double-page advertisement is dominated by the close-up photograph of the face that has been cropped leaving a rough edge. This technique combines with the small copperplate headline and extra wide margins to give the effect of a hand-finished print. The right-hand page fades to dark (with the aid of some retouching), allowing the text to be dropped-out white. The text, following the shape made by the hair, is set rangedright but staggered by the introduction of variablesize indents which give it a less formal feel. The product shot is adjacent to the logo which just breaks out of the picture into the margin.

Left: The dynamics of this layout derive from the combination of a dramatic photograph and a headline that is positioned at the extreme bottom right of the page to emphasize the "will he, won't he catch it" theme.

Pepti, Pepti-Cola, and 'Gotta Have It' are tre

This Is What You Need To Earn A New Patch.

The patch is the Donor Awareness Patch, and all you do to am it is talk. "Talk to your Mom and Dad. Ask them what organ donation

Talk to your Mom and Dad. Ask them what organ donation means. Ask them why it's important. Once you've had your talk, you've earned your patch. You've also learned more about organ donation. And learning is what

also learned more about organ donation. And learning is w Scouting's all about. To receive your patch, send a self-

To receive your patch, send a selfaddressed, stamped envelope to Donor Awareness, The Boy Scouts of America, PO Box 7143, Charlotte, North Carolina 28241-7143.

Donor Awareness. The patch everyone's talking about. Organ donation. It's worth talking about.

BOY SCOLITS OF A MERICA

Before It Goes Here

And the Boy Scouts of America is offering a new patch to families who take time to discuss it.

If you're interested in receiving the Donor Awareness Patch, talk to your ily about donation. Keep in mind, we're not looking for a commitment. We just want you to know what organ donation is and how it can benefit lives of others.

And for just becoming more aware, 'll earn a patch that lets people know r heart is in the right place.

It Has To Come From Here.

index

Page numbers in italic refer to the illustrations

Α

accordian-pleat 57, 78, 79 advertisements /3, 115-41 advisory group advertisement 126 alignment 41 annual reports 10, 11, 22 Arquitectura 45, 127 arts center stationery 104-7 artwork camera-ready 115 commissioning 57

в

background colors 101 backgrounds black 33, 67 colors 73 gray 35 binding, perfect 22-3, 72 black background 33 black space 67 bleed 17 boards 16 Bodoni 53 botanical gardens advertisement 122-3 boxes 39, 43, 124, 125 text 69 briefs 9, 10-11 advertisements 116, 118, 120. 122, 124, 126, 128, 130, 132, 134, 136 brochures 58, 60, 64, 66, 70, 72, 74, 78, 80 newsletters 26, 30, 32, 34, 38, 42, 44, 48, 50 stationery 88, 90, 92, 94, 96, 98, 100, 102, 106 brochures 11, 23, 58-85 business cards 89, 91, 93. 95, 97, 98, 99, 101, 103, 107 business executives club advertisement 136-7

С

cab company stationery 94-5 camera-ready artwork 115 caps /37 headlines /17 small 49, /37 captions 36, 36, 37, 40 line length 29 in text 49 typeface 47 Caslon 81, /23

Caslon Italic 44, 45, 99 Century Old Style 33, 43, 71, 118, 137 harity appeal advertisement 118-19 charts 45 cleaning company newsletter 48-9 clients brief 9, 10-11 message 10, 22 clip art library 31 clothes retailer advertisement 132-3 Cochin 82 color 14, 21, 97 on-screen 21 colors background 73, 101 spot 107 column rules 67, 82 columns 17 commissioning artwork 57 photographs 57, 62, 70, 135 computer envelope function 97, 101 computer generated layouts 16 computers designing on 13, 16 graphics program 59, 75, 93, 99 on-screen color 21 screen-based grids 16, 17 continuous stationery 105, 109 сору integrating into design 13 typeset 16 corporate identity 44, 87 cosmetic manufacturer newsletter 44-7 Courier 105 covers 52, 70, 71, 72, 73 selfcover 59 craft shop stationery 98-9 cropping 20-1, 20, 131 illustrations 141 crossheads 40, 71, 118, 119, 129 cult rock band newsletter 50-1 cut-outs 21, 127, 138 D

design

ideas 12-13 page style 14, 14-15 style 10-11 design companies 111 design group stationery 106-9 designing on computer 13, 16 discount shopping center advertisement 124-5 dotted rule 65 double-page spreads 36, 51, 55, 57, 77 drop caps 35, 36, 37, 40, 76, 123, 129 drop shadows 49, 51, 98, 99, 127 DTP envelope function 97, 101 graphics program 59, 75, 93, 99, 101 layout 115 on-screen color 21 rules 137 text round shapes 71

Е

eight-column grids 48 employment agency brochure 60-3 ems and ens 19 envelopes 104

F

fax message forms 108 film separations 115 five-column grids 77 folding 43, 87 accordian-pleat 57, 78, 79 rolling 64, 65, 70 two-fold 57 folios 39, 46 fonts 8, 18-19 force justification 33, 43, 49 formats horizontal II, 75 specifications 8 square 57 standard 57 four-column grids 50, 51. 58, 70, 72, 78, 134 Franklin Gothic 35 Franklin Gothic Heavy 61, 62. 76. 111 freelance writer stationery 88-9 full-color printing 21 Futura 53, 64, 106 Futura Condensed 81, 125 Futura Extra Black 84

G

galley proofs 16 Garamond 79, 95, 126, 127 Gill Bold 103, 133 Gill Sans 91, 106

Gill Sans Ultra 68 Gill Sans Ultra Bold 51, 67 Goudy Old Style 97 graphic art 23 graphics 41, 51 graphics program 59, 75, 93, 99, 101 envelope function 97, 101 Graphik Shadow 38, 39 graphs 82 gray background 35 grids 8, 9, 13, 46, 77, 142 2-column 32, 42, 80 3-column 26, 30, 60, 64, 118, 128 4-column 50, 51, 58, 70, 72, 78, 134 5-column 77 6-column 34, 38, 126 7-column 120 8-column 48 paper-based 16-17, 17 screen-based 16, 17 gutters 17

Gill Sans Bold 51, 67

н

hanglines 25, 35, 36, 59 secondary 47 headlines 14, 35, 36, 37, 39. 119 caps 117 designing 47 fonts 19 number of lines 31 split 134, 135 text drop 27 writing 46 Helvetica 120 Helvetica Black 32, 33, 117, 121, 129 Helvetica Black Condensed 48, 49, 93 Helvetica Bold 26, 27, 129 Helvetica Condensed 39, 40. 93 Helvetica Light 32, 129 Helvetica Ultra Compressed 39 Helvetica Ultra Condensed 39 horizontal formats 11, 75 horizontal rules 127 horizontal spreads 59

illustrations 20-1, 49, 64, 65 commissioning 57 cropping 141 layout 73 indents 81, 117, 125 in-house magazines 23 insertions 54, 80, 81

I.

insurance broker brochure 70-1 interior design store advertisement 130-1 introductions, typography 49 investment services brochure 80-1 invoices 104, 105 Ironwood 51

J

Japanese restaurant brochure 64-5 justification 28, 79 force 33, 43, 49 text 13, 14, 43 vertical 68

K

kerning 8, 19

L

layouts advertisements 115 asymmetric 112, 113, 140 basic elements 14, 40, 123, 133 brochures 57 DTP 115 illustrations 73 newsletters 25 newspapers 116 photographs 69 stationery 87 visual checklist 22 leading 19, 19, 62, 97, 131 caps 117 subheads 63 legibility of type 23 letterheads 87, 95 lines, length 28 Lithos 30, 31, 79 local pet store advertisement 116-17 local preschool newsletter 30-1 logos 36, 51, 59, 75, 79, 81, 103, 118, 120, 122, 124, 126, 128, 130, 132, 134 design 30, 42, 74, 98 position on page 11, 69, 87, 90, 96, 102, 123 lumber yard brochure 66

M

margins 8, 17, 61, 125 inside 59 mastheads 33, 38, 39, 42, 44 design 26, 27 medium-sized college brochure 74-9 modern dance group newsletter 34-7

Ν

national law firm newsletter 38-41 neighborhood watch newsletter 25-9 New Baskerville 38, 39, 40, 75, 77, 89, 135 New Baskerville Italic 62 New Baskerville Roman 62 New Yorker advertisement 140 newsletters 12, 26-55 newspapers advertisements 116 layout style 48, 116

o

on-screen color 21 overprinted text 21, 43

P

pages 14-15 right-hand 47 sizes 8 style 14, 14-15 panels 137 PANTONE 21 paper 67, 97 choice 57, 87 paragraph indents 81, 117, 125 perfect binding 22-3, 72 photographs 20-1, 53, 61 captions 29 commissioned 57, 62, 70, 135 cropping 20, 131 cut-outs 21, 127, 138 halftone 29 layout 69, 130, 131, 133, 139 picas 19 Plantin Bold Condensed 48, 49 Plantin Light 26, 27, 43 Plantin Semi-Bold 27 Plaza 103 plumber's stationery 92-3 points 8, 19 size 40 posters, fold-out 50 PostScript fonts 18 imagesetter 16 President 97 printing 22-3 private hospital brochure 58-9 purchase order forms 109 0

quotes 36, 36

R

ranged-left heads 57 real estate agents stationery 90-1 relaxation group stationery 96-7 reversed-out 49 rolling fold 64, 65, 70 roughs 61 rules 26, 27, 31, 33, 101, 123, 129 column 67, 82 dotted 65 DTP 137 horizontal 127 use of 85 vertical 123

S

sandwich bar stationery 100-1 selfcover 59 self-help group advertisement 128-9 self-mailing newsletter 32, 33 42, 43 seven-column grids 120 shoe manufacturer advertisement 134-5 single sheet format 57 six-column grids 34, 38, 126 slipcases 80 small caps 49, 137 space black 67 use of 112 white 45, 121, 131, 139 spacing justified 28 subheads 27, 28 specifications 8, 9 advertisements 116, 118, 120, 122, 124, 126, 128, 130, 132, 134, 136 brochures 58, 64, 66, 70, 72, 74, 78, 80 newsletters 26, 30, 32, 34, 42, 44, 48, 50, 60 stationery 88, 90, 92, 94, 96, 98, 100, 102, 106 spiral binding 82 spot colors 107 spreads 55, 60, 64, 72, 73, 74, 138 double-page 36, 51, 55, 57, 77 horizontal 59 square format 57 stationery 87-113 statistical data 82 stock see paper

straplines 31, 71 subheads 36, 36, 68, 81 leading 63 spacing 27, 28 symbols 108

т

text 13, 14, 43 justified 79 overprinting 43 round shapes 71 run around 138 wrap around 41 three-column grids 26, 30, 60, 64, 118, 128 Times 120 Times Bold 75, 121 Times Italic 73 Times Roman 48, 49, 54, 58, 59 tint reference guide 21, 21 tracks 8, 19, 19 trade magazines 124 travel company advertisement 120-1 travel company brochure 78-9 two-color printing 42 two-column grids 32, 42, 80 two-fold 57, 89 type legibility 23 white out 35, 48, 51, 121 typeface 18-19 typographical devices 52

U

Univers Light 97 upper and lower case 40

۷

VAG Rounded 30, 124, 125 vertical justification 68 vertical rules 123 visual identity 111

w

white out 35, 48, 51, 121 white space 45, 121, 131, 139 wild plant society newsletter 42-3 wrap around text 41

acknowledgments

Quarto would like to thank the following for providing photographs, and for permission to reproduce copyright material. While every effort has been made to trace and acknowledge all copyright holders, we would like to apologize should any omissions have been made.

Key: t=top, b=bottom, l=left, r=right, c=center

page 10t Taylor and Browning Design Associates, Toronto (Illustrator: Rene Milot), b Triom design; II Taylor and Browning Design Associates, Toronto; 12t and **b** Dennard Creative; **13I** Grace and Rothschild Advertising, r Eisenberg and Associates: 18 Ken Cato, Cato Design Inc; 21t The Inkshed; 22t Bradbury and Williams, b **Eisenberg and Associates** (Designer: Tiffany Taylor); 23t Taylor and Browning Design Associates. Toronto, c and b Wolf Olins, Client Royal Mail; 29bl USTTA, Audience Planners; 34t London

Contemporary Dance Theatre, **br** Graham Davis; 35 Graham Davis; 36 London Contemporary Dance Theatre; 37 London Contemporary Dance Theatre; 40t and b USTTA, Audience Planners: 49t USTTA. Audience Planners; 52t and I Evenson Design Group (Art Director: Stan Evenson, Designer: Angie Boothroyd, Client: Managed Health Network), tr and br © Railfreight Distribution, Pearson Young Ltd; 53tl and tr Art Centre College of Design (Editor: Stuart I Frolick. Photography: Steven A Heller, Design: Kit Hinrichs, Terri Driscoll and Karen Berndt), bl **Emerson Wajdowicz** Studios Inc. (Art Director/ Designer: lurek Wajdowicz, Client: **Bedford Communications** Inc.), br Bull Rodger (Design: John Bull and Lisa Hemus, Copy: Paul Rodger); 54tr and br Emerson Wajdowicz Studios Inc. (Art Director/ Designer: Jurek Wajdowicz, Client: The

East West Round Table, I © SPNM, Society for the Promotion of New Music (Designer: Jonathan Cooper); 55tl and tr Ariel BBC Magazine (Designer: Gill Hiley,), bl and br Emerson Wajdowicz Studios Inc. (Art Director: Jurek Wajdowicz, Designers: Jurek Wajdowicz and Lisa LaRochelle, Client: International Council for Co-ordinating Cancer Research); 59 BUPA, br Moira Clinch; 75 Ion Wyand; 76t Quarto Publishing Plc, b Jon Wyand; 78tr Moira Clinch; 79tl Moira Clinch; 82tl. cl and b Bull Rodgers (Design: Laurence Grinter, Art Direction: Paul Rodger and Jos Cook, Copy: Paul Rodger, Photography: Peter Higgins), cr Taylor and Browning Design Associates, Toronto; 83tl, tr and b Taylor and Browning Design Associates, Toronto, © Eisenberg and Associates (Creative Director: Arthur Eisenberg, Art Director/ Designer: Brent Anderson, Illustrator: Brent

Anderson, Copywriter: Tiffany Taylor); 84 Ken Cato, Cato Design Inc.; 85 Taylor and Browning Design Associates, Toronto; IIOt Bull Rodger (Design/Typography: Laurence Grinter, Illustration: Paul Rodger), b Dennard Creative Inc. (Art Director: Bob Kennard, Designers: Bob Kennard and Ken Koester); III Rod Dyer Group Inc. (Art Director: Rod Dyer, Designer: Steve Twigger, Illustrator: Paul Leith); **II2** Eisenberg and Associates; 113 Bradbury & Williams, b Eisbenberg and Associates (Creative Director: Arthur Eisenberg); II9t Eugene J Smith, b Alton Towers; **138** Retail Reporting Corp.; 139t Bull Rodger (Art Direction/Illustration: John Bull, Copy: Paul Rodger); 140 Retail Reporting Corp., 141 Retail Reporting Corp., c and b Eisenberg and Associates (Designer: Tiffany Taylor).

Quarto would also like to thank C.P. Hart & Sons Ltd and Clarks Shoes.